WORDS NOT SPENT TODAY
BUY SMALLER IMAGES TOMORROW
Essays on the Present and Future of Photography

by **David Levi Strauss**

aperture

Words not spent today
Buy smaller images tomorrow
. . .

The desperate are the greatest image makers
smoke signals at three paces
doctor I am dying
every word fights for an image
the most irrepressible state of an idea
only the desperate can help us
. . .

When the world was young images were strong

Images have sources and antecedents
to turn away from them is to have no images
to breathe life into

We have again become so young
that someone will have to turn on a light and find us

—Frederick Sommer, *Aperture*, vol. 10, no. 4, 1962

CONTENTS

INTRODUCTION

Writing about images is inherently polemical, because words and images are antagonistic toward one another. Words want images to illustrate and illuminate them, while images want words to clarify and contextualize them. The two are locked in an age-old struggle for dominance that is enacted, to some extent, each time they appear together.

The title of this book, *Words Not Spent Today Buy Smaller Images Tomorrow*, comes from the great American photographer Frederick Sommer. It is the first line of a poem that Sommer placed at the front of the issue of *Aperture* magazine devoted to his work in 1962. When I first read the line, probably in 1976 at the Visual Studies Workshop in Rochester, New York, I was immediately drawn to this idea of a possible economy of words and images relative to time. The notion that words might be seen as a kind of currency used to purchase images, and that the relative value of this currency is decreasing over time, struck me as both outlandish and prescient. It pointed to the eventual effects of the epochal shift from linear writing to technical images that Vilém Flusser would later describe in his 1983 book *Für eine Philosophie der Fotografie* (*Towards a Philosophy of Photography*), and that have continued to accelerate with time.

We now live in the Golden Age of Search, especially when it comes to images. In 2014 the volume of technical images being captured and stored is so great that it has overwhelmed our capacity for retrieval, let alone for reception, on a personal level. We take more pictures, but we look at them less often, and with less care. Consequently, our ability to decode images is actually decreasing. When words and images are reduced to "information," they lose significance and become elements that simply need to be managed. We are able to capture, store, manipulate, and sort images very rapidly, but not to decode them, which takes more time. That is, the less time we have and take to read or decode images (thereby "spending words"), the less we will get out of them (as they become "smaller"), and, paradoxically, the more power they will have over us.

We are just now waking up to the fact that the cost for this vast search capability and access is our personal privacy. As we search for information, GoogleAppleFacebookAmazon is collecting information (including images) from us. They have told us for years that information wants to be free, but this data, our data, turns out to be worth a fortune to the consumer-security state. Click here to accept all this without question.

I also read Sommer's line as a kind of stimulus proposal. We have to spend more words to stimulate more and better images, and to resist control through images. If we don't do it now, it will cost a lot more to do it later.

So I would like to spend some words on images today, in advance of the inflationary spiral. I discovered a long time ago that, in writing about photography, I could write about everything else in the world that interested me. Photographically derived images have long been a reliable measure of the values and desires that influence the social and political, and as these images have proliferated and accelerated, they have increasingly come to drive these discourses.

I have learned the most extraordinary things about photography from photographers. Their ideas about how images actually work are grounded in years of direct observation. It is true that some photographers grow weary of self-scrutiny and begin to ignore the most pressing questions about their medium, leading to a historic strain of anti-intellectualism in both art and documentary photography that continues in some quarters. But the photographers I have been most drawn to, those on whom I focus in this book, have continued to ask the difficult, persistent, and recurring questions that arise whenever someone attempts to represent someone else. Postmodern criticism of photography concentrated on these questions and provided useful means to isolate and clarify them, but it also left us with some exhausted terms and premature answers.

My previous book of essays on photography and politics, *Between the Eyes* (Aperture, 2003), ended with 9/11, and that 2001 event haunts this book as well, because it shifted the ground of our thinking about images, wiping away years of accumulated theories about their effects and meanings, and causing us once again to acknowledge and confront our irrational and enduring attraction to them.

I begin here with considerations of the work of five women: the discrepancy between information and storytelling in photographs by Susan Meiselas; the intimacy and mendacity of photography in the work of Sally Mann; the treatment of somatic trauma through images by Carolee Schneemann; inscription and contagion in Jenny Holzer's *Lustmord* series; and the poetic logic of technical images in Jane Hammond's photo-collages. The second section of this volume recounts my conversations with Frederick Sommer in Arizona, reconsiders the seminal work of John Wood and its relevance for new media, and meditates on Robert Bergman's portraits, the works of nine Latin American photographers, and Tim Davis's America. Part III comprises short appreciations of Susan Sontag, Larry Clark, Daido Moriyama, Helen Levitt, and James Nachtwey. In Part IV, I revisit the aestheticization-of-suffering critique today, the meaning of the death of Kevin Carter, the images from Abu Ghraib, and the decisions of the Obama administration to withhold and displace images from Abu Ghraib and Abbottabad. And in the book's final section, I look back at Chris Marker's approach to images and memory, the historic relation between images

and magic, Joseph Beuys and 9/11, and the transformative images from Tahrir Square and Zuccotti Park at moments of radical social upheaval and change.

Each of these essays has a history and is embedded in an intricate and often intimate web of particulars. But they are all part of an ongoing inquiry into what photographs do, which John Berger, in his 1968 essay "Understanding a Photograph," says is, fundamentally, to "bear witness to a human choice being exercised in a given situation." This is what makes the consideration of photographic images important to any discussion of human freedom.

—David Levi Strauss, January 2014

An Amplitude That Information Lacks

On Susan Meiselas

In the summer of 1975, I'd finished my first year at Goddard College in Plainfield, Vermont, and stayed on to work for the local farmers. The scale of farming was very different in Vermont than what I was used to growing up in Kansas. These hardscrabblers planted a bit of everything; put up a little hay; kept a few cows, chickens, ducks, sheep, and hogs; and did everything themselves in a makeshift way. At the end of the week, we sons and hired hands went out looking for trouble, and usually managed to find it, in the small towns scattered among the Green Mountains.

I had just turned twenty-two, but had already been around the world and seen some things. Even so, the traveling "girl shows" that came through towns like Rutland and Hardwick shocked me. The spectacle of drunken farmers and lonely woodsmen lining up to ogle and grope down-and-out battered women in the backs of trucks was like nothing I'd ever seen. I was curious at first, but seldom went beyond the front stage, where barkers displayed the girls like livestock before separating the rubes from their money and herding them in. The men's actions didn't surprise me much, but I couldn't figure out why the women put up with it.

That next spring, back at Goddard, my photography teacher Jeff Weiss gave me a new book called *Carnival Strippers*. The photographer and author, Susan Meiselas, had somehow gotten *inside* the girl shows, and told the story with the simplest of means: saturated black-and-white photographs of the scene and players, juxtaposed with straightforward testimonies of participants from both sides of the "stage." Meiselas managed to catch it all—the strange symbiotic relations between "the talkers" and the girls, the mind-numbing tedium between shows, and the camaraderie and intimacy among the women, outside of their anaesthetized stupor. And underneath it all lay the tawdry theater of desire on which all consumer advertising depends, leading to the monotonous hustle: the come-on, the tease, the exchange of money, the bait-and-switch, and the inevitable letdown.[1]

Meiselas's approach was remarkably cool and impartial, but not clinical or dull. If one looked at the images and read the statements by the strippers closely, it was clear that Meiselas had found something here that intrigued her, and she risked the exposure. This is Lena, who appears on the cover of *Carnival Strippers*:

Maybe I'm a daredevil, because I've always preferred being around men to being around women. I can identify with men. The girls I hung around seemed so finicky and childish. They seemed like they had to have somebody to make them whole. The men were more open. They could do or become anything they wanted to. They didn't whisper about people. . . . I don't want to be like a man, I want to share with men. I still want to be a woman, but I want to be able not to whisper. . . . Being a stripper is as close to being in a man's world as you can be.[2]

I had seen the girl shows from a distance, but Meiselas got up close, and told the story in a way that allowed me to understand something about them that I never would have come to on my own. Her storytelling carried a strong implicit political critique, without ever stating it explicitly. She represented the people involved with dignity and respect, but revealed the brutality of the situation in which they found themselves truthfully, without pulling any punches, in a way that implicated us all. She made this look easy, but I knew it wasn't. And I wasn't embarrassed by the method, but I noticed that a lot of other people were.

More and more often there is embarrassment all around when the wish to hear a story is expressed. It is as if something that seemed inalienable to us, the securest among our possessions, were taken from us: the ability to exchange experiences.

—Walter Benjamin, "The Storyteller," 1936[3]

Wanting to hear each other's stories is an embarrassment because it means we've already lost something. Telling someone else's story puts one in an almost untenable position. *How dare you put yourself in that position!* And yet, without the risk, so much would again be lost.

After *Carnival Strippers*, Meiselas was accepted into Magnum and went off to cover the war in Nicaragua, publishing her chronicle of the revolution, *Nicaragua, June 1978–July 1979*, in 1981. Once again, she told the story in her own images and in the words of the people involved in such a direct and full way, and in such a self-implicating way, that it became the story for a generation in and outside of Nicaragua that saw real hope in that struggle.

But the Nicaragua book also came out into the teeth of a trenchant new critique of the whole documentary approach. This critique held that documentary practice (the art of telling other people's stories) was so contaminated by the underlying assumptions of colonialism and imperialism that it could never serve a radical purpose. It held that documentary works like Meiselas's were products for consumers in the United States, selling the hope of political action while in fact helping to preclude such action, by making of it a spectacle,

and an *image*. Books like Meiselas's were based on exploitation, a manipulation of history for the aggrandizement of the individual heroic photographer. In her groundbreaking essay "In, around, and afterthoughts (on documentary photography)," first published in 1981, the same year in which Meiselas's *Nicaragua* appeared, Martha Rosler wrote:

> Documentary testifies, finally, to the bravery or (dare we name it?) the manipulativeness and savvy of the photographer, who entered a situation of physical danger, social restrictedness, human decay, or combinations of these and saved us the trouble. Or who, like the astronauts, entertained us by showing us the places we never hope to go. War photography, slum photography, "subculture" or cult photography, photography of the foreign poor, photography of "deviance," photography from the past— W. Eugene Smith, David Douglas Duncan, Larry Burrows, Diane Arbus, Larry Clark, Danny Lyon, Bruce Davidson, Dorothea Lange, Russell Lee, Walker Evans, Robert Capa, Don McCullin, Susan Meiselas . . . these are merely the most currently luminous of documentarian stars.[4]

In a review of *Nicaragua* first published by *In These Times* in June 1981, Rosler moderated her view of Meiselas's contributions a bit, and blamed more of what she saw as the shortcomings of *Nicaragua* on its publishers. And when Rosler later included the complete version of the review in her 2004 collection *Decoys and Disruptions*, she prefaced it by saying: "In the intervening years I have gotten to know Susan Meiselas, and my admiration for her commitment, skill, and resourcefulness . . . has grown."[5] But that did not prevent her from reprinting the essay as it was, beginning by lampooning the narrative of Meiselas's book as a "fairy tale":

> Once there was a brutal dictator in a small banana republic in steamy Central America who so abused his people, grabbing most of the wealth, stifling initiative, and causing misery, that waves of discontent spread throughout the entire population until finally peasants, lawyers, housewives, businessmen, and even priests and nuns rose up in outrage. Despite incredible atrocities, they eventually succeeded in driving out the beast and his minions, and they looked forward to living in peace forever after.[6]

In her essay, Rosler questions "the book's ability to inform and mobilize opinion," because of its inclusion of "mystery" and "romance." She points to the incompatibility of information and story, or news and art, concluding that "as 'art' takes center stage, 'news' is pushed to the margins," leading to "an antirealist effect."[7] The assumption is that art is inferior to news, and story is inferior to information, when it comes to political effect.

This critique of documentary is largely based on a set of assumptions about how this kind of work is actually received and used by the public. When I first met Meiselas in San Francisco in 1991, she challenged these assumptions:

> We really don't know very much about what happens when people look at photographs. We assume things. Theorists assume a great deal, and they often raise questions that are legitimate and valuable, but their analysis is not often based on real research. . . . I think it is an area about which we know very little, certainly not enough to make the kinds of assumptions we're dealing with here.
>
> In thinking about political effects, you have to ask to what extent is politics about action and to what extent is it about creating conditions for action. As much as I have at times wanted someone to do something in response to having seen an image that I made, I don't know that there's any proof [that it has happened]. People have told me they saw my book and then went to Nicaragua and spent the next five years of their lives, but who knows what role the book actually had in that process?[8]

Meiselas has spent a great deal of time in recent years trying to increase her understanding of the reception of images and their effects. She has returned to Nicaragua to find out what happened to her images and people's memories of them. When filmmaker and anthropologist Robert Gardner returned to the Baliem Valley in Western New Guinea in 1988, looking back to the Harvard Peabody Museum expedition of 1961 and his film *Dead Birds*, Meiselas went with him to find out what had changed, and ended up making the book *Encounters with the Dani*—a recollection in images and words of the cultural impact of previous images and words on the Dani people.[9] When Meiselas returned to Chile in 2006, sixteen years after the publication of her book *Chile from Within*, I was lucky enough to accompany her as she revisited the brave photographers of the Pinochet years, whose work she had collected and published.[10]

Meiselas's goal for the past thirty-five years has been to find effective ways for her chosen subjects—from the women in the "girl shows" in New England to peasant revolutionaries in Nicaragua to the Kurdish people—to tell their own stories clearly, forcefully, and memorably. The principal assumptions underlying this documentary drive are the reciprocity of experience, and the idea that the experience of an individual or group can be communicated to others through an intermediary; and, further, that such communication of experience is salutary, that it can lead to greater understanding.

These assumptions or beliefs can be fairly characterized as "liberal," in the sense of leading to reform rather than to revolution, and emphasizing individual freedom over the

claims of the community or the state. And these characterizations have brought documentary practice as a whole into the larger debates about the limits and failures of liberalism, especially concerning its tendency toward moral indifference: seeing morality as a private, rather than a social and political matter—and worse, moral philistinism: promoting individualistic, selfish, middle-class values to the exclusion of more public, social values. This is exactly what Rosler was aiming at in 1981: "The liberal documentary, in which members of the ascendant classes are implored to have pity on and to rescue members of the oppressed, now belongs to the past. The Jacquelines of the world, including Jacqueline [Kennedy Onassis], dance on its grave in upholstered mausoleums like the home of 'Concerned Photography,' Cornell Capa's International Center [of] Photography, at its ritzy New York address."[11]

But Meiselas's work in Nicaragua certainly complicates these characterizations. This was, after all, the documentation of a revolution, a revolution that was continually and blatantly misrepresented by the U.S. press and by U.S. government propaganda (President Reagan called the Sandinistas "terrorists"), and undermined by counterrevolutionary military forces, or "contras," that were backed by the U.S. government, at first directly, and later covertly. Meiselas's book was an incendiary device thrown into that history. As she said in her epigraph to the book, "NICARAGUA. A year of news, as if nothing had happened before, as if the roots were not there, and the victory not earned. This book was made so that we remember."[12]

The way that this work was made and presented led to it being embraced by the people of Nicaragua as their own in a very unusual way. This is a history that could usefully be placed in contradistinction to the cases of subjects and documentarians such as Florence Thompson and Dorothea Lange, or Allie Mae (Burroughs) Moore and Walker Evans, referenced by Rosler in her "In, around, and afterthoughts" essay. One particular instance of this is the various migrations of the "Molotov Man" image from Meiselas's *Nicaragua* book, which she traces in her 1991 film *Pictures from a Revolution*. She revisited this in 2007, in a defense of the rights of the man in the image, Pablo Araúz (called "Bareta" during the war), against the decontextualizing appropriation of the image by artist Joy Garnett, who made a painting based directly on Meiselas's photograph and included it with images of angry skinheads, screaming punk rockers, and frat boys jumping over bonfires in Garnett's Riot series. Meiselas responded:

> I made the image in question on July 16, 1979, the eve of the day that Somoza would flee Nicaragua forever. What is happening is anything but a "riot." In fact, the man is throwing his bomb at a Somoza national guard garrison, one of the last such garrisons remaining in Somoza's hands. It was an important moment in the history of Nicaragua—the

Sandinistas would soon take power and hold that power for another decade—and this image ended up representing that moment for a long time to come. . . .

There is no denying in this digital age that images are increasingly dislocated and far more easily decontextualized. Technology allows us to do many things, but that does not mean we must do them. Indeed, it seems to me that if history is working against context, then we must, as artists, work all the harder to reclaim that context. We owe this debt of specificity not just to one another but to our subjects, with whom we have an implicit contract.[13]

Meiselas has always taken that social contract with her subjects very seriously. "It is important to me—in fact, it is central to my work—that I do what I can to respect the individuality of the people I photograph, all of whom exist in specific times and places."[14] Stories are told about individual people, in specific times and places, by individual people. If you're telling the story, you're in the story.

There is a tension in social-documentary practice between liberal and radical ends. On the one hand, the tradition has had a reformist intent; on the other, it finds its existence only in the Social, and therefore has a radical core. This tension activates many parts of Meiselas's work, perhaps most visibly in her Kurdistan project. Traveling to Northern Iraq in 1991, then working with Human Rights Watch to document Saddam Hussein's Anfal campaign against the Kurds by photographing the refugees and mass graves, she became aware of the extraordinary lack of an image history of the Kurds, and set out, over the next six years, to recollect these images, these shards of the story, and to try to place them in context. In the introduction to her 1997 book *Kurdistan: In the Shadow of History*, Meiselas registers the difficulties of such an endeavor, and her doubts about its efficacy: "Every picture tells a story and has another story behind it: Who's photographed? Who made it? Who found it? How did it survive? I wonder what we can know of any particular encounter by looking at such a picture today. We have the object, but it exists separated from the narrative of its making."[15]

More information does not necessarily increase realism. Information can be indigestible in its raw form, and must be prepared differently in order to be effective, to be of use. Masses of data are not memorable. Images are memorable. Stories are memorable. As we move headlong into a world in which the delivery of information, in images and words, becomes more fluent and more rapid every day, the task of the storyteller is becoming more necessary, and more endangered.

In his 1936 essay "The Storyteller," Walter Benjamin put the dilemma in temporal terms, and looked forward to a future that we are now inside of:

Information . . . lays claim to prompt verifiability. The prime requirement is that it appear "understandable in itself." Often it is no more exact than the intelligence of earlier centuries was. But while the latter was inclined to borrow from the miraculous, it is indispensable for information to sound plausible. Because of this it proves incompatible with the spirit of storytelling. If the art of storytelling has become rare, the dissemination of information has had a decisive share in this state of affairs.

Every morning brings us the news of the globe, and yet we are poor in noteworthy stories. This is because no event any longer comes to us without already being shot through with explanation. In other words, by now almost nothing that happens benefits storytelling; almost everything benefits information. Actually, it is half the art of storytelling to keep a story free from explanation as one reproduces it. . . . The most extraordinary things, marvelous things, are related with the greatest accuracy, but the psychological connection of the events is not forced on the reader. It is left up to him to interpret things the way he understands them, and thus the narrative achieves an amplitude that information lacks.[16]

In all her work, from *Carnival Strippers* on, Meiselas has taken the task of the storyteller to heart. It takes time to tell the kinds of stories Meiselas wants to tell. Ultimately, it takes all the time one has.

NOTES

1. Twenty-five years later, Meiselas took this tawdry theater into another socioeconomic realm, photographing inside the exclusive S & M club Pandora's Box in midtown Manhattan, where wealthy executives went to get a little "discipline" from Mistresses Raven and Delilah (*Pandora's Box, NYC* [London: Magnum Editions, 2001]). As in *Carnival Strippers*, questions about power and agency are put into a frame where the answers become much more complicated (and revealing) than before.

2. Lena, quoted in Susan Meiselas, *Carnival Strippers* (New York: Farrar, Straus and Giroux, 1976), p. 148.

3. Walter Benjamin, "The Storyteller" [1936], in *Illuminations: Essays and Reflections*, ed. by Hannah Arendt (New York: Schocken, 1969), p. 83.

4. Martha Rosler, "In, around, and afterthoughts (on documentary photography)," first published in *Martha Rosler: 3 Works* (Halifax: Press of the Nova Scotia College of Art and Design, 1981), and repr. in *The Contest of Meaning: Critical Histories of Photography*, ed. by Richard Bolton (Cambridge, Mass.: MIT Press, 1989), quote on p. 308.

5. Martha Rosler, "Wars and Metaphors," in *Decoys and Disruptions: Selected Writings, 1975–2001* (Cambridge, Mass.: MIT Press, 2004), p. 245.

6. Ibid., p. 246.

7. Ibid.

8. David Levi Strauss, "The Documentary Debate: Aesthetic or Anaesthetic? Or, What's So Funny about Peace, Love, Understanding, and Social Documentary Photography?," *Camerawork: A Journal of Photographic Arts* 19, no. 1 (Spring 1992): 8. A version of this essay was collected in Strauss, *Between the Eyes: Essays on Photography and Politics* (New York: Aperture, 2003).

9. Susan Meiselas, *Encounters with the Dani* (New York and Göttingen, Germany: International Center of Photography and Steidl, 2003).

10. Susan Meiselas, ed., *Chile from Within* (New York: Norton, 1990).

11. Rosler, "In, around, and afterthoughts," p. 325. Jacqueline Kennedy Onassis was an early supporter of ICP.

12. Susan Meiselas, *Nicaragua: June 1978–July 1979* (New York: Pantheon, 1981).

13. Susan Meiselas, in Joy Garnett and Meiselas, "On the Rights of Molotov Man: Appropriation and the Art of Context," *Harper's* (February 2007): 57–58.

14. Ibid., p. 56.

15. Susan Meiselas, *Kurdistan: In the Shadow of History* (New York: Random House, 1997), p. xvi.

16. Benjamin, "The Storyteller," p. 89.

Eros, Psyche, and the Mendacity of Photography
On Sally Mann

Nietzsche said that "we have art in order not to be sunk to the depths by truth." But we must add that this does not happen unless art touches on truth. . . . It is in this sense that art is necessary, and is not a diversion or entertainment. Art marks the distinctive traits of the absenting of truth, by which it is the truth absolutely. But this is also the sense in which it is itself disquieting, and can be threatening: because it conceals its very being from signification or from definition.

—Jean-Luc Nancy, *The Ground of the Image*, 2005

Sally Mann became "America's Best Photographer" (in the 2001 judgment of *Time* magazine) by closely attending and remaining true to the peculiar properties of her chosen medium. Whether exploring the illuminations and shadows of childhood or those of storied Southern landscapes, Mann has let her eyes lead her, submitting to the limitations and glorying in the capacities of photography, and she knows, instinctively and professionally, that great images are often made on the border between these two, where the distinction blurs. Inhabiting that border over time requires an odd mixture of alertness and obliviousness, tenacity and openness, devotion and recklessness. It also requires an acute understanding of the way that photography's capacity for truth-telling is determined precisely by its mendacity. Our receptivity to photography is based on a lie—that photographs tell the truth about the physical world—and this imagined verisimilitude can be turned to reveal the underlying insubstantiality of things.

Ever attuned to this turning, Mann has spent the past forty years in the dogged and passionate pursuit of making better images. As she notes in *What Remains*,[1] Steven Cantor's 2005 documentary film about her work, each photograph one makes ups the ante for the next. This is the inherent contradiction in the acquisition of skill in the making of art: the better one gets, the more difficult it becomes. Facility is not a sinecure. And the sacrifices made by an artist and the people closest to her are not immediately discernible in the images themselves. In his probing 2005 meditation on the nature of images in *The Ground of the Image*, the philosopher Jean-Luc Nancy observes: "The distinction of the image—while

it greatly resembles sacrifice—is not properly sacrificial. It does not legitimize and it does not transgress: it crosses the distance of the withdrawal even while maintaining it through its mark as an image."[2]

Most of the controversy surrounding Mann's *Immediate Family* images arose from persistent willful confusions about the nature of photographic images.[3] Those images are neither transgressive nor legitimizing in relation to the real world of Mann's family. But they definitely do "cross the distance of the withdrawal" from that intimate world into the realm of art in a way that is deeply unsettling. They show what some would argue should not be shown: the psychosocial complexity of family relations, the terrors and erotics of childhood, and the beauty and violence (and delight and joy) that lie just below the surface of domestic life. But objections to the revelation of these things were transferred onto the artist, in charges of parental neglect and abuse. As the critic Janet Malcolm perceived, this was an abreaction and a defensive manoeuver, an attempt to *tame* the images. Malcolm writes:

> One of the ways we make ourselves at home, so to speak, in the alien terrain of new art is to deny it its originality, to transform its disquieting strangeness into familiar forms to which we may effortlessly, almost blindly respond. To look at Sally Mann's photographs of her children as unfeeling or immoral is simply to be not looking at them, to be pushing away something complex and difficult (the vulnerability of children, the unhappiness of childhood, the tragic character of the parent-child relationship are among Mann's painful themes) and demanding a cliché in its place.[4]

The Mann family images break contemporary taboos against the recognition of childhood sexuality that arise from repression and projection. In the sex panics of the 1980s and early '90s, the most obscene contention of all was that any photograph of a child without clothes on is obscene. This sick assertion led to mothers being arrested when their infant-in-the-bathtub images were processed by photo-finishers and turned over, by law, to the FBI.

This is not to say that Mann was oblivious to the taboos she was breaking, and blind to the social dangers of doing so. She knew, and her children knew, that they were conspiring to test these boundaries, and that it was important enough to take the risks. In that way, the *Immediate Family* images are not just records but *enactments* of the social dynamics of "growing up," of *becoming* social.

Our reluctance to accept the mendacity of photography makes it possible for an artist like Sally Mann to confront unexamined attitudes about sex and death in her works. In the 1980s Mann made a series of stunning portraits of pubescent girls (collected in the book *At Twelve*),[5] and her Matter Lent images from 2000–2001 focus on the anonymous dead and

decaying bodies at a forensics research site. Both puberty and the sanctity of the body after death are especially dangerous and subject to taboos in both traditional and modern societies, but Mann approaches them forthrightly, and with uncommon respect, tenderness, and compassion. As an artist, she exploits not only her relationships to those she loves the most—her immediate family—but also the relationship of the viewer to the photographic image. Our projection of belief in the reality of the photographic image and its relation to the truth becomes a subject of the work.

Detractors would say that the title *Immediate Family* is a pointed misnomer; that, in fact, the family has become irreversibly *mediated* by the insistent interruptions of their mother's camera into the childhoods of Emmett, Jessie, and Virginia Mann. But what is the nature of that mediation, in comparison to the passive mediation of televisions, computers, and manifold handheld devices that constantly interrupt the interactions of most families today? In the Mann family, the mediation is participatory and genuinely interactive. The family members are in touch through the intimacy of those images. Who is to say that this conspiratorial intimacy (familiarity) is invalid?

> The image throws in my face an intimacy that reaches me in the midst of intimacy . . . for this intimate force is not "represented" by the image, but the image is it, the image activates it, draws it and withdraws it, extracts it by withholding it, and it is with this force that the image touches us.
>
> —Nancy, *The Ground of the Image*[6]

An even more pointed intimacy inheres in the Proud Flesh series of portraits Sally Mann made of her husband of forty years, Larry Mann. In this work that transpired over the years 2003 to 2009, the Manns conspired to open their intimacy into the image—making the eye a part of their love. To put it another way, they *exploited* their intimacy for art, in order to show the truth about the changing male body in the traces it makes on a sensitive surface, rendered by a woman who loves him. Sally Mann's camera eye is unflinching and loving at the same time, and she insists that this is not a contradiction. To look and see directly and truthfully is to love, and vice versa. Exposure is truth. Everything she has ever done as a photographer and artist depends on this.

Of course, extra complications arise when this looking and loving are made explicit and public, in art. The exploitation of the Manns' intimacy involves the viewer in ways that are both generous and predatory, as Mann freely acknowledges:

> Rhetorically circumnavigate it any way you will, but exploitation lies at
> the root of every interaction between photographer and subject, even forty

years into it. Larry and I both understand how ethically complex and potent the act of making photographs is, how freighted with issues of honesty, responsibility, power, and complicity, and how so many good images come at the expense of the sitter, in one way or another.[7]

It is not a question of whether or not there is exploitation, but of the nature and quality of that exploitation. To exploit is to "employ to the greatest possible advantage." The word is derived from the Latin *explicitus*, explicit, referring to something that is expressed with precision; clearly defined, specific. To be explicit is to be forthright in expression, unreserved, and outspoken. And that's a pretty good description of Sally Mann.

In 2006 Mann turned the camera on herself alone, and began to make hundreds of self-portraits—close-ups of her face and torso in ambrotypes. These images are relentlessly intimate, and at the same time inscrutable.

> Every image is in some way a "portrait," not in that it would reproduce the traits of a person, but in that it pulls and draws (this is the semantic and etymological sense of the word), in that it extracts something, an intimacy, a force.

—Nancy, *The Ground of the Image*[8]

The qualities of the wet-plate collodion process and Mann's manipulations of it overwhelm any psychological particularities of the self-portrait that are further effaced through quantity and duration. She looks into the mirror of the camera lens with such unblinking intensity for so long and so often that the mirror blinks, and the lens records the glacial movements of surfaces over time. Even the eyes, over time, lose their specificity and become ageless global orbs. The images become not so much self-portraits as meditations on the surfaces of the human face at-large—facial landscapes. This process began in 2004, when Mann's camera closed in on Emmett, Jessie, and Virginia, in part, one suspects, to preserve their privacy as young adults. First she closed in, on their faces—then she pulled away, to the landscapes.

At a time when everyone else's attention is becoming increasingly distracted by the rapid flow of images, Mann has chosen to slow the process down, and to concentrate not on the *flow* but on the *trace*, of bodies living and dead, and of landscapes. One of the signal impetuses of photography from the beginning has been the desire to preserve a trace of things that will disappear, or change beyond recognition. In the old sense of the word, a "trace" was a way or route followed.

Landscapes: Lost Beauty and Blood

> Of only one thing, relative to a work of art, can we be sure: it was bred of a
> place. It comes from an application of the senses to that place, a music. . . .
>
> —William Carlos Williams[9]

When Sally Mann talks about her father, I always think of the poet William Carlos Williams. Both men were doctors, rather reserved in manner, with deep artistic instincts. And both were convinced that one needn't travel halfway around the world to find subjects for art. They believed that art is everywhere and that the best place to find it is in your own backyard.

Sally Mann took this paternal insight to heart. She finds the Other at home. Her greater backyard is the American South, especially Virginia, and specifically Rockbridge County, in the southwestern part of the state, between the Blue Ridge and Allegheny mountain ranges.

In her landscape work, Mann's use of nineteenth-century tools and techniques enhances our suspension of disbelief, because the images come to us through the history of the medium. We see her new landscapes of the Old South as if through the mists and selective clarities of a tortured history. Mann accepts romance as a contingency of the local.

Collodion (the word is derived from the Greek word meaning "to adhere")—a thick, syrupy liquid made by dissolving guncotton (nitrated cotton) in a mixture of alcohol and ether—was developed in 1847 as a protective covering for wounds. In 1851, a British sculptor named Frederick Scott Archer invented the collodion wet-plate process for making photographs, and it quickly replaced collotypes and daguerreotypes as the preferred process in the United States, holding sway for a quarter of a century until the dry-plate process was perfected in 1878. James Ambrose Cutting of Boston patented the collodion technique in 1854, and Marcus Aurelius Root, the first historian of photography and author of *The Camera and the Pencil or The Heliographic Art*, dubbed the collodion positives on glass "ambrotypes" (derived from the Greek word for "immortal").[10]

Psyche's Dossier

In her artist's statement for the *Proud Flesh* exhibition at Gagosian Gallery in New York in 2009, Sally Mann wrote: "I am a woman who looks. Within traditional narratives, women who look, especially women who look unflinchingly at men, have been punished. Take poor Psyche, punished for all time for daring to lift the lantern to finally see her lover."

But Psyche was not punished for all time. Venus (Aphrodite) did punish her for rivaling the goddess in beauty and for sleeping with her immortal son Cupid (Eros). But in the end,

Psyche was made immortal and lived happily ever after with her divine husband, Cupid, and their immortal daughter, Voluptas—or Delight—the goddess of sensual pleasures.

The story of Cupid and Psyche comes down to us in Lucius Apuleius's second-century novel *The Golden Ass*, most famously translated into modern English by the poet Robert Graves in 1951.[11] Apuleius wrote a Latin version of an earlier Greek story that was certainly a nuptial taboo tale, with many different layers. (Our word *taboo* comes from the Polynesian *tabu*, given to prohibitions enforced by religious or magical sanctions. The word itself probably means "exceedingly marked.")

Psyche, a mortal girl, was so exceedingly beautiful that people began to pray to her and turned away from the goddess of love, Venus. Some people even began to say that Psyche was the new Venus, born not of the sea but of the earth. Infuriated, Venus sent her son Cupid to arrange for Psyche to be consumed with passion for a "broken" man, a monster. But Cupid instead fell in love with Psyche himself, and became her secret lover. He went to her every night, but forbade her to look at him. Psyche's evil sisters convinced her that she must behold her monster husband and slay him, so she brought a lamp and a knife into her marriage bed. It was not enough for Psyche to love and not *see*. When she lights the lamp and lifts the knife, she sees that her husband is not a monster, but the magnificent Cupid. As she leans over to kiss him, a drop of hot oil drips from the lamp onto Cupid's right shoulder, wounding him. He awakes, sees Psyche with the lamp, and flees. The lamp wounds more deeply than the knife. In breaking the taboo of looking, Psyche loses her lover.

Venus punishes Psyche and then gives her four tests. She is to sort a mass of seeds into their kinds, gather the golden wool of some wild sheep, collect a glass of water from the River Styx, and bring back a box containing a little bit of Proserpine's beauty from the Underworld (which lies, according to Apuleius, "on a peninsula to the South"). Psyche passes all of these tests with help from various sources, but on the way back from the Underworld with the box of beauty, she cannot resist looking into it, something that she has been strictly forbidden to do. When she does, a deadly sleep falls over her. Cupid finds and wakes her, saying: "Poor girl, your curiosity has once more nearly ruined you." But, in the end, it doesn't ruin her. All-knowing Jupiter calls a conference of the gods, makes Psyche immortal, and announces the enduring marriage of Cupid and Psyche.

Any woman who dares to look is breaking the taboo, and one who repeatedly fixes the image of the beloved into photographs is asking for trouble. To survive, she must pass strenuous tests of her intelligence, commitment, cunning, and will.

"For the business of the artist is to bring things to light"[12]

In "A Poem Beginning with a Line by Pindar," the poet Robert Duncan looks at Goya's painting of Cupid and Psyche and observes that the two lovers "have a hurt voluptuous

grace/bruised by redemption," and avers that Cupid's body "is carnal fate that sends the soul wailing/up from blind innocence, ensnared/by dimness/into the deprivations of desiring sight." Psyche, at the beginning of the story, is "ignorant of what Love will be." When she finds it, with Cupid, it is blind. Shining a light on Cupid breaks a taboo, and she is punished for this. But she is protected and driven on by "passion, dismay, longing, search/flooding up where/the Beloved is lost." The tests arranged by Venus are difficult, and seem endless. "These are the old tasks./You've heard them before./They must be impossible."[13] But Psyche persists, and eventually finds her way to a love that is not ignorant, and not innocent — a love that *sees*. The relation of seeing to loving is there at the beginning, in the ageless parable "seeing is believing," which first appears in print as "seeing is leeving" (loving).[14]

What is both disturbing and enlightening about Sally Mann's work is that it is so insistent in the resident terms of photography — the search for the trace of animate things, alive and dead — and that it moves back and forth between the dead and the living in a way that threatens the boundaries we take for granted, and that is unsanctioned and free. This is truly dangerous. That she continues to do this without injury is remarkable. Only love can offer that kind of protection. Only love.

NOTES

1. *What Remains: The Life and Work of Sally Mann*, dir. by Steven Cantor (Zeitgeist Films, 2005).

2. Jean-Luc Nancy, *The Ground of the Image*, trans. by Jeff Fort (New York: Fordham University Press, 2005), p. 3. (This essay's epigraph is from p. 13.)

3. Sally Mann, *Immediate Family* (New York: Aperture, 1992).

4. Janet Malcolm, *Diana & Nikon: Essays on Photography*, expanded edition (New York: Aperture, 1997), p. 173.

5. Sally Mann, *At Twelve: Portraits of Young Women* (New York: Aperture, 1988, reissue, 2014).

6. Nancy, *The Ground of the Image*, pp. 4–5.

7. Sally Mann, "Artist's Statement" for the exhibition of *Proud Flesh* at Gagosian Gallery in New York, September 15–October 31, 2009.

8. Nancy, *The Ground of the Image*, p. 4.

9. William Carlos Williams, *A Recognizable Image: William Carlos Williams on Art and Artists*, ed. by Bram Dijkstra (New York: New Directions, 1978), p. 138.

10. Marcus Aurelius Root, *The Camera and the Pencil or The Heliographic Art* (Pawlet, Vt.: Helios, 1971), p. 404.

11. Lucius Apuleius, *The Golden Ass*, trans. by Robert Graves (New York: Farrar, Straus and Giroux, 1951).

12. Robert Duncan, "The H.D. Book, Part Two: Nights and Days, Chapter 9," *Chicago Review* 30, no. 3 (winter 1979): 73.

13. Robert Duncan, "A Poem Beginning with a Line by Pindar," in *The Opening of the Field* (New York: New Directions, 1960), pp. 62–69.

14. The first recorded appearance of "seeing is leeving" is in 1609, in a Simon Harward manuscript held in the library of Trinity College, Cambridge. See also the historical note in the entry for the word *belief* in the *Oxford English Dictionary* (Oxford: Oxford University Press, 1971), p. 782.

Revolt, She Said

On Carolee Schneemann

> I never thought of it as a rebellion. I thought everyone would recognize
> what I was doing as the curative, necessary step.
>
> —Carolee Schneemann, 1991

Carolee Schneemann has been in permanent revolt—against misogyny and its myriad concealed weapons and malevolent instruments, against body hatred and beauty killers, against repressive ideologies and their cowardly enablers, and also against conventional approaches to art making—for all of her adult life, and apparently before that. She told Linda Montano in 1982 that as a young child she knew that she could "locate . . . naturalness by making images and by loving" (imagemaking and lovemaking being naturally entwined or "fused"), and that "when sex negativity and the ordinary sexual abuse and depersonalization that females experience in our culture intruded, I tried to judge it, sort it out, not internalize it. I suppose that not internalizing prohibitions gave me some messianic sense that I was going to have to confront or go against erotic denial, fragmentations."[1] So we get the judging and sorting out, which are essentially analytical and critical, and the refusal to disintegrate, which is psychological and aesthetic.

> One might say that artistic production strips away the husk of corporeality
> from the fruitful seed, which then reaches full growth in the work itself. In
> Ernest Jones's words: "in the artist's striving for beauty the fundamental
> part played by these primitive infantile interests—is not to be ignored; the
> reaction against them lies behind the striving, and the sublimation of them
> behind the forms that the striving takes." Desire and reaction must both
> play a forceful role.
>
> —Lou Andreas-Salomé, "The Dual Orientation of Narcissism," [1921] 1962[2]

The refusal to internalize prohibitions gave Schneemann the freedom to explore forbidden subjects, and the "messianic sense" led her to go beyond conventional restraints of

decorum and taste. Some people who otherwise share Schneemann's political views think that she sometimes "goes too far" in her work. Others find it revolting. These responses recur so often in relation to Schneemann's work that going too far emerges as an aesthetic and ethical principle.

Schneemann certainly went too far in 1965, when she collected and collaged images of atrocities in the Vietnam War into a film with a sound track by James Tenney that combined Mozart and Bach with the Beatles, Vietnamese folksong, train whistles, and the sounds of orgasm, and then called the result *Viet-Flakes*, a title that seemed to combine war atrocities with breakfast cereal.[3]

And she went too far thirty-six years later, a few months after September 11, 2001, when she scanned images taken by sports photographers of individuals falling from the upper floors of the Twin Towers, repeated them in vertical columns so that the bodies seemed to be falling toward the viewers, and called it *Terminal Velocity*, a term that accentuated the brutal fate of these falling bodies.

Both of these works were considered beyond the pale when they were made. The earlier one has already become an enduring landmark, and I suspect the later one will in time. When Schneemann invited me into her studio to see the *Terminal Velocity* images and asked my opinion about her exhibiting the work in December 2001, I told her I thought it was too soon after the trauma—definitely too soon for the families of the people in those photographs—and that she should wait to show them. She ignored my counsel that time, and thought less of me, I think, for offering it. My point was that the wound was too fresh, the trauma too recent to allow effective treatment, but for Carolee, that was precisely the right time.

"Going too far" is a tried and true therapeutic principle, as well as an aesthetic and ethical one. To treat traumas in the whole social body and psyche, it is sometimes necessary to push things toward a healing crisis. The illness needs to get worse before it can get better. Of course, there is always a risk in this, that the crisis will be too much for the organism to bear, and the patient will succumb. But without precipitating the crisis, there is no hope of a cure.

I've written elsewhere that *Viet-Flakes* is "a profoundly moving meditation on the effects of history on human bodies, and a poignant attempt to recollect the shards, to put the shattered bodies back together again."[4] And on one level, *Terminal Velocity* is an attempt to freeze time, to keep those falling bodies from ever hitting the ground. One of Schneemann's most effective means has always been her ability to materialize and reflect psychic disturbance and crisis in her joinery—in film montage, photo-collage, and the use of language and sound with imagery.

Both *Viet-Flakes* and *Terminal Velocity* take horrific public images and bring them into an intimate viewing space, activating them through formal means to get around the

usual protective filters. The images are "aestheticized," but in a particular way that does not allow for "disinterested contemplation." In pulling these catastrophic images out of the news cycle and into the space of active imagination, Schneemann makes them more palpable, body to body, and thus even more unbearable.

Like Nancy Spero's War Series, made just after this, in 1966–70, *Viet-Flakes* is an indictment not just of the Vietnam War, but of all wars. As Leon Golub said of the War Series: "This is carnage, the holocaust, the sanguinary abattoir."[5] Because of its formal integrity (and because villains recur and the images proliferate), *Viet-Flakes* remains all too relevant to our current situation.

And so, too, do the falling bodies of *Terminal Velocity*. Other artists and writers (Paul Chan and Don DeLillo, among others) have recognized the deep significance of those falling bodies, but Schneemann was, once again, the first one to catch the movement of history—desire and reaction in equal measure. Her refusal to disintegrate, to separate the personal from the political, sometimes goes too far, but that is often, and perhaps more and more, the required distance.

> In the case of art, artistic creation, or more generally in all activity which is poetically rather than practically oriented, we do not first have to detect the traces of infantile narcissism, as we must in the case of object-cathexes and value judgments. Here the trail leads straight from the beginning to the end, judging and cathecting with narcissism. This method would be at the command of all of us all our lives, and every moment and in every one of our impressions, had we not got so thoroughly rid of it by means of our logical and practical adaptation to the world determined by the ego and reality. For the most part we can only, through recollection, reach back to the realm where inner experience and external event represented the same occurrence.
>
> —Andreas-Salomé, "The Dual Orientation of Narcissism"[6]

NOTES

1. Carolee Schneemann, interview with Linda Montano, originally published in *Flue*, produced by Franklin Furnace (New York, 1982), pp. 6–8. Repr. in Schneemann, *Imaging Her Erotics: Essays, Interviews, Projects* (Cambridge, Mass.: MIT Press, 2003), p. 132.

2. Lou Andreas-Salomé, "The Dual Orientation of Narcissism" [1921], trans. by Stanley A. Leavy, M.D., *Psychoanalytic Quarterly*, no. 31 (January 1962): 26. This text was given to the author by Carolee Schneemann in 1998.

3. As in Schneemann's closely related performance piece *Snows* (1967), the intended reference was more to snowflakes than to cornflakes (and more appropriate for someone whose name translates to "Snowman": "I plan to die in the snow. When I'm old and feeble I plan to go out and lie in a blizzard and die that way"), but I'm speaking here of general reception.

4. David Levi Strauss, "Love Rides Aristotle through the Audience: Body, Image, and Idea in the Work of Carolee Schneemann," originally published in *Carolee Schneemann: Up to and Including Her Limits* (New York: New Museum of Contemporary Art, 1996). Repr. in Strauss, *Between Dog & Wolf: Essays on Art and Politics* (Brooklyn: Autonomedia, 1999), and then in Schneemann, *Imaging Her Erotics*.

5. Leon Golub, "Bombs and Helicopters: The Art of Nancy Spero," in Leon Golub, *Do Paintings Bite?* ed. by Hans Ulrich Obrist (Ostfildern, Germany: Hatje Cantz Verlag, 1997), p. 160.

6. Andreas-Salomé, "The Dual Orientation of Narcissism," p. 22.

Written in the Blood of Women
On Jenny Holzer's Lustmord

On the morning of November 19, 1993, over half a million German households awoke to find that something both familiar and unfamiliar had entered their homes. The *Süddeutsche Zeitung Magazin*, the Friday supplement to the main Munich newspaper, with one of the largest circulations in the country, looked somewhat different than normal. The usual colorful image on the cover was gone, leaving a funereal black field, with a plain folded white card, like an invitation or an announcement (or an offering), pasted onto its center. Printed on the face of this card, in handwritten red block letters, were the words *Da wo Frauen sterben bin ich hellwach* (I am awake in the place where women die). When the folded card was opened, two more statements were revealed, each written in black block letters, one above the other, in two different hands: *Sie fiel auf den Boden meines Zimmers. Sie wollte beim Sterben sauber sein aber sie war es nicht* (She fell on the floor in my room. She tried to be clean when she died but she was not), and *Die Farbe ihrer offenen Innenseite reizt mich sie zu töten* (The color of her where she is inside out is enough to make me kill her).

This was bad enough. This was not public language, and was not fit for public consumption. What in the world was it doing on the cover of the Friday supplement, delivered like a rude ransom note with our *Kaffee und Brötchen*? Opening the magazine, one found a title, *Lustmord*, and the attribution "A Photo Series by Jenny Holzer for the Magazine of the *Süddeutsche Zeitung.*" Ah, an artist's work, then. A provocation. Subscribers had seen three others of these, once a year over the past three years (Anselm Kiefer in 1990, Francesco Clemente in 1991, and Jeff Koons in 1992). On the right-hand side of the spread, next to the table of contents, ran another red text, informing readers that the lettering on the card affixed to the cover was not printed with normal ink, but with blood, and that when one touched the printed card, one was touching the blood of women. STOP.

The text went on to explain that the artist intended, with this symbolic act, to call attention to the political violence being perpetrated against women in the former Yugoslavia; but most people did not read that far, or even if they did, the blood rushing in their ears drowned out the rest of the introductory text.[1]

We're touching the blood of women? Our news is contaminated? Public endangerment for the sake of an art project? How dare this American woman, this "artist," presume to put blood on our hands, literally!

It turned out that the fear of personal contagion from tainted blood far outweighed (at least in the short run) any sense of complicity or compassion for women being raped and tortured to death in Bosnia. Blood shed elsewhere, in whatever quantities, is no match for an imagined fly-speck of it being introduced into our own living rooms. Even the hint of the latter was enough to turn half a million Germans into so many Lady Macbeths, furiously scrubbing.

This quickly grew into a full-scale panic, with hastily called press conferences, self-righteous statements from politicians and public officials (a representative of the German Red Cross called Holzer's piece "repulsive and absurd"), and courts demanding that the magazine be recalled and impounded. The vehemence of the tabloid press reactions was reminiscent of their responses to the antics of "Prof. Beuys" in the 1970s, when Joseph Beuys's public provocations often appeared on the front pages of German newspapers.

Ultimately, the panic did lead to discussion of the very issues Holzer wished to illuminate. Critic Joan Simon reported: "According to [editor of the *Süddeutsche Zeitung Magazin* Christian] Kämmerling, the tabloids every day for a week—under a banner headline—discussed a different aspect of the project, bringing the discussion to a million readers."[2] Thus proving, once again, that there is no such thing as *bad ink*.

In text-based art like Holzer's, there are always two registers of effect: the actual content of the texts, and their context; that is, the modulation or extension of that content in the form of its presentation. The reaction to the cover of the *Süddeutsche Zeitung Magazin* temporarily collapsed that distinction and delayed the reception of the entire intervention. But beyond the immediate local abreaction of the contagion panic, the *Lustmord* photo-series printed in *SZ* magazine that November may be the most effective materialization of a Holzer text ever achieved.[3] In her first public project since the whirlwind of 1990 (major exhibitions at the Guggenheim Museum, Dia Art Foundation, and the United States Pavilion of the Venice Biennale), Holzer embraced a form that scared her ("I get lost on the printed page. . . . If people ask me to create something for a blank page, I'm frozen"),[4] and pushed the boundaries of public speech to the edge.

Designed in collaboration with the estimable graphic designer Tibor Kalman, the twenty-eight-page series in the *Süddeutsche Zeitung Magazin* is devastatingly effective. Each page carries a close-up color photograph (taken by Alan Richardson) of one of the texts, written by hand in block letters on human skin. The twenty-eight skins are surprisingly various—with different tones and hues, different frequencies of hair, blemishes, goose bumps, and submerged blue veins—and all printed as full bleeds, so that as one turns the pages one becomes hyperaware of the skin of one's fingers on the pages; it seems almost like a book made of skin. The viewer shudders at the sight of writing on skin, and a string of associations—from butcher shops to concentration camps—is immediately invoked. The terms of this inscription in memory are mostly illicit, signaling the exercise of power.

Who is writing on whom? Writing on living human skin makes explicit a violence that is otherwise elaborately concealed in expression.[5]

The texts printed in the magazine—fifteen in German and eleven in English, with two skins left blank—are terrifying singly, and become even more so in accumulation:

> "I find her squatting on her heels and this opens her so I can get her from below."
> "She acts like an animal left for cooking."
> "I want to fuck her where she has too much hair."

> "Hair is stuck inside me."
> "With you inside me comes the knowledge of my death."
> "I have the blood jelly."

> "She started running when everything began pouring from her because she did not want to be seen."
> "I find her towels shoved in tight spots. I take them to burn although I fear touching her things."
> "I want to suck on her to make her respond."

The three voices—perpetrator, victim, and observer—are interspersed throughout. The observer, whom Holzer has described as a "witness incapable of intervening," also represents the spectator, we who create the tremendous market for images of political violence. Over time, the longer lines in the third category pull away from the others. The empathy and tenderness in some of the observer lines ("I want to lie down beside her. I have not since I was a child. I will be covered by what has come from her")[6] are jarring when juxtaposed with the violence of "I want to fuck her where she has too much hair." Rape and torture are political acts, but death by natural causes is not. In the perpetrator and victim texts, the "I" is not a personal "I." Jenny Holzer is not the First Person in these texts. We—the readers/viewers—are the First Person, and we gag on this "I."

Blood on the Page

> Power is in its fraudulent as in its legitimate forms always based on distance from the body.

> —Elaine Scarry, *The Body in Pain: The Making and Unmaking of the World*, 1985[7]

In fact, there is nothing incomprehensible about the viewpoint that sees menstrual blood as a physical representation of sexual violence. We ought, however, to go further: to inquire whether this process of symbolization does not respond to some half-suppressed desire to place the blame for all forms of violence on women. By means of this taboo a transfer of violence has been effected and a monopoly established that is clearly detrimental to the female sex.

—René Girard, *Violence and the Sacred*, [1972] 1977[8]

No human being is indifferent to the displacement of blood—to blood being (or perceived to be) where it doesn't belong: outside the body, outside the *skin*. The reaction to such displacement is visceral and primal.

Holzer's and Kalman's symbolic act of having the cover text of *Lustmord* written in blood mirrored the greater transgression of making interior language, secret language—the language of torture and murder—public. Seeing and hearing this abject language in a public context delivers a shock similar to that of seeing photographs of torture and abuse at Abu Ghraib appear on CBS-TV and in the pages of the *New Yorker* and the *New York Times*. It is partly the transfer of such material from one context to another, its displacement, that shocks.

Unlike some earlier Holzer series, which mimicked and condensed the stereotypical messages of commercial and official public speech, *Lustmord* transferred an interior, suppressed, abject language—the language of sexual violence—into the public realm. By publishing this language in the *Süddeutsche Zeitung Magazin*, Holzer and Kalman breached a conventional boundary symbolized by the skin. These texts were unsettling because they got *under the skin* of readers. They penetrated and corrupted the audience. This irruption was rightly perceived by readers/viewers as an attack.

At the time he was working on the *Lustmord* project with Holzer, Kalman appeared on the *Today Show* with Katie Couric, to talk about his work as editor-in-chief of the Benetton magazine *Colors*. Four issues of the new magazine had appeared in the first two years, and the most recent issue included a series transforming well-known faces along racial lines: a black Queen Elizabeth II and Arnold Schwarzenegger, an Asian Pope John Paul II, etc. Couric asked: "Is your intention to stimulate discussion or really to shock people? Which is it?" And Kalman replied: "Well, I don't know if there's much of a difference between the two. People never talk about things unless you shock them a bit."[9]

"Murder Has Its Sexual Side"[10]

Holzer's *Lustmord* series responds to and interferes with a long tradition in German art. The term *lustmord* arose in the late nineteenth century in reference to Jack the Ripper and

others, and then became a prominent theme in the art of Weimar Germany ("idealized as the breeding ground for modernist culture") in the 1920s.[11] As Maria Tatar writes in her 1995 book on this subject: "The sheer number of canvases from the 1920s with the title *Lustmord* (*Sexual Murder*) ought to have been a source of wonder for Weimar's cultural historians long before now."[12] Tatar holds that, even given the incalculably long history of women's subjugation, the pronounced aestheticization of sexual violence during this period amounted to a disturbing trend, about which there was little or no critical discussion. Tatar poses a number of pointed questions:

> Why . . . did Otto Dix paint one canvas after another with the title *Lustmord* yet never directly address what was at stake for him in the production of images of murdered and disemboweled women? That critics avoided discussing the issue is even more telling. Why did George Grosz, who was his own severest critic, never question the asymmetrical nature of the representational practices he applied to the men and to the women in his drawings? Why did there seem to be a conspiracy of silence when it came to the role of women in Alfred Döblin's novel *Berlin Alexanderplatz*? And how is it that a man who murders children could become the target of our sympathetic identification in Fritz Lang's film *M*?[13]

The pursuit of answers to these questions leads Tatar to a number of realizations about the agency in sexual violence, its relation to artistic expression, and its connection to war.

> Time and again, we have seen how the status of victim has a remarkable appeal for agents of terror, an appeal so powerful as to produce behavior that is ultimately self-defeating, self-destructive, and suicidal. Consider how German soldiers marched off to war in 1914—invading foreign territory and engaging in combat, yet perceiving themselves as victims engaged in heroic acts of sacrifice. . . . Nor is it accidental that Hitler could appeal to Germans by railing on endlessly about Germany's victimization, exploitation, and martyrdom. . . . That the *Lust* in *Lustmord* had more to do with the retaliatory pleasures of an aggressor who perceives himself as victim than with sexual desire is a point worth emphasizing. We have seen how the war "sacrifices" were perceived as a painful tribute paid to those who had remained protected on the home front or as an obligation imposed on men by sexual and reproductive rivalries rather than by conflicts in national interests. . . . Cultural representations of victims of *Lustmord* reveal the brutal realities of what

happened to the victims, but they also cloud issues of agency through their aestheticizing strategies and their focus on women as provocative, complicitous, or deserving targets of violence.[14]

Holzer's *Lustmord* was not immune from charges of aestheticization and exploitation, and not only from the offended readers of the *Süddeutsche Zeitung Magazin*, but also from at least one feminist critic. In her review, published in *Flash Art*, of Holzer's 1994 sculptural extension of *Lustmord* at the Barbara Gladstone Gallery in New York, Laura Cottingham wrote:

> While Holzer's attempt to take on a subject as serious as rape is conceptually impressive, the results are deplorable. "Lustmord" evidences first and foremost the artist's lack of engagement with or understanding of her subject. The pseudo-poetic text ("Her breasts are all nipple." . . . "Hair is stuck inside me." . . . "I want to lie down beside her.") de-brutalize, romanticize and eternalize rape—a naturalization made complete by the installation's complete lack of historical specificity. The German-language title, kept for the U.S. show, is out of context; the piece itself makes no direct reference to Bosnia, or, for that matter, New York City or the U.S., where male rape of women is as routine in so-called peace time as it is in any governmental war time. . . . In refusing to follow either an artistic engagement based on personal experience, such as that of Adrian Piper, or one of determined historical specificity, such as that of Hans Haacke, Holzer's attempt to synthesize political reality into art fails miserably as both art and politics. Ultimately, even as she claims to be presenting three perspectives on rape, she presents only one: that of the perpetrator.[15]

Cottingham criticizes Holzer's *Lustmord* for inhabiting an untenable position in relation to rape—not personal enough on the one hand, and not historically specific enough on the other. And that is the risk that Holzer takes, in *Lustmord*, as in much of her other work. She mixes the personal and the political in problematic, extremely unsettling ways, in order to implicate us, her readers/viewers—to try to place us at the scene of the crime. When it works, as I think it does in the print version of *Lustmord*, we are drawn in and called to attention. When it doesn't, we often blame the provocateur.

By deliberately provoking the readers of the *Süddeutsche Zeitung Magazin*, Holzer and Kalman did demonstrably call attention to the political violence being waged against women in Bosnia. Whether this increased attention then led to measurable changes in perceptions, let alone to substantive policy changes, is very difficult to tell. The aesthetic is

primarily a destabilizing force, questioning assumptions and shaking up calcified avoid-ances. In the printed version of *Lustmord*, Holzer and Kalman used aesthetic means, applied to words and images, to make the subject of rape and sexual torture palpable to a general audience. The risks—of trivialization, reduction, and naturalization—are great, but these are the risks of communication, and are surely worth taking. Because if art cannot deal with these highly charged political subjects, it will become an irrelevant vestige. Even when the ends are elusive, the means create meaning. In her extraordinary 1969 essay "On Violence," Hannah Arendt makes this radical statement about the relation between ends and means:

> The very substance of violent action is ruled by the means-end category, whose chief characteristics, if applied to human affairs, has always been that the end is in danger of being overwhelmed by the means which it justifies and which are needed to reach it. Since the end of human action, as distinct from the end products of fabrication, can never be reliably pre-dicted, the means used to achieve political goals are more often than not of greater relevance to the future world than the intended goals.[16]

NOTES

1. Most readers also didn't get to the accompanying interview with Holzer by editor Christian Kämmerling, titled "Death Is Not a Hygienic Matter," which was interrupted by an explanatory red box headlined "Can a Magazine Print with Human Blood?" detailing how the blood, donated by eight German women and women from the former Yugoslavia, had been tested for hepatitis and HIV, and then heat-treated (boiled) to eradicate any possible infectious agents before the pigment was removed from it and treated so as to make it soluble in printers' ink. Then a very small amount of this pigment was mixed with the seven liters of red ink needed to print the entire edition.

2. Joan Simon, "No Ladders; Snakes: Jenny Holzer's *Lustmord*," *Parkett*, nos. 40/41 (June 1994): 82.

3. The *Lustmord* texts were presented and exhibited in various manifestations after this: in 1993 at the Haus der Kunst in Munich; in 1994 at the Städtische Galerie in Nordhorn, Germany, the Bergen Billedgalleri in Norway, and Barbara Gladstone Gallery in New York; in 1995 at Monika Sprüth Galerie in Cologne; and in 1996 at the Städtische Galerie Rähnitzgasse in Dresden and the Kunstmuseum des Kantons Thurgau, Kartause Ittingen in Warth, Switzerland.

4. Jenny Holzer, "Lost and Found," interview by Peter Hall, in Hall and Michael Bierut, eds., *Tibor Kalman: Perverse Optimist* (New York: Princeton Architectural Press, 1998), p. 342.

5. Two recent instances illustrate this, with a twist: U.S. Army reservist Sabrina Harman's inscription on the skin of an Abu Ghraib detainee of the word *Rapeist* [*sic*], to be photographed; and Louisiana Governor Kathleen Blanco's ominous admonition to reluctant evacuees of New Orleans after Hurricane Katrina that if they refused to leave, they should inscribe their own Social Security numbers somewhere on their bodies in indelible ink, so that their corpses would be easier to identify. At Abu Ghraib, Harman was the one wielding power over her charges, so to label the Iraqi detainee a rapist was a telling reversal. Governor Blanco's attempt to scare people out of their homes threatened and demeaned those too poor to leave. In both situations, the power of agency trumped gender.

6. The "observer" lines were written by Holzer as she attended to her dying mother.

7. Elaine Scarry, *The Body in Pain: The Making and Unmaking of the World* (New York and Oxford: Oxford University Press, 1985), p. 46.

8. René Girard, *Violence and the Sacred* [1972], trans. by Patrick Gregory (Baltimore and London: Johns Hopkins University Press, 1977), p. 36.

9. Transcript of Kalman's appearance on the *Today Show*, NBC, June 17, 1993, published in Hall and Bierut, eds., *Tibor Kalman: Perverse Optimist*, p. 274.

10. From Holzer's Truisms series, 1980.

11. Maria Tatar, *Lustmord: Sexual Murder in Weimar Germany* (Princeton, N.J.: Princeton University Press, 1995), p. 69.

12. Ibid., p. 4.

13. Ibid., p. 67.

14. Ibid., pp. 182–83.

15. Laura Cottingham, "Spotlight," *Flash Art* 27, no. 178 (October 1994): 91.

16. The essay was published in book form: Hannah Arendt, *On Violence* (New York and London: Harcourt Brace Jovanovich, 1969), p. 4.

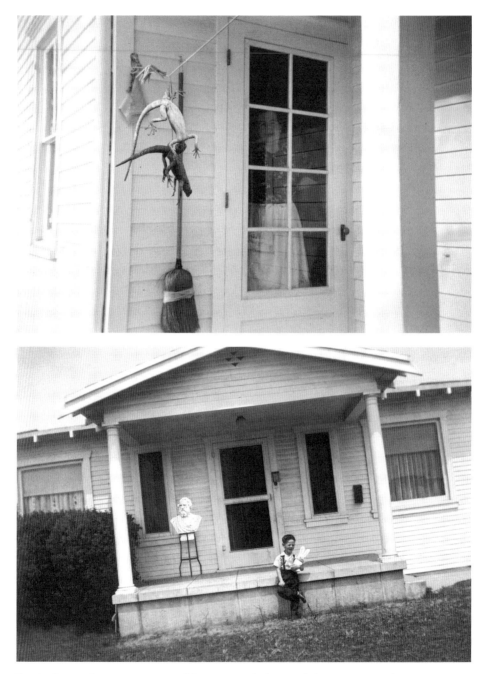

Top: *Mechanic Falls*, 2005. Bottom: *Longfellow*, 2005. Both photographs by Jane Hammond

Fictrix Jane
On Jane Hammond's Photo-Collages

Jane was born in a model-maker's studio, on a sturdy stand, with all of America behind her, and her parents—lounging on an oil derrick and turning their backs on their own map—looking on. Jane was made under an intense gaze, with plenty of material lying around. The drawers were open and anything was possible. She had an insatiable eye and a little toy boat, and quickly took up the combinatory arts, making improbable connections among disparate things. The model-maker didn't start from scratch. None of us do. He didn't give Jane wings and a radiant crown; they were already there, in someone else's map.

That's how it happens. Some things are already there when you show up, and those things with enough gravity or charm attract other elements to them, and when these other elements belong, they stay, and maybe attract other parts, and things happen. A man in bronze lifts his hand in benediction over listing ships and sinking Buddhas, under an arc of seagulls, while another appears on a bridge that no longer exists, whispering suicide. Longfellow's bust looks away from the little fellow's bunny, on the classical porch, and Orpheus rides the Bee Line over the guardrail as the giant wounded snail closes in and the Fairlane fades.

From this process of moving dismembered fragments around in time and place and recombining them comes new information (evidence of a novel kind), like the secret behind Ping-Pong, and the similarity between a collapsible dog named Trix and a Mummer, and the fact that the Nation-Wide market for Swan Lake is *this* big. As William Burroughs and Brion Gysin discovered, the manipulation of words and images can also allow one to move around in time and glimpse things before they happen, like the spectral gunnysackers over the young ballerina, or the quintuplets nesting in an exploded tank muzzle, or the young Norma Jean imagining her tabloid death and resurrection as an image.

As in her paintings, Jane herself appears frequently in her photographs: in her mother's womb, carried in poppy procession by white-robed cone-hatted Tunisians; as a child, defiant, setting up shop with her twin mother, peddling SOS pads, Swan soap, and Mother's Oats; bravely piloting a two-person boat solo on an impromptu Mexican beer canal; and glancing up the stairs at Mom on her birthday to see if she notices the nice lady ensconced on the family fauteuil; or older, lounging *mit Streifen*, enacting the male gaze under a double-barreled tail section, and posing in a swimsuit in the Lone Ranger's big head shop.

This is Jane's world, but the interchangeability of memories and images is universal, so we all recognize the inquiring woman behind the storm door in Mechanic Falls, and the pyramid of boys on the Tour Royale. And we recognize the way certain reflective and transparent materials come alive when photographed: corrugated or sheet metal, sheer curtains and fishing nets, cellophane and soaped windows, water and clouds. And we know the recurring typologies of women and girls posing as men shoot them (casting their shadows across the image, Friedlanderish), and workers showing their backsides to the leisure class, who sail on, oblivious, and the inevitable damage from floods, wars, windstorms, and honeymoons.

Jane Hammond comes to digital imaging as a painter, sculptor, and collagist, not as a photographer. But her informed approach is thoroughly "photographic." She appreciates the *information* in photographs, for itself, for the reality it reveals, while also being dizzyingly attracted to its *contingency*. So that when she manipulates and recombines parts of images, she does so in a way that is consistent with the preexisting form-language of the photographs, and the resultant images, no matter how outlandish, remain insistently *photographic*, and therefore *believable*.

Jane Hammond is a *fictrix*—she who forms, fashions, and models by hand. In her hands, photographs are malleable, but not infinitely so. Before she manipulates them, she listens to them, very closely (with her eyes), and the process becomes a conversation. The image in the window in *Perpetual Love* is not arbitrary, but foretold by the apprehension of the two girls with their paddles poised. The "accidental" sighting of a cockatoo in an ice storm is conceptually improbable, but perceptually inevitable: white on white, feathers and ice. Chai Wan's rows of tenements separated by balconies hung with wash become a matrix of images, repopulated with bread sellers, nudes in sombreros, and pumpkinhead playmates.

Sometimes the juxtapositions collapse the time separating points in the history of photography, bringing them together in one image, as when the aproned woman looks out the door of the white clapboard house in Maine past iguanas hanging on the clothesline, bringing Alfred Stieglitz together with Graciela Iturbide. Or when the blond girl with a net steps into a mountain fishing village, introducing Margaret Bourke-White to Sebastião Salgado, all ages contemporaneous in the image.

The conversation that Hammond so assiduously and delightfully joins is carried out in the vernacular and aesthetic form-language of photographic representation, so the connections she makes—between balloons and 1950s TV sets, or an airplane kite and the skies over Camp Detrick, or even a coy boy and a koi, have an irresistible logic to them—the poetic logic of technical images. And because we have become so subject to this logic, over time, it is also the way we see and apprehend the world. These images, however idiosyncratic in their particulars, are still recognizable to us, and credible, so we are well into Jane's world before we notice, with a start, how very much has changed.

II

Words Not Spent Today Buy Smaller Images Tomorrow
On Frederick Sommer

In the beginning, I couldn't believe he was still alive, and in the end I couldn't believe he was dead. The line between living and dead seemed tenuous then, out there in the desert, where we talked.

I had first been introduced to Frederick Sommer's photographic work in 1974, by Jeff Weiss at Goddard College; and then in 1976, when I was studying with Nathan Lyons at the Visual Studies Workshop, concentrating on the relation between words and images, someone gave me a little book called *The Poetic Logic of Art and Aesthetics*, by Sommer in collaboration with Stephen Aldrich. It was an unassuming, plain little volume, self-published in 1972, with gray laid covers stapled over cream-colored paper, and no images. The main text consisted of eight unnumbered pages of aphoristic writing separated by as many blank sheets. On the first page appeared these lines:

> Words represent images:
> nothing can be said for which there is no image.
> Linkages between images exist a priori
> and are the logic of display.
> Linkages between words are the logic of grammar.
> Images can be named; linkages can only be displayed.
> Images and their linkages are states of affairs.
> Words and their linkages are propositions.
> Words occupy language structure as display of grammar:
> what can be said can be seen as represented image.[1]

To a young poet and philosophy student recently enamored of photography, this lapidary text arrived with the force of revelation. I read it first as poetry, then as philosophy, then again as poetry. The poet Michael Palmer once noted that "aphorism is, when interesting, an aspect of philosophical skepticism. It relates to poetry because philosophical skepticism also has a lyrical and condensed character to it, as in Nietzsche or Wittgenstein, or at moments Derrida."[2] Sommer's *Poetic Logic* was the most serious attempt I'd yet found to articulate a poetics of images that was both philosophically skeptical and lyrical. From

that time on, I looked for an opportunity to engage Sommer's work in depth, and finally, almost twenty years later, it came.

In 1993 I was awarded a Visiting Scholar Research Fellowship by the Center for Creative Photography, at the University of Arizona in Tucson, to spend a month in their archives, photography collections, and libraries doing research on Sommer's work. To underscore Sommer's warning that "photography cannot afford an iconoclasm of ideas,"[3] I wanted to draw connections between Sommer's images and ideas and the writings on images and aesthetics by Italian Renaissance philosophers Marsilio Ficino and Giambattista Vico; Benedetto Croce's *Aesthetic* (1902) with Antonio Gramsci's commentaries; sections of Nietzsche's *The Will to Power*, with Heidegger's commentaries, and Heidegger's *Poetry, Language, Thought*; and sections of Henri Bergson's *Matter and Memory* (1896), especially chapter 3, "Of the Survival of Images," with Gilles Deleuze's commentaries in *Bergsonism* (1966). I also wanted to relate Sommer's *Poetic Logic* to that of the poet Jack Spicer, whose *logos* is the dark brother to Sommer's *logic*, and whose poetic syntax is very close to Sommer's, and to the work of the artist Jess, whose visual and linguistic borrowings and translations are akin to Sommer's, and whose "paste-ups" operate within a poetic logic similar to Sommer's collages. Basically, I wanted to connect Sommer to a host of related endeavors beyond the stifling confines of American art photography; to bring him back into the larger world of art and letters from which he had come. Most of all, I wanted to ground this inquiry in a close viewing of his images in the magnificent collection at the Center in Tucson. As Minor White said: "A superficial glance at [Sommer's] pictures reveals about as much as a locked trunk of its contents."[4] So as not to remain in the area Sommer called "thinking about thinking," but to move into "using thinking about thinking as a means to serve images,"[5] I wanted to apply all my research toward closer readings of those images.

When I was awarded the fellowship, the Center's director, Terry Pitts, called to make arrangements for my stay in Tucson. After we'd talked for a while, he suddenly asked me if I'd like to meet Fred. I gasped and almost dropped the phone, since until that moment it hadn't occurred to me that Sommer could still be alive. He'd have to be, what, almost a hundred years old? Pitts informed me that Fred was, in fact, very much alive, at age eighty-eight, and continuing to work at his place in Prescott.

In June of 1994, I wrote to Sommer telling him of my plans to come to the Center, and asking if I could come up to Prescott to speak with him during that time. Sommer's principal assistant, Naomi Lyons, immediately called me and suggested I come to Prescott first, to "get the goods from the master himself," before going on to the archive in Tucson. I flew into Phoenix and drove two hours north to Prescott on the morning of September 12, 1994.

When Naomi gave me directions to the Sommer place, she described it as "a small, modest house," and she was right—a gray, one-story converted summer cabin, with a sloping roof and

one large picture window facing north that I never saw opened to the light. When I drove up, Naomi came out to the car to greet me and led me to the door, where Sommer was waiting, dressed in a worn robe. I thought he looked like a bird, perhaps a raptor, with a face that came to a point and piercing eyes that coldly scrutinized me. He was polite but wary. I was terrified. He immediately led me into his workroom (the room with the always-curtained picture window), which contained a small table covered with brown craft paper, a few chairs, and a daybed.

He sat on one chair, motioned me to take the other, and said we could do this any way I liked. I said I'd like to ask him some questions and we could proceed from there. He consented to being recorded and as I began to set up the tape recorder and microphone, he asked me how much time I had. "As much time as it takes," I replied. He laughed and said he hoped he had that much time left. He'd celebrated his eighty-ninth birthday a few days before I arrived, and had, as it turned out, only another four years to live.

As I continued to set up, he leaned over to touch my arm and whispered that he had only one request: that we not talk about trivial things. He used the word *pedestrian*, a term of opprobrium that he would often employ in the days ahead to refer to something not worth our attention. I became very aware of the pressure of time passing. But as soon as I asked my first question, about the persistent strain of anti-intellectualism in some of the old art-photography community in the United States and its effect on him, he loosened up and concentrated on the task at hand. In our first talks, he was sentated and occasionally resorted to old scripts and certain well-worn turns of phrase that he'd obviously used many times before. But then he would catch himself, stop, and ask for another question. That first day he acted like an old man, tapping his forehead when his memory failed, interrupting his speech periodically with "Now where was I?" or "What were we just talking about?" But by the end of the day we had progressed far enough that he asked me to return the following morning, when he would be fresh.

The second day was very different. It soon became clear that he wanted to have a conversation, not an interview, but for that, he needed to know the person he was talking to. He asked me many questions about my background and interests, and put me through a series of tests, to gauge my knowledge and determine my level of commitment. When we resumed taping, his manner and attitude had completely changed. He became much more animated and demonstrative. When we began to get into more serious philosophical discussions and his active intellect was engaged, age dropped away and the fifty years separating us collapsed. By lunchtime, he was speaking with great enthusiasm about "our work here together."

Our conversation over the next two weeks ranged over many subjects, from the relation of aesthetics to ethics ("a coherent sense of interrelationships over our actions generally") to the "sexual selection system" of machines, but we kept coming back to the poetics of images. At one point he said he thought the thing he'd done that might have the most lasting impact was putting "logical display" and pictorial logic in relation to "linguistic logic" as "the act of

art." He was very excited about the possible extensions of these fundamental ideas into an educational context—for the education not just of artists, but of everyone.

I also spent a good deal of time pressing him on certain contradictions I saw in his work and life. To me, the principal Sommerian paradox was that he had always sought, in art and life, to achieve integration of the most disparate things, but at the same time his fundamental stance was one of resistant and sometimes intractable difference, leading ultimately to relative isolation. These two motivations were always in conflict, and this conflict formed the art—a fundamentally *impure* art, in which one gets these tremendous contrasts, like extreme innocence and the grittiest of experience. This is, I think, what Sommer meant when he said: "My things are not *pure*: they are a seething wealth of imperfection."[6] And this made it difficult for those in the photographic establishment who preferred *resolution* in their images to accept his work.

In "The Linguistic and Pictorial Logic of General Aesthetics" (1979), Sommer wrote: "More and more people are realizing that the coherent way of investigating any field is to examine its possible relatedness to other things."[7] Sommer did not see photography as separate from other arts. His work was as influenced by painting, drawing, poetry, and music as by other photography. He paid attention to the underlying structure of visual works, regardless of their medium of display: "If it were possible to remove the occupiers from an image and look only at the positions where subject matter was located, we would see structure. A photograph is a given and a construct, mapping the logic of display."[8]

Sommer has mistakenly been called an iconoclast, something he never was. He was involved in the transformation of images, not in breaking them. His transmutations of everything from chicken entrails and coyote corpses to musical scores and Dürer woodcuts follow certain well-articulated compositional principles. His alchemical understanding of the transformation of matter put him in touch with Giordano Bruno and Paracelsus. In order to change matter, one must first see its underlying structure, and thereby glimpse something else in it, as when Sommer saw Leonardo's *Virgin and Child with St. Anne and the Infant St. John* in a quarter-sized lump of melted metal. What was once a discarded piece of a wrecked Chevy became a vision of amity and grace. And this transformation was effected within a strict economy of gesture, Sommer's definition of elegance.

After lunch, I sat at the table in the workroom while Naomi showed me the medical collages that Sommer had been working on very recently (the first ones were made in 1989). I found them extraordinary. When Sommer came into the room, I said: "Nothing you do is ever very far from the anthropomorphic." These collages are all a reconstitution of the human figure, and yet operate as new, freestanding organisms. Emmet Gowin said they all have to do with "leverage, rather than weight." Later, Naomi talked to me about Sommer's relation to his own body, about the elegant way he moved. He was remarkably agile for a man nearing his ninetieth year. I remembered then that this somatic elegance was something Sommer himself remarked on with regard to his two most direct and persistent artistic companions: Edward Weston and Max Ernst.

The primacy of placement and position was not just a philosophical abstraction to Sommer. One day, as I was setting up the tape recorder and microphone between us on a low table, Sommer got up, moved his chair a half-inch to one side, and sat back down. Then he reached over and moved the microphone stand a quarter of an inch. As I watched him, I realized that a faulty arrangement—a bad composition—actually caused him physical pain.

Sommer spoke about how Michelangelo often went a little beyond reality in his depiction of sinew and muscle to make the whole composition stand on its own. When I asked him if he thought Michelangelo was getting closer to the Real in this way, or further away, he said: "The infinitely near is as far as the infinitely far."

After our second conversation, Sommer asked if I'd like to spend some time looking through his library, since I'd mentioned it in my initial letter to him. I said I was very eager to do this. He pointed out that the books were arranged by size, not by subject (position being more important than occupier). I spent a good deal of time in subsequent visits going through Sommer's library and recording its contents. Some of the things I found confirmed my imaginings of sources and affinities—in German: Hegel, Freud, Nietzsche, Novalis, Hölderlin, Heidegger, and of course Paracelsus; in Italian: Vico, Bruno, and Croce; in French: Nerval, Lautréamont, Rimbaud, Baudelaire, Mallarmé, Alfred Jarry (*Œuvres complètes* in eight volumes), and Valéry; and in English: Shakespeare, Donne, Blake, Hopkins, and Joyce. Then some surprises: Jean Paul Richter's *School for Aesthetics*, Borges's *Selected Poems*, Luís de Camões, Johann Georg Hamann, the metaphysical vaudeville of Nestroy, and lots and lots of Leopardi. And the pointed absences, including any postwar American vanguard poetry. No Pound, Olson, Williams, H.D., Zukofsky, Robert Duncan, Jack Spicer, Robin Blaser, George Oppen, etc., etc. I was surprised by this, and it became a bone of contention in my conversations with Sommer. Why was there not more conversation between him and the poets of his generation? After I'd been pressing him on this for some time, he finally ended the conversation by saying: "I am not overawed by things that don't give me pleasure."

It was only afterward that I remembered that Sommer had created the image of Charles Olson's Maximus. In the 1960 publication of *The Maximus Poems* by Jargon/Corinth, publisher Jonathan Williams had printed Sommer's image on the title page, with this note:

> A word on the title-page device: this "glyph" becomes Olson's "Figure of Outward," striding forth from the domain of the infinitely small; and, also, a written character for Maximus himself—the Man in the Word. It is (*really*, like they say) the enlargement of a sliver of perforated tin ceiling found on the floor of a bar room in a ghost town in Arizona. Frederick Sommer made the discovery and the photograph.[9]

There were times when Sommerland seemed to me like a ghost town, and I felt like a premature historian, wandering around in the archives before the subject had quite left, picking up slivers and glyphs as he looked on, amused. Sommer told the organizers of a show in Delaware at about this time: "Treat me as if I were dead." This was very hard to do in proximity to a still very much alive Sommer. At one point he said to me: "You know, I'm going to be doing the ultimate disappearing act sometime pretty soon."

When he did, in January 1999, we were left, once again, with nothing but the work, in words and images—marvelous discoveries in meticulous arrangements.

Life is the most durable fiction that matter has yet come up with
and art is the structure of matter as life's most durable fiction.

—Sommer, *The Poetic Logic of Art and Aesthetics*

NOTES

1. Frederick Sommer, in collaboration with Stephen Aldrich, *The Poetic Logic of Art and Aesthetics*. (Self-published by Sommer, 1972), n.p.

2. Michael Palmer, interviewed by Peter Gizzi, in *Exact Change Yearbook* 1 (Boston and Manchester, U.K.: Exact Change and Carcanet, 1995), p. 179.

3. Frederick Sommer, "Art and Aesthetics, 1982," in *Sommer: Words* (Tucson, Ariz.: Center for Creative Photography, 1984), p. 9.

4. Minor White, editor's introduction, *Aperture* 4, no. 3 (1956). This was the first issue of the magazine to show Sommer's work. In 1962, vol. 10, no. 4, was devoted entirely to Sommer's photographs. My title for this essay, and for this book, is taken from that 1962 issue of *Aperture*.

5. Frederick Sommer, "A Talk Given at the Art Institute of Chicago, October 1970, revised June 1983," in *Sommer: Words*, p. 42.

6. Sommer, quoted in Mary Ann Fittipaldi, "Frederick Sommer: Photographic and Philosophical Development" (MA thesis, East Texas State University, 1981), p. 15.

7. Frederick Sommer, "General Aesthetics, 1979," in *Sommer: Words*, p. 25.

8. Ibid.

9. Jonathan Williams, editor's note, in Charles Olson, *The Maximus Poems* (New York: Jargon/Corinth, 1960), p. 162.

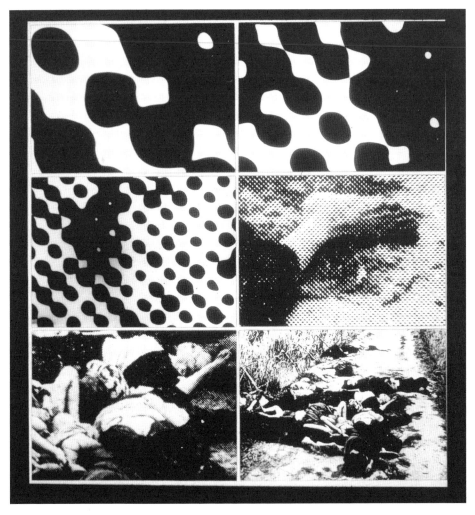

John Wood, *My Lai Massacre*, 1969

On the Edge of Clear Meaning
On John Wood

When I was studying with Nathan Lyons at the Visual Studies Workshop in Rochester in the mid-1970s, someone gave me a couple of offset prints of photographic portraits by John Wood. They are straightforward full-face portraits, with the subjects—a young woman and man—looking directly into the lens with great openness and affection. I liked these portraits right away, and have kept them with me for more than thirty years. Over time, they have come to be, for me, icons of the ideals of teaching—an Adam and Eve of pedagogical possibility based on trust.[1]

One unusual thing about these simple portraits is that they have always been clearly and unmistakably identifiable as works by John Wood. Out of all the millions of photographic portraits made in the last two centuries, why and how is this pair of portraits so remarkably recognizable as the work of a particular practitioner? Is it their guilelessness and honesty? Is it the clarity of composition and presentation? Or is it the fact that no one but Wood would think to do something so simple and pure so well?

Historically, "purity" is not a term that has often been applied to the work of John Wood. In photo-historical terms, he is thought of as one of those renegades who went against "pure photography" by incorporating drawing, painting, collage, and every other technique he could get his hands on into his practice, thus helping to usher in the multimedia 1960s that caused a crisis in "straight photography." Long before it became a signal medium of the avant-garde, collage was a folk art, practiced by children, lovers, and grandmothers. I suspect this is one of the reasons Wood was initially attracted to it, just as he would later make art out of whirligigs. And there have always been, in fact, strong folk qualities, including insularity and self-sufficiency, attached to photography itself, which long delayed and much complicated its acceptance as fine art.

From the jaundiced perspective of our pluralistic present, those once furiously enforced and ferociously defended divisions seem quaint. Now that those and most other boundaries have dissolved, and digital imaging has normalized "impurity" and made the combination and alteration of different kinds of images commonplace, John Wood's work emerges as an especially prescient and relevant progenitor. It presages much of what has been done in mixed-media over the last two decades, and looks forward to the digital future.

Wood took his first drawing class at the Memorial Art Gallery in Rochester, in the third grade, and never stopped drawing. "Drawing is the thing that affects me the most," he said. "I'm continually in a state of drawing and no day goes by that I don't draw something—mark making, calligraphy, the kinetic motion of the movement of the hand, are very important to me; probably more important than anything else."[2] His next big discovery was the kinetics of flying, when he became a bomber pilot in the Air Force. "I was a pilot for a long time," Wood has said, "and some of the changes of space that take place as you go from looking out at the horizon straight ahead to moving up where you may be looking down, where there's no horizon, are the kinds of things that have activated my work, more than any romantic notion of landscape."[3] In her 1987 MFA thesis on Wood, the artist Laurie Sieverts Snyder, who would later become Wood's wife, tells us that in the Air Force, he had a German Robot camera, developed for aerial gunnery work, that exposed half-frame 35 mm negatives "as fast as you could press the button," and that Wood did his first sequence photography (which he later called "positional sequences") with this camera.[4]

At about age twenty-seven, after rattling around a bit, Wood discovered László Moholy-Nagy's 1947 book *Vision in Motion*,[5] and was transfixed and transformed by it. Hungarian-born Moholy-Nagy had taught the foundation course at the Bauhaus in Weimar and Dessau from 1923 to 1928, and left Germany after the Nazi electoral victory in 1933, ending up in the United States. He became the director of the New Bauhaus in Chicago in 1937, and when that failed financially after one year, he founded the School of Design, which became the Institute of Design in 1944. Moholy-Nagy's vision of the new unity of art and technology had photography at its center, and promulgated the idea that the *process* of making art was integral to the making of meaning; in other words, form reveals meaning.

Soon after Wood discovered Moholy-Nagy's *Vision in Motion* (and *The Language of Vision*,[6] by another Institute of Design luminary, György Kepes), he applied to the Institute of Design program and was accepted in 1950, on the G.I. Bill. He described his work at the Institute as ranging from "purely abstract exploration to image making of one sort or another,"[7] and his most important teacher there was Harry Callahan, followed by Art Sinsabaugh. Aaron Siskind was also a big influence, although Wood never took a class from him. When he graduated from the Institute in 1954, Wood immediately took a job teaching photography and printmaking at Alfred University in southwestern New York State, where he remained for the next thirty-five years. One of his students at Alfred was Nathan Lyons, who later became a friend and steadfast supporter of Wood's work, through the auspices of the George Eastman House in Rochester, where Lyons was active from 1958 to 1969 (advancing to become associate director and chief curator), and later through the Visual Studies Workshop, which Lyons founded in 1969.

Taking Care of the Edges

> The true artist is the grindstone of the senses; he sharpens eyes, mind, and feeling; he interprets ideas and concepts through his own media.

> — László Moholy-Nagy, *Vision in Motion*[8]

The four earliest works in the exhibition *John Wood: On the Edge of Clear Meaning*[9] indicate the range of Wood's work that follows. The first, a 5-by-7 ½-inch black-and-white silver print from the early 1960s titled *Women and Snake, Rattlesnake Hunt, Pennsylvania*, pictures a scene that Garry Winogrand might have photographed, but not quite like this. Two women, possibly a daughter and her mother, wear matching 1960s-style eyeglasses. The older woman clasps a snake and grimaces stage right, while the younger one smiles into the camera, complicit. The frame is full of heads and torsos, and divided into thirds. The two women occupy the first two-thirds, left to right, while a man, set back in shadow, also smiling but unspectacled, fills the remaining third; together they are complicitous subject, oblivious subject, and knowing witness. The woman in the center pivots around the snake, from girl to man. The scene is sexual and mythical and wholly human, and the image exudes a delight in fellow feeling that lets the subjects of the photograph speak, unencumbered by the "self-expression" of the image maker. Even here, in this "straight" photograph, the action occurs at the edges of things, where girl, woman, snake, and man meet. Wood often told his students to "take care of the edges and the middle will take care of itself."[10]

Nantucket Diptych, also from the early 1960s, very simply turns one of the standard conventions of landscape photography — a horizon line parallel to the picture frame — on its ear. Here the horizon, on land and sea, at both dusk and dawn, cuts each of these two photographs at a different angle. Since the horizon is taken as a given, it remains horizontal, while the images rotate around it, highlighting the reciprocity of sea, earth, and sky. As Wood once wrote on a drawing: "At night or dusk in flying sometimes we do lose the horizon and must find it again or we are in trouble." In the image, balance is maintained by adjusting weight and volume.

It is extremely difficult to put photographs together with drawing and collage because the relative valences are so unstable, but Wood managed these relations with uncommon grace. "I'd like each material to maintain its own *integrity*," he said.[11] *Head with Projection* (1960) is an early serial collage combining drawing and a photograph. The composition works as a three-frame sequence, with a drawing of a black-and-white checkered head silhouetted against an orange ground at left, and a black-and-white photograph of two objects in flight against a black ground at right. This concern with figure-ground relations and reversals continues throughout Wood's oeuvre. The left edge of the photograph is

curved to mirror the back of the head at left. Between these two is another drawing of the head, squeezed by the flanking images, and further morphed and extended by a three-lane highway (the checkerboard head and orange color evoke a racetrack) or a musical staff drawn across the top of the two drawings. Are these thoughts flying from the mind? And is this, perhaps, a premonition of John F. Kennedy's assassination?

Greek (1964) is another three-frame sequence, this time combining graphite, ink, and a gelatin-silver print, but the images transformed here are all of words. Wood's attention to and direct operations on words can be traced through his many sketchbooks, and are persistent features in his work. In the early 1970s, Wood persuaded another professor at Alfred University, Richard Borst, to help him use a Xerox Sigma 5 computer, with a then-incredible fifty-two-thousand-word memory, and forty-nine million characters of disk storage, to devise a random choice system to generate something Wood called "Computer Chants Chance," yielding combinations like:

Danger	Cage	Bomb
anger	overage	Bang
age	Age of	Banger
	Rage	anger

In one of Wood's sketchbooks from 1970–72, I found this written under a drawing:

MOWN	MOUNT	MOAN	MIGHT	MOUND
FIELD	FOUND		SHAPE	SQUARE SKY

Like his work with images, Wood's word pieces concentrate on the edges of things, the live ends where meaning is produced.

The seeds of much of what was to come can be discerned in these early pieces, and this points to something distinctive about Wood's whole body of work: namely, its insistent attention to both continuity and constitutive events. Spanning more than fifty years and incorporating a dizzying array of media and techniques, Wood's oeuvre encompasses a remarkably consistent investigation into what sustains an image, and how we as viewers are implicated in that sustenance, in the constantly shifting relation between what we see and what we make of it.

In Wood's work, the photograph often represents the given thing, what is received of the world. The work then is to put that given and received thing into play, to activate it conceptually, aesthetically, and kinesthetically. For Wood, that means transforming it haptically, through the hand. Wood's drawing and collaging and intricate manipulation of images are ways of understanding and informing photographs. In the conflicted history of "art photography" this has been considered, in some quarters at some times, a heresy. But it is

a heresy that preceded the orthodoxy, and will certainly outlive it. The "pure" photograph was a temporary, though powerful, fiction. Photography was born out of a desire to write and draw differently, to write or draw with light, and was always integrated with other arts. Speaking of the way Nathan Lyons was the first one receptive to the idea of hanging photographs, drawings, and collages together, Wood said: "I wanted them viewed in relation to each other, not as separate mediums, but rather as images that flowed together."[12]

Wood's work has always concentrated on the permutations of an image, a symbol, a sign, and from this intense investigation has arisen an involvement with what I would call the *image unconscious*, and Wood, I think, would call the exigencies of shape and structure.[13] "Shape is very strong with me," he has said. "I like the idea that shapes have a life unto themselves, which is not a narrative life, but some kind of feeling that affects us very strongly. I think these things are universal."[14] One gets the sense from some of Wood's works that he could spend the rest of his life investigating the possibilities of one simple shape, like a triangle. He once said of Buckminster Fuller, who lectured at the Institute of Design when Wood was a student there: "He would start with a little triangle and gradually the whole world would evolve out of that."[15]

"Quiet Protest"

Political concerns came into John Wood's work beginning with his opposition to the Vietnam War and his antiwar photo-collages of 1963 and 1964, and came to include gun violence, nuclear waste and proliferation, and ecological challenges. Wood addresses these issues, in most instances, in compositional terms. He brings representations of these things into the formal logic of his work, and then examines and expands upon the results. He wants the viewer to be able to *see* what happens, preferably without prejudice or a lot of prior assumptions. What does a gun in a landscape, or an oil spill, or the problem of what to do with nuclear waste, *look* like?

The sense of implicate order is very strong in Wood's work,[16] and this sense of order has an ethical dimension that is *offended* by threats to it. These threats are intentionally allowed into the visual ordering of the work so that the menace becomes visible and palpable. The effects are structural and implicit rather than superficial and explicit.

In 1970, Wood wrote:

> [M]aybe the time has come
> for creative photography
> to encompass the large
> problems without propaganda
> or journalism[17]

And in 1977:

> I would like my pictures to be abstract
> And poetic visual images
> Of friends and the world
> No story telling
> Sometimes slight propaganda and quiet protest
> On the edge of clear meaning.[18]

Wood has always been careful to leave some leeway for viewers to find meaning in his work, thus implicating us in that making. He also implicates us, as citizens, in the problems he addresses. It is not enough to point a finger at politicians, or corporations, or the army, he insists; in a democracy, we are all responsible for what happens.

Sometimes the protests are so quiet that their referents are only revealed in their titles, like *Maine Permits Moose Hunting* (1983), *Chain and Monument Shadow* (1990—across the foreground of this image falls a shadow of the Washington Monument), or *How to Hide Nuclear Waste* (1991). *Triangle in the Landscape: Eleven Second 90 Degree Turn of a Paper Triangle*, a sequence of four gelatin-silver prints made from scratched 35 mm negatives, is a protest so subtle that it might easily be mistaken for a purely formal exercise, but for its title and its date of origin: August 6, 1985, the fortieth anniversary of the day the atomic bomb was dropped on Hiroshima, and the fact that eleven seconds is the time it takes a bomb to reach its target after being released. In eleven seconds, Wood's paper-triangle construction turns ninety degrees. The agitated scratches into the negative image indicate the flash of the explosion and the sudden devastation, and the paper triangle (we remember that the project to produce the bomb was called "Trinity") appears to be as fragile as the human lives that were snuffed out in those first seconds of impact.

But the *quiet* in Wood's "quiet protest" is a relative term, and some of his political works do turn up the volume. The LBJ and Hands images from 1965 turn on the senses that President Lyndon Baines Johnson had blood on his hands because of his inability to stop the war in Vietnam, that he was attempting to "wash his hands of it," and also that whatever else happened, he was still subject to the agency of U.S. voters and protestors, raising their hands in opposition to the war. *My Lai Massacre*, from 1969, graphically encourages viewers to look more closely at the images of atrocities in Vietnam, since these things were done *in our names*. And the *Loudspeaker Collage* from 1968 is an explicit call to speak out and be counted. The fact that the handprints in this collage derive from those on prehistoric cave walls gives them a certain gravity. Architecture critic and historian Sigfried Giedion wrote that such images of the hand "always express a supplication to invisible powers."[19]

Later works, like *Flag* and *Eagle Pelt*, both from 1985, and *Eagle Pelt Doublet 1 and 2*, from 1989, appropriate the national symbols of America to register a quiet but pronounced protest about the direction in which the country is heading. These images are perennially potent. In 2007 critic David Denby called the U.S. occupation of Iraq "a dead eagle hanging around our necks."[20]

The *Exxon Valdez* oil spill in 1989 prompted the *Exxon Valdez* Series: I Made a List of 62 Water Birds with Color in Their Names and a host of related pieces by Wood. In one of the worst man-made environmental disasters in history, eleven million gallons of crude oil were spilled into Alaska's Prince William Sound, devastating marine life of all kinds and killing an estimated 250,000 to 500,000 sea birds and 250 bald eagles. Aerial photographs of the heavy sheen of oil on the surface of Prince William Sound and close-up photographs of the oil-coated rocks and dead birds brought the catastrophe into focus.

Characteristically, Wood responded with images of great power and subtlety, in his extended series of bird names: *Green Heron*; *Cinnamon Teal*; *Blue-Winged Teal*; *Golden-Eyed Red-Throated Loon*. One rather anomalous image, *Laurie's Cobble with ¼ Tsp. Asphaltum Spill* (1989), is perhaps the most affecting of all. A small, round stone covered by a spreading stain of pitch black oil is photographed from above, at close range, which has the effect of monumentalizing it and making it intimate at the same time. In this image, Wood brings the point of irreversibility and responsibility home, into the personal, but ends up making an image that evokes a whole planet blackened by pollution.

Also from this time comes a related series of reflections on the problem of nuclear waste—*Baby Loons and Bomb* (1987); the *Cooling Tower/Cactus* doublet (1989); *Pear Tree Cooling Tower and Apples* (1991); and *Cooling Tower: With What Will We Store Our Waste* (1991)—that are both nuanced and devastatingly direct. "I think that art has its greatest effect when it makes people sensitive to life," Wood has said. "And that's more important than how well or badly images can stir people to immediate political action. That belief gives me the courage to do the kind of things I do."[21]

When I met with John Wood in his studio in Ithaca in May 2007, he tried to recall something that John Berger had said about poetry being the only real counter to the awful indifference of the world. After I left, I found the quote at the end of Laurie Snyder's thesis, where she notes that Wood often used the quote to end public presentations about his work. It reads:

> Poetry makes language care because it renders everything intimate. This
> intimacy is the result of the poem's labor, the result of the bringing-
> together-into-intimacy of every act and noun and event and perspective

to which the poem refers. *There is often nothing more substantial to place against the cruelty and indifference of the world than this caring.*[22]

John Wood was always too modest to apply these last words celebrating the substantial caring of poetry to his own life's work, but we now can, and do, in retrospect and respect.

NOTES

1. John Wood told me in 2007 that the individuals in these portraits were, in fact, students of his at Alfred University, Alfred, New York.

2. Wood, quoted in William S. Johnson, "John's Story" (working paper, 2007), p. 10.

3. Wood, quoted in Charles Hagen, "An Interview with John Wood," *Afterimage* 4, no. 7 (1977): 15.

4. Laurie Sieverts Snyder, "Monograph on the Work of John Wood—Artist and Teacher" (MA thesis, Syracuse University, 1987), p. 13.

5. László Moholy-Nagy, *Vision in Motion* (Chicago: Paul Theobald, 1947).

6. György Kepes, *The Language of Vision* (Chicago: Paul Theobald, 1944).

7. Wood, quoted in Johnson, "John's Story," p. 7.

8. Moholy-Nagy, *Vision in Motion*, p. 29.

9. *John Wood: On the Edge of Clear Meaning* was presented in Rochester, New York, at the George Eastman House, the Memorial Art Gallery of the University of Rochester, and the Visual Studies Workshop, October 17, 2008–January 17, 2009; in New York City at the International Center of Photography and the Grey Art Gallery, New York University, May 12–September 6, 2009; and in Syracuse, New York, at SUArt Gallery at Syracuse University, October–December 2009. The exhibition was curated by Nathan Lyons.

10. Wood, quoted in Snyder, "Monograph on the Work of John Wood," p. 36.

11. Ibid., p. 44.

12. Ibid., p. 33.

13. But Wood did not discount the image unconscious, and once complained that when people look at images, they are too quick to attach fixed narratives to them, and so stop seeing, because "they're not letting the images flow through their unconscious." Wood, in Hagen, "An Interview with John Wood," p. 10.

14. Wood, quoted in Johnson, "John's Story," p. 8.

15. Ibid.

16. On the idea of implicate (or "enfolded") order, see David Bohm, *Wholeness and the Implicate Order* (London: Routledge, 1980).

17. Wood, quoted in John Benson, ed., *12 x 12* (Providence: Carr House Gallery, Rhode Island School of Design, 1970).

18. Artist's statement in conjunction with the exhibition *John Wood: Photographs, Collages, Drawings*, Vision Gallery of Photography, Boston, 1977.

19. Sigfried Giedion, *The Eternal Present, Volume 1: The Beginnings of Art* (New York: Bollingen Foundation/Pantheon, 1962), p. 107.

20. David Denby, "War Wounds," *New Yorker* (August 6, 2007): 77.

21. Quoted in Johnson, "John's Story," p. 12.

22. John Berger, *And Our Faces, My Heart, Brief as Photos* (London: Writers and Readers, 1984), p. 97. (Emphasis added.)

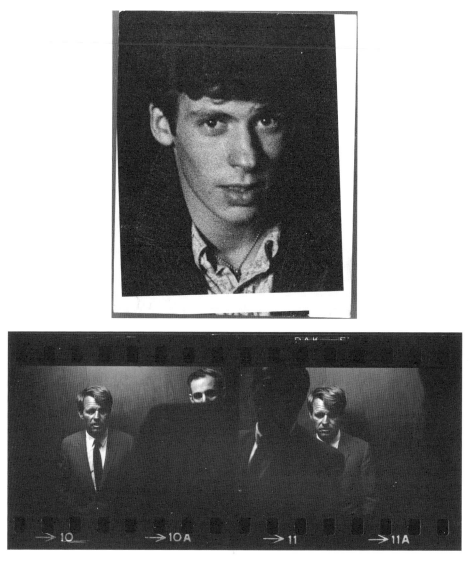

Top: untitled (portrait of Danny Seymour, ca. 1963) Bottom: untitled (Bobby Kennedy in elevator, 1968). Both photographs by Robert Bergman

The Democracy of Universal Vulnerability

On Robert Bergman's Portraits

There is not enough kindness in the world. Human beings are notoriously cruel in their treatment of the other species that share our planet. But compared to the brutality we regularly visit upon our own kind, this chauvinist violence pales. We injure, torture, terrorize, and enslave each other on a massive scale. We have killed millions of our own kind, not for food or territory, but because we have discerned some difference in the other that we imagine overrules our common humanity. Some of us even treat those closest to us, our loved ones, badly, inflicting wounds that may remain invisible, but that never heal.

Over the past nearly two hundred years, photography has served as faithful witness to and interrogator of this legacy of unkindness, with remarkable tenacity and inventiveness. Each new generation of image makers finds fresh ways to make human cruelty visible. The motivations for this are many and complex, both personally and socially, but the underlying premise is one of productive self-consciousness. If we can only *see* what we are doing to each other, if it is materialized before us as an image, we might become conscious of it as a thing in the world that can be changed. This premise has been questioned, criticized, and mocked over the years, but it has never been abandoned.

It is said that, once photographically derived images became ubiquitous, any reflective distance they might once have engendered diminished or disappeared. There are now too many images coming at us too fast for us to consciously respond to them. The once-imagined evidential veracity of these images has long ago dissolved into imperceptible patterns of endlessly mutable pixels. But still we believe and depend on them, and they continue to play a key role in our political and moral determinations.

The art history of photography (or the history of art photography) is riven by the attraction/repulsion to the empathic powers of photography. Edward Steichen believed that photography was conceived as "a mirror of the essential oneness of mankind throughout the world,"[1] and he organized "the most ambitious and challenging project photography has ever attempted"[2] at the Museum of Modern Art in 1955 to celebrate this mirroring. *The Family of Man* was a tremendous popular success, but drew critical fire from both right and left. Conservative critic Hilton Kramer complained that the exhibition embraced "all that is most facile, abstract, sentimental, and rhetorical in liberal ideology."[3] Photographer and educator Henry Holmes Smith later called the show "white supremacist, anti-black,

anti–Third World."[4] Allan Sekula, who wrote the most trenchant critique of *The Family of Man* from a left perspective in 1981, revisited it in 2002, two years into the Bush/Cheney administration, and observed that "it is hard (for many Americans, at least) not to look back at *The Family of Man* today without a tinge of nostalgia for an exhausted liberalism."[5]

Steichen included a number of Robert Frank's photographs in *The Family of Man* exhibition and book. But a few years later, in 1959, Frank produced a book that might be seen as the broken *Family of Man*, and signaled a whole new generational approach to documentary practice. If *The Family of Man* represented an implicit empathic approach that still relied on a mostly restrained, "objective" visual rhetoric, Frank's *The Americans* opened up a strikingly subjective vein in an attempt to collapse the distance between image and viewer, to bring the viewer *inside* the experience.

The critical reaction to *The Americans* was immediate and vociferous. Whereas many viewers saw the book as courageous and true, some popular critics saw it as dishonest and morbid. The hapless Bruce Downes, editor of *Popular Photography*, who had already fulminated against the new "Photo Bohemians" and "Photointellectuals, looking like beatniks," saw *The Americans* as the ultimate manifestation of everything he despised in the new photography. "They are images of hate and hopelessness," he wrote when the book appeared, "of desolation and preoccupation with death. They are images of an America seen by a joyless man who hates the country of his adoption."[6] Downes quickly gathered six other critics to help heap calumny on Frank's book in the pages of *Popular Photography*. Arthur Goldsmith said the book was not about a real America, but about the "wild, sad, disturbed, adolescent, and largely mythical world" created by the Beats. Charles Reynolds complained that "the only slight vestiges of nobility left in this wasteland of vehicles, juke boxes, and American flags are possessed by Negroes and small children," and James Zanutto called *The Americans* a "sad poem for sick people."[7] The *Popular Photography* critics were joined by a chorus of aggrieved patriots from around the country, including William Hogan at the *San Francisco Chronicle*, who called Frank's photographs "neurotic, and to some degree dishonest."[8]

For Frank in 1959, the only way to tell the truth about America was to make it *personal*—to come out from behind an imagined journalistic objectivity or distanced reportage and work up close and from the heart, subjectively. Because of his later success, it is easy to forget how thoroughly this decision exposed him to some very extreme abreactions, and exacted a tremendous emotional toll. It is also easy to forget how completely this new subjective approach flew in the face of every reigning institutional photographic aesthetic regime of the time, including the one propounded by Steichen's successor at the Museum of Modern Art, John Szarkowski.

During his tenure as director of the Department of Photography at MoMA, from 1962 to 1991, Szarkowski became the single most powerful arbiter of photography in the world. His kind of minimalist formalism was inhospitable to Frank's expansive, engaged

responsiveness to social reality. Frank made his own way, regardless, but many others working in this vein were marginalized during this period.

Robert Bergman managed to survive. As the great art historian Meyer Schapiro wrote in an afterword to Bergman's first book, *A Kind of Rapture* (1998): "Certain photographers—Robert Frank, as well as Robert Bergman, come to mind—discover, like the poets, otherwise ignored qualities of the person and environment, hidden moments of feeling, and present them to our entranced scrutiny—for our meditation."[9]

What Bergman's photographs have in common with Frank's is that they are intuitive *recognitions* rather than formalist constructions. Both artists go looking for something in the world and discover "otherwise ignored qualities of the person and environment" and "hidden moments of feeling." When we look at their images, we are put in the place of this recognition. The distance collapses. It is not epistemological, but phenomenal.

Bergman's early (ca. 1965–68) black-and-white photographs of people on the street share with Frank's that certain bemused awe—again, finding something in the world that tells us something about our condition: four faces in the crowd, contemplating their own mortality; a little girl on a concrete step before two clapboard houses, laughing in the face of it; and a woman in a raincoat and galoshes, striding between two dark windows, utterly self-contained. Even a double image of Bobby Kennedy in an elevator is singularly haunted, suspended forever between life and death.

Crazy About Images

Dr. Sam Bergman was an eye, ear, nose, and throat man, but his son Robert concentrated early on the first of these. He was attracted to all kinds of optical devices—microscopes, telescopes, cameras—as a child, and developed an intense interest in photography from the age of five or six. When his father died prematurely, at age forty-five, Bergman found solace in photography, using his Brownie camera to make images of the people he loved, the ones who were left, bereft—his mother and his younger brother Bill asleep in the Pullman car on the train from New Orleans, where his father died, to Minneapolis, where his mother had grown up.

But Bergman's life took a more radical and decisive turn in 1963, when he and Danny Seymour, a neighbor of his in Minneapolis, made a pact, at ages nineteen and twenty, to become great visionaries and artists of the camera. On their first night out to photograph, Bergman took Danny's portrait with a borrowed Nikon, and they rushed back to Robert's mother's laundry room to develop and print the image. From that point on, they were inseparable, until Danny moved to New York and began working with Robert Frank.

In 1971 Ralph Gibson's Lustrum Press published Seymour's book *A Loud Song*. I discovered it a few years later, and it had a tremendous effect on me. I had never seen anyone use words and images in such an immediate and effective way. And it was the

first photographic work I ever tried to write about, as a poet, in 1975. I was twenty-two years old.

Danny Seymour's life story was a very complicated one, but in *A Loud Song* he managed to tell the story with only a few scattered images and some scribbled words, and he did it in an emotionally powerful way without falling into sentimentality. After working with Robert Frank on the filming of the Rolling Stones chronicle (and brilliant meditation on the dark side of fame) *Cocksucker Blues*, Seymour "disappeared" from a sailboat returning from Colombia in December 1972, and his body was never recovered. In his introduction to *A Loud Song*, Seymour wrote: "When I turned to photography, it was as a drowning man reaches out for a liferaft. . . . This book is not an autobiography. It is not that complete. It is an attempt to use the photographic image as a language, and with that, to make literature."[10]

In 1972 Lustrum Press published Frank's *The Lines of My Hand*, which was thought to be an homage to *A Loud Song*. Or perhaps the reverse is true, since Frank must have been working on *Lines* when Seymour made his *Song*, and the lines of influence are more likely to have run in that direction. In any case, when Frank made later versions of *The Lines of My Hand*, he included a double image of Danny holding a microphone, over this epitaph: "WE MEET IN NEW YORK. He is young—crazy about images. We become friends. Daniel Seymour travels fast. We work together—it ended with Cocksucker Blues. Fate. And Danny will never return from his last trip. GOOD BYE—CUT."[11]

Rapture and Kindness

In 1998 Pantheon published a selection of Robert Bergman's street portraits titled *A Kind of Rapture*, with an introduction by Toni Morrison and an afterword by Meyer Schapiro. One of the book's dedicatees is Daniel Seymour, and it includes an epigraph by Seymour's mother, the poet Isabella Gardner:

> If there is a theme with which I am particularly concerned, it is the contemporary failure of love. I don't mean romantic love or sexual passion, but the love which is the specific and particular recognition of one human being by another—the response by eye and voice and touch of two solitudes. The democracy of universal vulnerability.[12]

The portraits that follow in that volume, taken from a body of work that was made over the course of twelve years, from 1985 to 1997, are unlike any others in the history of photography. A superficial glance through them will yield little, but prolonged viewing opens up worlds of connection. This is what I wrote after curator and publisher Phong Bui first showed me prints of some of Bergman's portraits, in 2004:

When my mother died, I was holding her face in my hands and looking into her eyes. I wanted to see what she was seeing, then, but I couldn't. I could feel it, but I couldn't see it. I thought that I should be able to save her, and I tried to hold her gaze, to hold her here, but the moment she died, her eyes went out, and I was left alone.

In the last weeks, the skin of her face had pulled taut around her skull to create a face I had never seen before, though I'd known her all my life. It was her face, definitely, but she'd never shown it to the world before this. It was her true face, and it was new, and it was the most beautiful face I have ever seen.

This is what I remembered when I first saw Robert Bergman's photograph of the old woman in a lavender robe, with light on her hair and behind her eyes. It's the first photograph in his extraordinary book, *A Kind of Rapture*, and it's still the hardest one for me to look at.

Cartier-Bresson has said that one of the most difficult things to do in photography is to make a portrait. It's no problem, of course, to aim a camera and shoot someone, but to portray (literally, *to draw forth or reveal*) another is something else entirely. Cartier-Bresson said his passion "has never been for photography 'in itself,' but for the possibility— through forgetting yourself—of recording in a fraction of a second the emotion of the subject, and the beauty of the form: that is, *a geometry awakened by what's offered.*" The poet Robert Duncan wrote that "to see the face rightly, one must see the skull in the face; to see the skull rightly, one must see the face."

The faces in Robert Bergman's photographs are all so penetrating that one must spend a good deal of time looking at them to begin to realize their scope. Finally, it is difficult to identify a human emotion that is not revealed in them.

The truth is, photography can do only a couple of things really well. It can make visible the tracery of a relation, beginning with the relation between the photographer and his or her subject, and it can reflect on death. Neither of these effects is automatic, by any means, but it is possible. One would think that, out of the millions of photographs that have been made between people over the last two centuries, it would have happened more often, but in fact it is exceedingly rare.

I guess that's because real portraits enact a contradiction: that each human being is unique and, at the same time, alike. There is no such thing as a "typical person." People are very different, one from another. But when you get down below the surface, to the skull, we're ultimately the same.

Robert Bergman is a great portraitist. What's going on in these images can't be faked. We've never met, but based on these portraits, I trust him. I would even have trusted him with my mother's face.[13]

I trust him still, because I think he knows what images are and what they can do. He knows how dangerous images can be, and so is extremely careful with them. And he recognizes that photographs are not only formal constructions, but also magical acts.

> [The] space and time peculiar to the image is none other than the world of magic, a world in which everything is repeated and in which everything participates in a significant context. . . . The significance of images is magical.
>
> —Vilém Flusser, *Towards a Philosophy of Photography*, [1983] 2000[14]

> The vicissitudes of light among bodies can give rise to any number of effects which we cannot resist comparing with the states of our inner sense of perception.
>
> —Paul Valéry, "The Centenary of Photography," [1939] 1970[15]

Robert Bergman found these states in human beings, out in the world, and photographed them. Somehow, Bergman managed to make one truthful portrait after another, to draw forth the inner life of perfect strangers—not once or twice, but time after time, over twelve years. What emerges from these street portraits after prolonged viewing is the astonishing variety of states expressed: affection, pity, anger, contempt, confusion, ecstasy, pain, sorrow, regret, dejection, delight, curiosity, predation, shyness, menace, hatred, compassion, clarity, confidence, despair, shame. . . . But it is really the admixture of emotions that most attracts Bergman: menace mixed with affection, fear with curiosity, clarity with dejection, sorrow with delight, and many other combinations for which I have no words, which can only be *seen*.

The Lost Beauty of Mankind

Since at least the middle of the sixteenth century, ideas about portraiture in art have turned on the distinction between imitation or mimesis (representing things according to particular principles) and portraying (representing things as they are and not as the artist believes they should be). The rise and fall of portraiture in people's estimation over the past five centuries has been largely determined by fluctuating attitudes about imitation and portrayal.

Although this distinction is sometimes reduced in theory to that between beauty and truth, the relation is more complicated in practice.

The rise of photography in the nineteenth century complicated this distinction even more, by introducing the idea of inherent likeness in the medium. This inherent likeness, or direct relation to the real, recalled earlier senses of the *acheiropoetic* image, an image "not made by hand," such as the True Image of Christ in the Veronica, or Mandylion. These icons had special power because they were believed to be direct traces of the divine, unmediated by human agency. Although these beliefs were thought to transcend art, they also engendered and empowered it. As Hans Belting wrote in his groundbreaking study *Likeness and Presence: A History of the Image Before the Era of Art* (published in English in 1994), these earlier beliefs in images survived and influenced everything that came later: "The image and its beholder, in ultimate terms, related to each other like archetype and copy, like Creator and creature. The material image, as a mediator, thus became the tool for a contemplation of *the lost beauty of mankind*."[16]

In the modern period, and especially in photography, portraiture has concentrated more on the physical traits of subjects in an attempt to reveal social typologies and assert identity, and also to explore the evolution of physical, psychological, and social types through the conventions of representation. The older sense of portraying moral or spiritual ideals, in the direct contemplation of the "the lost beauty of mankind," has been mostly eclipsed in recent times.

Meyer Schapiro knew the details of this history, and their implications for the art of his time, better than anyone. And this is what he said about Bergman's portraits:

> Robert Bergman's color portraits of people encountered by chance on the
> streets of American cities address the viewer with captivating simplicity
> and directness, in an idiom that is unencumbered by the norms or conven-
> tions of a period style. . . . The resulting energy and beauty of forms imbue
> these portraits with unnameable yet compelling spiritual qualities. . . . He
> has introduced the processes of unification, as in a painting, with the search
> for harmony, movement, variety and distinction within it, beyond what I
> have ever seen in a photograph.[17]

Who are these people in Bergman's photographs? I think the question contains its own answer. They are "the people" in "we the people," the sovereign populace on which American democracy is based. They are "chosen" not by divine intervention, but by virtue of having come into relation with an artist intent on representing them. And whatever they do or are in front of his camera is faithfully and lovingly embraced, not as a personality or as a type, but as a true physical and spiritual embodiment of our common humanity and ultimate vulnerability.

Where does the age-old struggle in figural art between resemblance to the subject and idealization or transfiguration leave us today? It leaves us with the willful contemplation of each other. This is what art can do. If we can see each other clearly, in our revealed radiance, then perhaps we might recognize one another again, and bring some kindness back into the world. It can't be too much to ask.

NOTES

1. Edward Steichen, introduction to *The Family of Man* (New York: Museum of Modern Art, 1955), p. 4.

2. Ibid.

3. Hilton Kramer, "Exhibiting the Family of Man," *Commentary* 20 (October 1955): 365.

4. Henry Holmes Smith, quoted in Joel Eisinger, *Trace & Transformation: American Criticism of Photography in the Modernist Period* (Albuquerque: University of New Mexico Press, 1995), p. 124.

5. Allan Sekula, "Between the Net and the Deep Blue Sea (Rethinking the Traffic in Photographs)," *October*, no. 102 (Fall 2002): 3.

6. Bruce Downes, et al., "An Off-beat View of the U.S.A." (orig. pub. in *Popular Photography* 46, no. 5 [May 1960]), quoted in Joel Eisinger, *Trace & Transformation*, p. 130.

7. Ibid.

8. Ibid., p. 131.

9. Meyer Schapiro, afterword to Robert Bergman, *A Kind of Rapture* (New York: Pantheon, 1998), n.p.

10. Daniel Seymour, *A Loud Song* (New York: Lustrum, 1971), n.p.

11. Robert Frank, *The Lines of My Hand* (orig. pub. New York: Lustrum, 1972; expanded ed., New York: Pantheon, 1989), n.p.

12. Isabella Gardner, afterword (dated summer 1979) to *The Collected Poems* (Rochester, N.Y.: BOA Editions, 1990); epigraph to Bergman, *A Kind of Rapture*, n.p.

13. David Levi Strauss, "On Seeing Robert Bergman's Photographs," *Brooklyn Rail: Critical Perspectives on Arts, Politics, and Culture* (May 2004): 11.

14. Vilém Flusser, *Towards a Philosophy of Photography* [1983], trans. by Anthony Mathews (London: Reaktion Books, 2000), p. 9.

15. Paul Valéry, "The Centenary of Photography" [1939]; in *The Collected Works of Paul Valéry*, vol. 11, *Occasions*, trans. by Roger Shattuck and Frederick Brown, no. XLV in Bollingen Series (Princeton, N.J.: Princeton University Press, 1970), p. 165.

16. Hans Belting, *Likeness and Presence: A History of the Image Before the Era of Art* [1990], trans. by Edmund Jephcott (Chicago and London: University of Chicago Press, 1994), p. 209. (Emphasis added.)

17. Schapiro, afterword to Bergman, *A Kind of Rapture*, n.p.

La Mirada, and the Evidence of Things Not Seen
On Latin American Photography

In the year 1999, the artist Vik Muniz was invited to work with street kids in his native Brazil. These children lived on the streets of Salvador da Bahia. When Muniz showed them photographs of a sculpture made by a Swiss artist almost a century before and half a world away, they immediately recognized its formal language and understood its content. The sculpture depicts a female nude, seated on a simple bench or chair, with her bent knees and shins pressed against a kneeling board. The figure and chair are elongated and flattened. A large bird head sits next to the figure on the edge of the chair. The head of the figure is heavily stylized, like a mask. The vertical ridge of the nose bisects the face into two flat planes, and intersects a uniform hairline above. The eyes and mouth are wide open, and there is a spoked wheel in the right eye and a broken one in the left. The figure appears to be in a state of ecstasy or enlightenment or holy dread. Her attention is wholly fixed on her hands, held out in front of her body, caressing an invisible object.

That the formal language of this sculpture would be familiar to the Bahian street kids is intriguing, but it is even more compelling to learn that its meaning was so readily available to them. They immediately saw that the piece is about the invisible—what we cannot see, but know is there—and our physical, perceptual (aesthetic) relation to these unseen things.

Alberto Giacometti made *L'Objet invisible — Mains tenant le vide* (known in English as *The Invisible Object [Hands Holding the Void]*) in 1934, at a time of extreme crisis for him and for the world around him. His father had just died, leaving him as the new head of the family. Giacometti's secondary title for the sculpture, *Mains tenant le vide*, is a pun, sounding also as *Maintenant le vide*, "Now the Void." This was the year that Hitler and Mussolini met in Venice, and Hitler was elected Führer in Germany. The following year would see the founding of the Croix de Feu in France and the formation of the Luftwaffe in Germany. The head of the woman in *L'Objet invisible* is said to have been inspired by a prototype of an iron mask designed by the French Medical Corps during World War I. Giacometti probably borrowed the overall shape and attitude of the figure from something he saw at the former Museum für Völkerkunde (today the Museum der Kulturen), the ethnological museum, in Basel: a seated statue of a deceased woman, from the Solomon Islands.[1]

L'Objet invisible is one of the very last Surrealist pieces Giacometti made. Dissatisfied with his academic modeling of the figure's torso and legs, Giacometti returned to life studies to try to get closer to reality, in order to (in art historian Peter Selz's words) "come to grips with the optical phenomenon of reality."[2] Giacometti's new focus on optical reality, in making life studies from models, got him excommunicated from the Surrealist group in short order.

Drawing on the street kids' embrace of Giacometti's sculpture, Muniz asked them to describe something they wanted but could not have. After describing these objects, and drawing them, they made three-dimensional representations of them in ceramic and papier-mâché. Muniz photographed the children holding these objects of desire, then removed the objects and photographed them caressing the void.[3]

The exercise is brilliant in its simplicity. The truth is that photographic images are used most extensively to stimulate desire for consumer goods in people who cannot afford to buy them, especially children. These images work so well and are disseminated so widely that they have effectively created a new desiring subject, or, one could say, a new species of desire in its subjects.

> Now faith is the substance of things hoped for, the evidence of things not seen.
>
> —St. Paul, New Testament, Hebrews 11:1[4]

> Black-and-white photos tell the truth. That's why insurance companies use them.
>
> —Allan Sekula, "The Bo'sun's Story," in *Fish Story*[5]

One of the central paradoxes of photography is that this medium, believed to be a direct technical transcription of reality (from the "pencil of nature" to the "emanation of the referent"), also has a special (symbolic, metaphoric) relation to the invisible and to those things that can only be verified by belief. This paradox is exploited by all photographers to some degree, of course, but an argument can be made that it has been mined more extensively, or at least mined differently, in Latin American photography.

Nathaniel Hawthorne once described Herman Melville in this way: "He can neither believe, nor be comfortable in his unbelief; and he is too honest and courageous not to try to do one or the other."[6] It could be said that many Americans (Anglo- and Latin-) have sunk into that middling state of neither believing nor being comfortable in their unbelief, lacking Melville's honesty and the courage to make a choice. But a number of Latin

American artists, photographers, and writers are grappling with the dilemma and depicting the struggle in their art.

The great Mexican writer Elena Poniatowska has written of Latin Americans that "the only thing that truly unites us is language, exploitation, and poverty."[7] But she continues: "Still, all in all, Latin American unity has not been shattered, since the people of all our countries have an astonishing capacity to resist."[8] And she makes an important distinction in considering the evidence of hopefulness: "The dearest things I know about Latin America I know from its writers, filmmakers, photographers, painters, sculptors, musicians, choreographers, and dancers. The most depressing things I've learned from its presidents and politicians."[9]

Let us consider the work of nine artists making photographic images. All were born or have worked much of their lives in Latin America: four in Brazil, two in Cuba, and one each in Mexico, Guatemala, and Chile. Though their work is tremendously diverse, they have in common a penchant for exploring the relationship between photography and belief. For some, it is their main subject; for others, it is a means to other ends. But for all, it can be argued, the paradox is primary and active.

Both Vik Muniz and Manuel Piña have put the crisis of believability in photographic images at the center of their work. Muniz has practically reinvented the art of trompe l'oeil for our time, by turning it back on itself. Rather than painting things in a photographically realistic way to fool the eye, Muniz makes pictures out of photographs using unlikely materials—thread, chocolate syrup, spaghetti and marinara sauce, black bean soup, and dust, for instance—and then makes them back into photographs. Following this bait-and-switch routine, the images become believable again because they are photographs, and we believe photographs in a way that we do not believe any other kind of image. Rather than presiding over the disintegration of the "aura" of the work of art (as Walter Benjamin predicted), photographs have acquired a new aura: the aura of believability. Muniz both trades on and subverts that aura.

> To understand media, you have to go back to the most basic forms of art. I think it started out as two kinds of art—art that comes from embodiment, which is theater, dance, and music, and art that's a graphical projection like drawing. These two arts were probably developed by primitive shamans. They understood they were exercising a kind of power. Because the shaman, like a mechanic, knew how to create something in which belief could be produced. Whereas a king or a chief has power and knows how to use it, but he doesn't know how it's produced. That's the secret that shamans, magicians, salespeople, con men, and artists hold.[10]

Muniz has also spoken of how growing up in Brazil influenced his later examinations of the claims and realities of representations: "The 1970s in Brazil were like a semiotic black market. Nothing could be said directly; you had to sift through things to get to what you really wanted to say. Once you're exposed to that, you become very aware of information that's inside information, or of something being pregnant with many meanings at once."[11]

Manuel Piña's confrontation with photographic veracity is also a confrontation with social beliefs, especially those concerning political and religious utopias. A lifelong resident of Havana (and trained as an engineer in the former Soviet Union), Piña has a particularly informed view of the successes and failures of social utopias. "I feel that the Cuban Revolution has gone through many variants of utopia," Piña has said, "and yet has managed to continue to be one."[12]

Viewers' own beliefs about the Cuban Revolution will largely determine their interpretations of the images in Piña's 1992–94 series Las aguas baldías (Water wastelands). The images show vast stretches of ocean seen from the Malecón, the seaside promenade in Havana. Across that stretch of water, the Straits of Florida, lies another world. And how one feels about the world bordered by the Malecón and that other world across the straits, and their relation, will determine how one sees these images. "This way," writes curator Juan Antonio Molina, "Piña leads us to the problem that really concerns him as an artist: the relativity of notions such as truth, history, and reality, and the way that that relativity can turn photographs into suspicious objects."[13]

If Muniz and Piña operate in the aftermath of the crisis of believability in photographic images, Maruch Sántiz Gómez and Marta María Pérez Bravo make images that seem to precede the crisis, or bypass it, to a time when photographs still do act as evidence, even if it is "evidence of a novel kind."

Sántiz Gómez's 1993–98 series Creencias (Beliefs) pairs straightforward images of objects with short statements of traditional beliefs held by the elders in Sántiz Gómez's Mayan community of San Juan Chamula in Chiapas, Mexico. In one of her books the titles and statements are printed in three languages: Tzotzil, Spanish, and English.[14] *Akuxa/ Aguja/Needle, 1996* pictures a long, white needle, threaded with a piece of dark yarn, lying on the ground, accompanied by text reading: "It is bad to sew at night, because from a young age you could become blind." And a photograph of a little girl holding a woven basket to her head warns: "Children especially should not use a basket as a hat because when a child has measles, the measles will grow in his heart and he could die."

These are *documentary* images, in the Latin-root sense of "lessons, instructions, warnings." Their deadpan style recalls the look of photography in Conceptual art of the 1960s and '70s. But paired with these statements of belief, they assume a kind of whimsical authority. "The *Creencias* as given to us by Maruch are a bridge in time," wrote anthropologist Gabriela Vargas-Cetina. "They create communication between the generations which

preserved memory—those who know that not everything is readily apparent—and those who have been educated in systematic doubt."[15] That is, between those who recognize the evidence of things not seen and those who don't.

We are told that Marta María Pérez Bravo is not a believer in the Latin American magic of Santería,[16] but she is demonstrably a believer in photographic magic (in sociologist Marcel Mauss's sense of a practice "created by the inferior necessities of domestic life").[17] Pérez Bravo's faith in photography allows her to work with an extreme economy of means—her own body, a few props, and a white wall in the sun—to make something happen.

Although most of her images have an oblique relation to the practices of Santería, some are more direct. In *Osain* (1994), we see Pérez Bravo's bare back, shoulders, and head hanging upside-down, wearing a necklace made of feathers and leaves (*maná*). In Santería, Osain is the god of the forest and keeper of all secrets of herbal magic. He is a one-armed, one-legged, one-eyed god whose symbol is the twisted tree branch.

The Cuban critic and writer Gerardo Mosquera has rightly compared Pérez Bravo's use of the photograph with that of Ana Mendieta, "where the important element was the mystical-artistic liturgy which she achieved in her inter-relation with nature, to which the photography bore witness." He has called Pérez Bravo's work "an example of the re-encounter of art and religion within the context of the new Cuban art."[18]

Luis González Palma and Mário Cravo Neto both draw on the iconic and hieratic possibilities of photography in order to activate the relation between viewer and image. Faced with González Palma's powerful portraits of Mayan Indians in his native Guatemala, one recalls Giacometti's statement that the difference between a living person and a corpse is the gaze. In González Palma's images, the gaze is fetishized into a cult object. "For me the gaze is a wound," he has said, "and the photograph the scar."[19]

González Palma's later projects introduced a new reflexivity to the work. In *La mirada crítica* (*The Critical Gaze*), presented at the Australian Centre for Photography in the Sydney suburb of Paddington in 2002, he hung, in an elaborately decorated nineteenth-century interior, ten gilt-framed photographs of a Mayan girl with a cloth tape-measure tied around her head. The image recalls the kind of measuring (the "measured gaze") that has always characterized the European approach to indigenous peoples. González Palma has said that the installation is

> a metaphor for power. A meditation on cataloguing and evaluating. . . . The work is a meditation on the power of the gaze in a political world as well as in an artistic world. This "power" begins with me, as the photographer (not myself an indigenous Maya), with the selection of the models, and continues with an art-world chain of evaluation and selection—art gallery dealers,

curators, critics. In the end, showing the face of this or that woman or man is simply the result of a chain of political and aesthetic decisions.[20]

Mário Cravo Neto is the son and grandson of artists, and his photographic works are solidly traditional, hinting always at unseen mysteries. "It is my intention," he has said, "to charge these photographs with the mystical and religious energy which expresses itself in the temperament, sentiment, and humanity of religious and cultural syncretism in Bahia."[21] In *Odé* (1989), a woman firmly grasps the beak of a pure-white goose. Between the woman and the goose's long, white, phallic neck stands a young girl. The animal eye of the silenced goose replaces that of the child, producing a layered gaze—relating to sexuality, race, age, and species—of considerable power.

The iconography of Cravo Neto's images derives from Candomblé (Yoruba rites in Brazil), in which the *orishas*, or gods, are immaterial, pure force. The only way the *orishas* can make themselves perceptible to humans is to incorporate themselves into one. This is analogous to the way an idea or symbol must incorporate itself into a material form in order to be photographed.

Paz Errázuriz and Rosângela Rennó make images from the margins of society, where social beliefs and prejudices are revealed. In her long and varied career, Errázuriz has photographed men and women in mental institutions (since 1981), transvestite prostitutes (1983–89), boxers (1986–87), and the elderly in old-age homes (1983–2000), among many other subjects. These groups are excluded not only from social and economic life, but from the image a society has of itself, and what it chooses to believe about itself. In a statement about her own work, Errázuriz wrote:

> And of course it's fantasies that intrigue photographers too. There's the contrast between the real violence of these people's lives, and how they see themselves. They imagine that through all this brutality they will dig themselves out of the hole they're in. Something similar happens in the project I've been working on more recently, with the elderly who also have their ideals, their illusions. Or with the psychiatric hospital patients, literally walled in, but who retain their own world inside themselves.[22]

Rosângela Rennó's work also interrogates beliefs about social identity and hierarchies, but one series is more about memory and amnesia: fourteen images of prison tattoos culled by Rennó from a São Paulo state penitentiary archive of more than twenty thousand glass negatives. Most of these photographs were taken between 1920 and 1950 for the Brazilian Servicio de Biotipología Criminal (Service of criminal biotypology), and the tattoo images were classified under thirteen different headings, including: "ethnic, political, criminal, love, obscene, ornamental, accidental, and therapeutic." Originally made for classification

and identification purposes, these images have meanings that have migrated over time, from the documentary to the symbolic. They no longer identify individuals, but rather the collective trauma, and mystery, of identity.

I have left the photographs of Miguel Rio Branco for last because I am closest to this work (having written about it a number of times),[23] and also because I find his installation *Entre os olhos, o deserto* (Between the eyes, the desert) to be especially relevant to this question of how we see and believe images. To accompany the images in a 2001 book of the same name, I wrote a parable from the point of view of the seers in Plato's cave, who know nothing about "reality," but only the images or shadow plays they see projected onto the cave walls. When one of the seers is taken out of the cave and shown the world, he returns shaken and confused, and another seer tries to console him:

> I tell him that when we look at images we're like Orpheus looking back. Like him, we're looking back out of love and doubt—love for the subject we've left behind, and doubt in the laws of consequence—so our gaze is always both faithful and illicit.
>
> . . .
>
> The seer on my left has devised a theory of origin for the images. He says that they are the remnants of a world that was destroyed long ago, that they are the only survivors of this ruined world, and that we are their only disciples.[24]

NOTES

1. These references were first pointed out by Reinhold Hohl in *Alberto Giacometti* (New York: Solomon R. Guggenheim Museum, 1974), and elaborated further by Rosalind E. Krauss, *The Originality of the Avant-Garde and Other Modernist Myths* (Cambridge, Mass., and London: MIT Press, 1985).

2. Peter Selz, introduction to *Alberto Giacometti* (New York: Museum of Modern Art, 1965). After his discussion with the artist, Selz wrote: "Everyone before him in the whole history of art . . . had always represented the figure as it is; his task now was to break down tradition and come to grips with the optical phenomenon of reality. What is the relationship of the figure to the enveloping space, of man to the void, even of being to nothingness?"

3. See "Vik Muniz: The Invisible Object," in France Morin and John Alan Farmer, eds., *A quietude da terra: Vida cotidiana, arte contemporânea e Projeto Axé* (Salvador, Brazil: Museu de Arte Moderna da Bahia, 2000), pp. 150–55.

4. Like many writers, I do not think of St. Paul when I hear those lines, but of James Baldwin's incendiary essay responding to the murders of black children in Atlanta, published as *The Evidence of Things Not Seen* (New York: Holt, Rinehart and Winston, 1985).

5. Allan Sekula, "The Bo'sun's Story," in *Fish Story* (Düsseldorf: Richter, 1995), p. 62.

6. Nathaniel Hawthorne, quoted in Hershel Parker, *Herman Melville: A Biography*, vol. 2, *1851–1891* (Baltimore and London: Johns Hopkins University Press, 2002), p. 300.

7. Elena Poniatowska, "Memory and Identity: Some Historical-Cultural Notes," in Rachel Weiss and Alan West, eds., *Being América: Essays on Art, Literature, and Identity from Latin America* (Fredonia, N.Y.: White Pine Press, 1991), p. 14.

8. Ibid., p. 19.

9. Ibid., p. 25.

10. Muniz, quoted in Mark Magill, "Vik Muniz" (interview), *Bomb*, no. 73 (Fall 2000): 34.

11. Muniz, quoted in Susie Linfield, "Sweet Deception," *Artnews* 98, no. 2 (February 1999): 90.

12. Piña, quoted in Ricardo Viera, interview with Manuel Piña, in *From the Negative: Conceptual Photography from Cuba* (Minneapolis: Parts Photographic Arts, 2000), n.p.

13. Juan Antonio Molina, "De construcciones (Homenaje a Eduardo Muñoz Ordoqui)," in *El voluble rostro de la realidad: Siete fotógrafos cubanos/The Changing Face of Reality: Seven Cuban Photographers* (Havana: Fundación Ludwig de Cuba, 1996), p. 60.

14. Maruch Sántiz Gómez, *Creencias de nuestros antepasados*, ed. by Pablo Ortiz Monasterio (Mexico City: Centro de la Imagen, Casa de las Imágenes; San Cristóbal de las Casas, Chiapas, Mexico: Archivo Fotográfico Indígena—CIESAS, 1998).

15. Gabriela Vargas-Cetina, "*Creencias* by Maruch Sántiz: A Bridge between Time and Cultures," in ibid., p. 12.

16. The origins of Santería lie among the Yoruba people of West Africa, brought as slaves to the New World five hundred years ago. Their rich and complex mythology and religious practices combined with those associated with the Catholic saints to form "Santería" (the way of the saints). Conservative estimates put the number of Santería practitioners in Latin America and the United States at over a hundred million. It is especially strong in Cuba and Brazil, but also in New York and Miami.

17. Marcel Mauss, *A General Theory of Magic* [1902], trans. by Robert Brain (London and Boston: Routledge & Kegan Paul, 1972).

18. Gerardo Mosquera, "Marta María Pérez: A Self-Portrait of the Cosmos," *Art Nexus*, no. 17 (July–September 1995): 86.

19. Luis González Palma, *La mirada crítica* (Paddington, N.S.W.: Australian Centre for Photography, 2002), p. 1.

20. González Palma, quoted in Alasdair Foster, "The Art of Sadness," in *La mirada crítica*, pp. 11–14.

21. Cravo Neto, quoted in Martin Marix Evans and Amanda Hopkinson, eds., *Contemporary Photographers* (Detroit: St. James Press, 1995), p. 223.

22. Paz Errázuriz, "Chilean Disguises," in Amanda Hopkinson, ed., *Desires and Disguises: Five Latin American Photographers* (London: Serpent's Tail, 1992), p. 32.

23. David Levi Strauss, "Smoking Mirrors: The Photographs of Miguel Rio Branco," *Artforum* 35, no. 8 (April 1997): 62–67. "Beauty and the Beast, Right Between the Eyes: Reflections on a Book of Images by Miguel Rio Branco," and "In the Dark," both in *Between the Eyes: Essays on Photography and Politics* (New York: Aperture, 2003), pp. 106–14, and 192–96, respectively.

24. David Levi Strauss, "Between the Eyes, the Desert: In the Dark," in *Miguel Rio Branco: Entre os olhos, o deserto* (São Paulo, Brazil: Cosac & Naify Edições, 2001), n.p.

Out on Hypoluxo Road

On Tim Davis's America

(With Apologies to Jack Kerouac, on *The Americans*)

THAT CRAZY FEELING IN AMERICA, when the glow from the Golden Arches reaches in through a shabby suburban window and sucks a sad poem out of the sleepers within. Or when the colors of Cumberland Farms sweep across a bay window and storm door of a yellow clapboard house like an electric brushstroke. Or when an Exxon sign warps into Japanese Pop animation, scrambling the faux bricks and confounding the Tom Sawyer fence of a row house under a violet sky. Approaching these images, we feel like the thief in St. Gregory of Tours' book of miracles who stole the stained glass windows from the church of Yzeures-sur-Creuse because he thought they must be infused with precious metals, only to discover they were made of sand. We're all see-creatures under the skin, wandering in the "forlorn sands of the isolate earth," chasing mirages, collecting "pencil traceries of our faintest wish," and trying desperately to find beauty in what we're given.

And who would think we'd find it here, in the Tow-Away Zone? In the Drive-Thru Zone, where billions and billions are served, and the Colonel never sleeps. There is no parking or standing in the Zone, only flicker and flux, and shimmering excrescence. Out on Hypoluxo Road, we're "beneath the light," but also "beneath excess" (and haunted by Hypnos). Under the sign of excess, light is a luxury, and all dreams have been converted into the local currency. In this place, reflected light and color must compensate for those other promised but always deferred goods. This is where Dunkin Donuts is a classic. This is where the Burger King and his nights errant pursue their quest for the holy grail of marketing: ubiquitous naturalization, where no placement is out of place and no sign is insignificant. As the poet Robert Duncan used to say, the state in which everything signifies is the state modernity has deemed *psychotic.*

And where are we in all of this? "We" are on the sign tonight in the parking lot of the Spinning Wheel Motel, with rooms from $22 and an HBO Jacuzzi. We are on the sign of the beast leaning against the vandal pumps at Good Way Oil, where we I.D. and Pre-pay After Dark. And we are with an abandoned but still-hopeful mattress, cornered behind Denny's, too marginal to stand and too colorful to fall.

Like Vilém Flusser said, one does business in the daytime and philosophy at night. These nocturnal images probe the commercial unconscious of America, the real estate of

the realm, where those too poor to insulate themselves from consumer advertising live in its unrelenting glare.

Tim Davis finds beauty in these ghastly stigmata, and employs a kind of *vitreous humor* to pun on glass stained by signage instead of pigments. Artists and poets are in the dirty business of transformation, and the fouler the dross, the finer the attempt.

The real life referent (or back lot) of Hypoluxo Road has been described by Davis as "a long straight stretch of strip malls and infirmaries in South Florida." From this serial monotony, this developers' domain of the infantilized and the infirm, Davis has fashioned a Zone of inquiry, where lots are recast and all ballots are off. Robert Frank's and Jack Kerouac's "mad road, lonely, leading around the bend into the opening of space" has been malled and parked into oblivion. Davis doesn't need to travel that "changing restless mute unvoiced road," because Hypoluxo Road is everywhere now. Cars don't race "on, illuminate" anymore, but crawl in long lines past signs, and "death is like life, what else?"

Another area of the Zone is called the Office. This is where the residents of the Zone perform their duty. After they have performed their duty someone comes and takes it away and it enters the Market, from which it will eventually be sold back to the residents as consumer products and services. This is the Circle of Life in the Zone.

The Office is filled with implements intended to facilitate communication, but without their human handlers they appear monstrous or forlorn—like a drawer full of drinking straws or a wounded tape dispenser. A wall full of credentials will get you a chrome drinking fountain, or a scented wreath, or a gorilla skeleton, but it won't get you out of the Zone.

Besides, where would you go? It's Valentine's Day at the Boys' Club, where hearts hang from strings and the world has fallen out of its frame, and everyone important has moved to Extension 4459, leaving Manet's melancholy serving girl behind, gazing wistfully through the blinds.

When something goes wrong in the Office, or when there's an accident, victims are sent to a uniquely inhospitable area called the Hospital, where one finds all manner of malevolent furniture, stultifying storage-and-retrieval systems, and occult messages concealed in the ceiling. A wall of files shows the scars from a lifetime of cutting it too close, and what must be someone's last supper is poised like a toxic still life on a forgotten tray. The operative motto in this therapeutic institution is "First, do no good."

Davis's images show all residents of the Zone as damaged but game. We now know that a jukebox is sadder than a coffin, but sadder still is a lightbox holding X-rays of tumors, illuminating a red-vinyl-and-stainless-steel stool that, though weary from misery, offers itself as if we're about to sit down to our morning coffee in a friendly diner.

The madcap solemnity of these images is entirely appropriate to their illumination of the "intermediary mysteries," like the way a bound book looks peering out from within a stack of manuscripts, or the way the tabs on a drawer full of gray file folders

show the marks and stains of the filers' fingers, searching for data. A kind of deadpan delirium ensues.

There's a lot to deal with. Red Target carts are massing into a green hillside in Connecticut. A lot on the K Line in Jersey is clogged with anonymous headstones. Dr. John's old mirrors and windows have hypostasized and metastasized into one big gaping fenestra of want. There's no place like home in the Zone, where normalcy is the most exotic of all states. If you want to survive, you'd better study alchemy. If you want to send a Western, call Grand Union, or go out onto the veranda at K-Mart, where a motorized Trojan Horse with its head in a bag has put suicide before the carts. When your dealership is threatened by foliage and the chickens have come home to KFC, it may just be time to throw in the shroud. Developers and consumers have inherited the earth and remade it in their own image, creating a hypoaesthetic landscape of precisely global proportions. Tim Davis, a recovering imagist, pulls sights for sore eyes from the ruins.

To him I now give this message: You got nerve.

III

On Susan Sontag

In 1976 I arrived at the Visual Studies Workshop in Rochester, to study "photography as language" with Nathan Lyons. At that time, VSW was arguably the best school of photographic studies in the country—intellectually rigorous, competitive, and austere. I was a poet and fledgling critic, younger than almost anyone else there, and intimidated by the heady atmosphere.

Susan Sontag's essays on photography in the *New York Review of Books* (collected in *On Photography* in 1977) detonated with excessive force at VSW. Photographers and writers who identified themselves as part of the "photography community" were outraged that an "outsider" would dare to make pronouncements about the fundamental meanings and social effects of photographs. Photography had endured decades of condescension and the bitter fruits of the "Is it art?" debates, and had, in response, adopted a circle-the-wagons, defensive posture that (to my mind) too often drifted into anti-intellectualism. So Sontag was seen as an interloper, a "New York Intellectual" poaching on hallowed ground. Who did she think she was?

Well, she thought she was Susan Sontag. She thought she was an independent agent, a *writer*, who could address any subject that interested her without having to become an expert in the field. This was anathema to all specialized discourses within academia, where expertise is the coin of the realm, and where Sontag's kind of criticism is sometimes dissed as "belletristic," as if writing beautifully is the consolation of the untenured.

In his 1993 Reith Lectures for the BBC, published in book form as *Representations of the Intellectual*, Edward Said identified specialization as the first of the four pressures that most impinge on an intellectual's ingenuity and will. "Specialization," he wrote, "means losing sight of the raw effort of constructing either art or knowledge; as a result you cannot view knowledge and art as choices and decisions, commitments and alignments, but only in terms of impersonal theories or methodologies. . . . In the final analysis, giving up to specialization is, I have always felt, laziness, so you end up doing what others tell you, because that is your specialty after all."

Sontag was less lazy than the competition. She eschewed specialization and expertise (and the specialized language that necessarily results from them), preferring to operate as a free agent and pay attention to whatever she pleased. Photography fascinated her.

"Photographs," she wrote, "are perhaps the most mysterious of all the objects that make up, and thicken, the environment we recognize as modern." How could a writer resist photography? Or camp, or cinema, or the Vietnam War, or the way we think about illness and pain? Whether one ultimately agreed with Sontag's analysis or conclusions, it was always a pleasure to read her, because her delight in the play of the mind through language was contagious. And in a number of crucial instances—Hanoi in 1968, Sarajevo in the early 1990s, September 11 in 2001, Abu Ghraib in 2003—she spoke out for those who had no public voice. There is a certain "indignity in speaking for others" (as critic Craig Owens said, quoting Gilles Deleuze on Michel Foucault), but there is also a destabilizing, galvanizing power in it.

For me, *On Photography*, along with Roland Barthes' *Camera Lucida* and the writings of John Berger, opened the field, and made it all active—again. As Sontag recognized: "To write about photography is nothing less than to write about the world." It felt like fetters falling.

The first party I went to in Rochester must have been around Halloween, and was thrown, I think, to welcome incoming students. I was angry about what people were saying about Sontag's essays on photography, and wanted to mix it up. I wore a long, brown, hooded robe I'd just brought back from Senegal, painted my face white with a black question mark on it, and hung a hand-lettered sign around my neck reading: "This civilization is at an end, and nothing we do will put it back together again. —Susan Sontag." It was a great night.

On Larry Clark

At the book party for Larry Clark's *Punk Picasso*, held at Andrew Roth's New York gallery in 2003, Clark told collector, curator, and publisher Thea Westreich that it felt a little strange to see it, finally, because "it's the kind of book they do about you after you're dead." But surely "they" wouldn't be so brutally frank about your faults, nor so willingly expose your demons. Yes, it's bracketed by that mock-swaggering title (actually bestowed by David Denby in his brilliant review of Clark's 2001 film *Bully* in the *New Yorker*: "This punk Picasso combines the multiple desires of lover, artist, and voyeur") and a three-panel poster of the comely Tiffany Limos in a bikini, captioned: "My girlfriend is 19 years old 1999," but the driving narrative of this often forensic autobiography (originally titled *Heroin*) is Clark's lifelong drug and alcohol addiction and his inability to leave it behind and move on. Anyone who's been through AA or NA or both will recognize the markers — scribbled confessions and apologies, lots of obituaries, "The Ten Most Common Dangers," and a tearful letter from a child pleading for the withheld love of her father — documented here with savage attention, along with Clark's other obsessions: early R & B, teenagers, celebrity, autoerotic asphyxiation, and Roger Maris.

But Larry Clark is an artist, not a case study, and he has spent the past five decades (the photographs in his Tulsa series began in 1963) transforming his obsessions into art. This art has consistently and aggressively limned an essentially Sadean metaphysics of desire, perhaps best exemplified in the film *Bully*, in which, as Denby so eloquently put it, "the kids' complete absorption in one another leads to a catastrophic innocence — not moral innocence but metaphysical innocence," in which they "do not know anything outside their desire exists." One of the scribbled epigraphs to *Punk Picasso* is from William Blake's "Proverbs of Hell," stripped of its originally satirical intent in *The Marriage of Heaven and Hell*: "Sooner murder an infant in its cradle than nurse unacted desires."

The importance of Clark's work, for me, has always been its reflection of the image-unconscious of contemporary American society — its meanness combined with gross sentimentality, its simultaneous worship and hatred of adolescents, its pathetic projection of desire and ambition onto celebrities, and its entrenched social autism. My arguments with the work have been both metaphysical and aesthetic. Clark believes that the relation between style and substance is a mechanical one; that style is something *added on*,

like clothes, and in trying to make images that are more real and direct, he has repudiated style. The first epigraph in *Punk Picasso* is from martial-arts master Bruce Lee: "I don't believe in styles anymore. . . . If you do not have style, you just say here I am as a human being, how can I express myself, totally and completely. That way, you won't create a style, because style is a crystallization . . . that way is a process of continuing growth." Or continuing repetition, without the organic relation between style and substance that makes growth possible.

Punk Picasso recalls another autobiography in words and images, from Clark's past: Danny Seymour's *A Loud Song*, published in tandem with *Tulsa* in 1971. Though their differences are readily apparent, there are some telling similarities between the two works. Both authors are addicts. Both had photographer parents. Both books begin with dreamy homages to the author's parents, and end with the same for their lovers. And both men turned to photography, as Seymour said, "as a drowning man reaches out for a life raft." That life raft carried Danny Seymour over the edge long ago, but it continues to buoy the irrepressible Larry Clark.

On Daido Moriyama

"More truth, less art." I remember that Shakespearean motto scrawled across a wall in the Robert Frank retrospective at the Whitney Museum of American Art in 1995. The idea that one can tell the truth using photography is as preposterous as that one can tell the truth using words, but Frank has been attempting, and often achieving, it for more than fifty years in the art. It is now clear that the one other photographer who most closely resembles Frank in this quixotic quest is Daido Moriyama. Born fourteen years after Frank, in 1938, and working within a very different social and cultural milieu, Moriyama has similarly pushed photography to the very limits of representation in order to make images of what is commonly thought to be invisible to the eye. In a statement displayed at the entrance to his 1999 Japan Society exhibition, Moriyama was quoted as saying: "My approach is very simple—there is no artistry, I just shoot freely. . . . For me, photography is not about an attempt to create a two-dimensional work of art, but by taking photo after photo, I come closer to truth and reality at the very intersection of the fragmentary nature of the world and my own personal sense of time."

Also like Frank, Moriyama has always found books to be the most effective method of transmission of still images. The 1999 retrospective *Daido Moriyama: Stray Dog*, curated by Sandra S. Phillips at the San Francisco Museum of Modern Art and Alexandra Munroe at the Japan Society Gallery in New York, was organized around the most well-known of Moriyama's more than twenty books. An earlier show, at New York's Roth Horowitz gallery, displayed some of the publications themselves, including Moriyama's first, *Japan: A Photo Theater* (1968), as well as *Bye, Bye Photography, Dear* (1972), *A Hunter* (1972), *Another Country in New York* (1974), *Japan: A Photo Theater II* (1978), and the first three issues of the seminal postwar avant-garde journal *Provoke*, which ran from 1968 to 1969, in which Moriyama played a major role.

One section of the retrospective consisted entirely of images from *A Hunter*, which reflects Moriyama's affinity with Frank most insistently. Moriyama dedicated his book to Jack Kerouac, and emulated Kerouac's quick, spontaneous style in both his shooting (on the move in cars and on the run, with no-viewfinder grab shots) and editing (one image after another, bleed to bleed, through the gutter, in one continuous line). The images are all done in a gritty, high-contrast-and-grain style, and the subject is the darkened soul of

an increasingly Americanized postwar Japan. One pair of photographs from 1969 shows cans of Campbell's soup (Andy Warhol was a treasured influence) and Green Giant cream-style corn arrayed on supermarket shelves like troops in formation, massing for an attack. The Warhol effect is clearly evident in the images Moriyama lifted from pop culture, from Brigitte Bardot on a bike and the death scene from Arthur Penn's 1967 film *Bonnie and Clyde* to professional midget wrestling on TV and a police safety poster showing a rear-end collision.

Like most of his generation in Japan, Moriyama was both fascinated and repelled by the sleazy culture that sprang up around U.S. military bases in his country, and he photographed its prostitutes, strippers, bikers, and soldiers with a jaundiced and unblinking eye. During this time, Moriyama was a stalk-and-ambush hunter, active mostly at night. (When he came to New York in 1971, he stayed at the Chelsea Hotel and spent days at the Museum of Modern Art going over the Weegee photographs.) Eschewing the sharp-focus, authoritative view for the furtive, peripheral gaze, Moriyama used his camera to steal glances, as if to linger would be dangerous, perhaps even fatal.

The Japan Society exhibition consisted of 130 images from the 1960s through the 1990s, with several images selected from each of Moriyama's major series. Although superficial stylistic alterations occur, the most striking effect of the retrospective was the coherence of Moriyama's vision, wherein the brutality and callousness of human society is chronicled with a dogged determination and a concomitant interrogation of the very terms of communication. In the photographs from *Bye, Bye Photography, Dear*, Moriyama pushed this movement to the point of incomprehensibility and exhaustion. This book was his *A Season in Hell*, and he almost didn't survive it. Moriyama's alienation drove him to seek a level of anonymity in his photography, as if the images were making themselves or were being made by a man who'd become a machine. The most recent work in the Japan Society exhibition was a room-size installation of 3,400 small Polaroid photographs placed edge to edge like tiles in a huge grid, in which Moriyama's studio and living quarters in Tokyo are recorded with an obsessive, mechanical precision.

Moriyama was seven years old when the United States dropped atomic bombs on Hiroshima and Nagasaki, so he grew up under the weight of that defeat and devastation, and of the subsequent Americanization of Japan. In Robert Frank's best-known work, he saw the Americans as no one else had before. I have the sense that Moriyama did that for the Japanese, and I can't imagine that they were any more pleased with the revelation, initially. Now he is a treasured elder, recognized as the crucial link between the older masters Shomei Tomatsu and Eikoh Hosoe and younger photographers like Miyako Ishiuchi and Nobuyoshi Araki. The hard truths revealed in his images are less threatening now, subsumed in art.

On Helen Levitt

Helen Levitt may well have been the most respected and celebrated unknown photographer of her time. She had her first solo show at the Museum of Modern Art in 1943, before she turned thirty, and by the time of *Crosstown*, her 1997 exhibition at the International Center of Photography, she was recognized as a modern master (the show marked Levitt's winning of that year's ICP Infinity Award for Master in Photography). Still, much of the contemporary viewing public continued to either undervalue her work or take it for granted. Even those who claimed to know the photographs well would admit they hadn't looked at them closely for years.

Levitt was blessed early on with mentors and friends—James Agee, Henri Cartier-Bresson, Walker Evans, Janice Loeb—who took the time to see what she was doing and were articulate in their responses. A number of critics have written well on Levitt's work, but still it remains clouded by misapprehensions. Part of this is due to the way her images have often been contextualized, under the terms of institutional art photography, as a kind of sentimental realism. Over the years they acquired a vaguely humanistic, *Family of Man* patina, and were presented as nostalgic chronicles of street life in old Harlem and charming images of children at play. Her 1943 show at MoMA, titled *Photographs of Children: Helen Levitt*, was inhospitably paired with *Eliot Porter: Birds in Color*. It appears that this sort of institutional pigeonholing acted as a kind of protective coloring for a rare and exceptionally private artist. And the photographs incorporate their own naturalistic camouflage. At first encounter, they appear to be as stylistically innocent and guileless as their young subjects are reputed to be. It is only with prolonged and repeated viewing that these images open up to reveal their complexity and depth.

Levitt's oeuvre deserved another look, and the *Crosstown* show made it possible. ICP curator Ellen Handy worked closely with the artist to provide a fresh approach to the photographs, achieved with a great economy of means: no narrative titles, no didactic labels, only the skillful juxtaposition of images. The four galleries grouped photographs loosely by themes, but it was the variations that predominated. The playful sequencing revealed hidden connections among the pictures and delineated their intricate subtleties. By freely mixing black-and-white images from the 1930s and '40s with more recent ones in both black and white and color (and the astonishing film *In the Street*, made by Levitt, Agee, and Loeb in 1945–46, admired by Charlie Chaplin, and ranked by Stan Brakhage as one of

the greatest films ever made), *Crosstown* emphasized the continuity of Levitt's work over the course of sixty years. In this way it provided a useful corrective to the 1991 retrospective organized by the San Francisco Museum of Modern Art, which tended to separate earlier and later and black-and-white and color images, resulting in a misleading bifurcation.

The first photograph in *Crosstown* was the last one in *A Way of Seeing*, the book that Levitt made with Agee in the 1940s (though it was not published until 1965). A little girl walks barefoot out of the street toward a woman on a stoop. Behind and above the girl, a liberated fire hydrant sprays a fog of water, wetting the street. The child is wet, too, and a bit fearful, hurrying toward the rescuing woman. The eyes of the child and the woman are shadowed and dark; all expressive clues are in their gestures. The girl walks stiffly, pigeon-toed, and holds her closed hands up in front of her for balance. Her raised arms rhyme with the woman's, raised to greet her. The wet street is a mirror—as above, so below—as well as the site of a gritty baptism.

Levitt's compositions are mostly centrifugal, so that significant details often occur at the edges of the frames. Even when there is a central figure, it is what is going on around the figure—what the subjects project out of themselves—that matters. This is why Levitt's original cropping of the early work and her later restoration of the full frames is so instructive.

Levitt's kids are not those of Larry Clark or Jim Goldberg, but neither are they all sweetness and light. They're more *acute* than cute. Innocence brings pain and fear along with delight and joy, as it continually runs up against the constraints of experience. And innocents crave experience more than anything.

Although Levitt's work never fit the given definitions of social documentary (Walker Evans's didn't either, but that's another story), anyone who claims that these photographs are not *political* is operating with a severely limited sense of that term. Over and over in these images, innocence comes into conflict with power, as kids are slapped or dressed down by imperious adults, caught in that politically constitutive moment when imagination collides with reality: the divisive moment. Justice is elusive, but passionately pursued.

Levitt's work is closest to that of Cartier-Bresson in its aspiration, and has often been compared to that of her friend Evans (hers is less monumental and less grave), but I think it also has an affinity with the work of Robert Frank—not in its particular emotional register, but in its inexhaustible recognition of the emotional tracery of photography. Photographs of people trace relationships, especially between the photographer and the ones photographed. It's what can't be faked. Levitt is often able to articulate these relationships without showing people's eyes, or even their faces—only their suspended movements and the geometry of things seen. In her 1945 image of four girls in summer strolling up Park Avenue, the girls are walking away from the camera, their faces in profile against the white stream of the street. They turn their heads in unison to the left, where five soap bubbles

arrange themselves against a stone block wall like whole notes on a staff. It is the best moment, the only possible moment, for this image. If anything in the frame were moved, it would diminish the effect.

One of the things that makes these images relevant today is that they exhibit an insistently *unspectacular* way of seeing. Levitt's street society is the society of the unspectacle, which is as much a projection as a record. As with any old photographs, there is a certain element of nostalgia. But in Levitt's case it is experienced more as homesickness—a longing for home that is not dependent on geographic displacement.

On James Nachtwey and 9/11

James Nachtwey awoke early on September 11, 2001, having flown into New York from France late the night before. It was unusual for him to be in the city at that time, when he would normally be on assignment elsewhere in the world, documenting conflicts. He took his morning coffee to the east side of his Water Street loft, and looked out across the East River to the Brooklyn Bridge. He remembers that the sky was the bluest and clearest he'd seen it in a long time, a condition pilots call "severe clear." The bridge was lit from behind, with the sun glinting off the surface of the water. Nachtwey glanced down, and noticed some people standing on an adjacent roof, looking west and pointing toward the sky. He crossed the room to the windows on the other side of the loft and saw the north tower of the World Trade Center in flames. A few minutes later, the second plane hit the south tower. Nachtwey, the greatest war photographer of our time, knew instantly that this was an act of war, that the attack came from Osama bin Laden and Al Qaeda, and that we would retaliate by sending troops into Afghanistan. He packed up his cameras, loaded all the film he had, and ran toward the burning towers.

As he had done so many times before, Nachtwey ran toward something that everyone else, except for the other first-responders, was running away from. He was going to do his job: to get to the site and document what was happening. But this time it was different. This time it was happening in his own backyard. Talking with me in his apartment ten years later, he noted the difference: "I've always gone away, and been involved in other people's tragedies and dangerous situations, and coming back to America was always a refuge," he said. "But now the war had reached us, and I think we became part of the world at that point in a way that we hadn't been before. Maybe it was a long time in coming, but it's happened now, and nothing will ever be the same."

The photographs that Nachtwey took that day, over the next twelve hours, are some of the most iconic images of 9/11: the south tower collapsing behind the cross atop the First Presbyterian Church on Fifth Avenue; ghostly figures coated in white dust emerging from the smoke; three firemen working around their leader, on his knees, bareheaded, looking back to see the flames sweeping toward them; and the twisted, otherworldly ruins of 1 World Trade Center, looking like the "set of a silent film of the apocalypse."

At 10:29 a.m., Nachtwey heard "what sounded like a waterfall in the sky," and looked up to see the north tower coming right down on top of him. "I understood then that I had about five seconds to live, and that my chances of surviving this were very slim. It was actually a very beautiful sight, with the smoke and the metal and the paper against the blue sky. It was visually stunning, one of the most beautiful things I've ever seen. But it was going to kill me, and there was no time to take a picture." He quickly scanned the area, spied the open door of a hotel across the street (the Millennium Hotel) and lunged toward it. Inside, he dove into an open elevator just as everything went black. "You couldn't see a thing. I might have been dead, except that I was suffocating, so I knew I must be alive." He called out to see if there was anyone injured around him who needed help, and then began inching forward, out of the open elevator doors, into the darkness. After a while, he saw pinpoints of light that turned out to be the blinking lights of abandoned police vehicles. "Then I knew I was outside, and I realized, well, I must not be buried under the wreckage if I'm outside." He instinctively headed north and eventually came out into the light. Then he turned around and went back to Ground Zero.

> It was beyond belief. Everything was covered in that white dust, with giant pieces of metal lying around, and the buildings crushed beneath it. There wasn't much the firemen could do, but they were still trying, searching and calling out for people. I mean it was just solid wreckage. It was so unbelievable that I guess you just had to rely on what you normally do, and just keep doing your job. And the firemen and police were there, they were doing their job, they were professional. I think they understood they'd lost a lot of their comrades, but they were holding that in pretty good.

One of the things that made 9/11 different from many of the battlefields where Nachtwey has worked for the past thirty years was that he wasn't seeing the bodies of the dead. "The absence of bodies put your heart in your throat, understanding how great the loss must be. There was no one to rescue, no one to treat. They were all underneath the wreckage, and they were all dead."

Nachtwey spent the rest of the day at Ground Zero, doing his job. He had brought twenty-eight rolls of film, and gave one precious roll away to a fellow photographer. In 2001, Nachtwey had not yet switched over to digital, so there are twenty-seven contact sheets from September 11. Fourteen of Nachtwey's images that were posted on Time.com had two million page views on that first day.

Like all the documentary photographers I know, Nachtwey has an unshakeable belief in the power of images, and that there is a real social purpose in people being able to see what happened. He said to me in 2011:

What sustains me is the overall value in communicating. People need to know and they need to understand in a human way. Photography is a language, with its own limitations and strengths, but these are my tools, so I have to try and use them well. I want my pictures to be powerful and eloquent. I want to reach people on a deep level. Because I'm presenting my images to a mass audience, I have to have faith that people care about things. People are innately generous, and if they have a channel for their generosity, they'll respond. People know when something unacceptable is going on, and they want to see it change. I think that's the basis of communication. Mass awareness is one element of change, but it has to be combined with political will.

In the case of 9/11, the fact that it was wrong and that it was an atrocity was obvious—it didn't take me to prove it. All I could do was document it to the best of my ability. I think a lot of times, my pictures can actually change people's minds, and push the process that needs to happen in a certain direction. But in this case it was going to happen with or without me. Unfortunately, the Bush administration used the emotional power of the images of 9/11, including mine, to justify and gather support for an ill-conceived invasion of Iraq, a country that had absolutely no connection to the attack on 9/11. So things get manipulated in all kinds of ways. But I really did feel the personal anger about 9/11. This was an attack on my country, my city, my neighborhood.

After we had talked for a while, Nachtwey went to his flat files and pulled out a photograph he had made thirty years before 9/11, as he was learning his craft on the streets of Lower Manhattan. It shows the first of the newly built Twin Towers, apparently shrouded in smoke, presaging the attack to come.

PLATES

Susan Meiselas, *Before the Show, Tunbridge, Vermont*, 1974, from *Carnival Strippers* (1975)

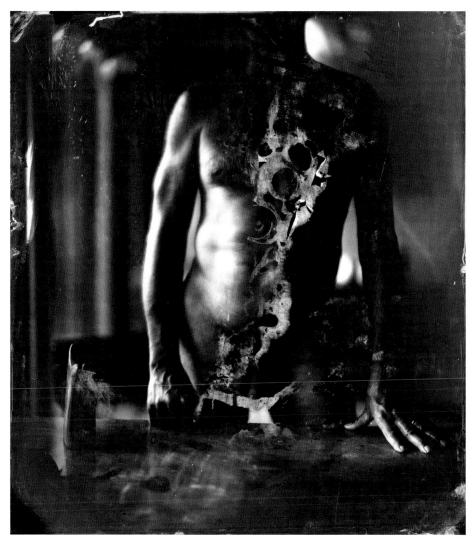

Sally Mann, *Hephaestus*, 2008

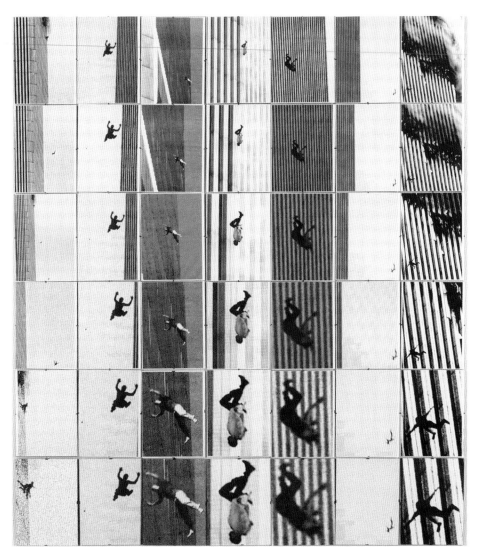

Carolee Schneemann, *Terminal Velocity*, 2001

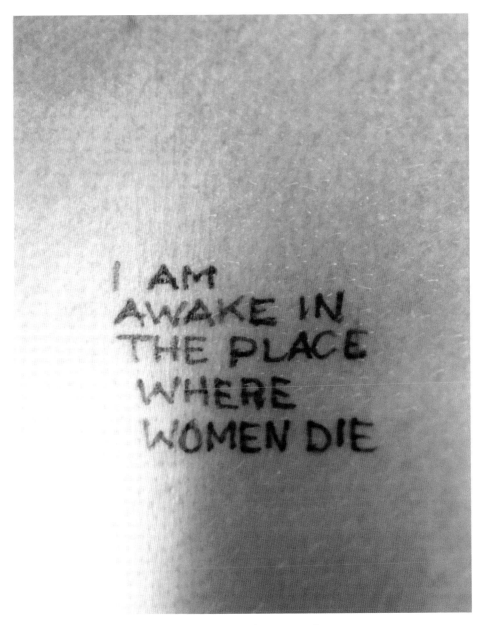

Jenny Holzer, *I am awake in the place where women die*, from *Lustmord*, 1996

Jane Hammond, *My Birth*, 2005

Frederick Sommer, *Paracelsus*, 1959

John Wood, *Eagle Pelt*, 1985

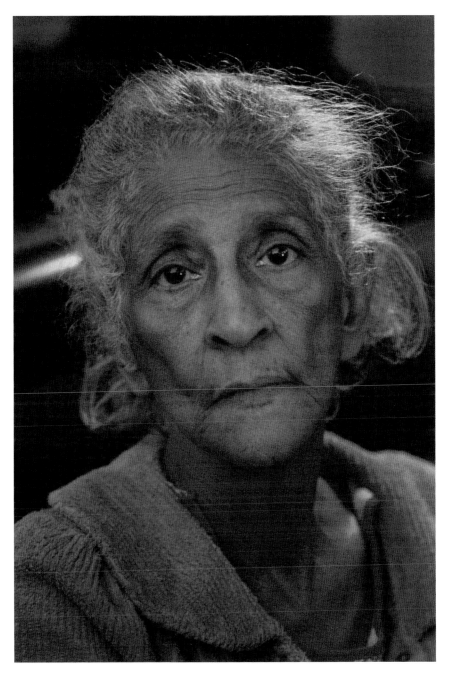

Robert Bergman, untitled, 1987

Vik Muniz, *Che (Black Bean Soup)*, 2000

Tim Davis, *Exxon 1*, 2000

Robert Heinecken, *The S.S. Copyright Project "On Photography,"* 1978 (detail; a portrait of Susan Sontag composed of scraps of writing from her book *On Photography*)

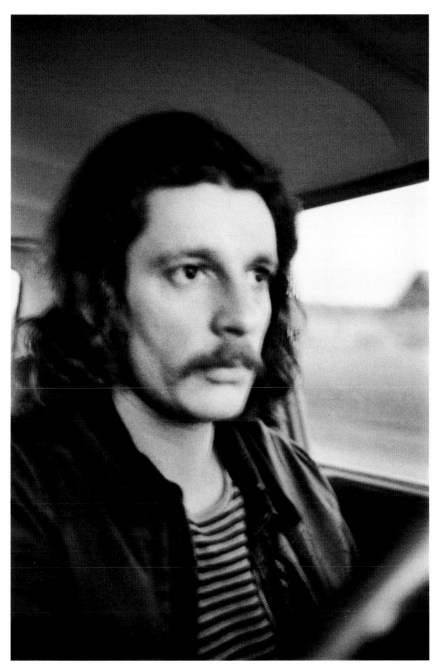

Larry Clark, *Self-Portrait*, 1971

Daido Moriyama, *Japan Theater Photo Album*, 1968

Top: *New York*, ca. 1945. Bottom: *New York*, ca. 1939. Both photographs by Helen Levitt

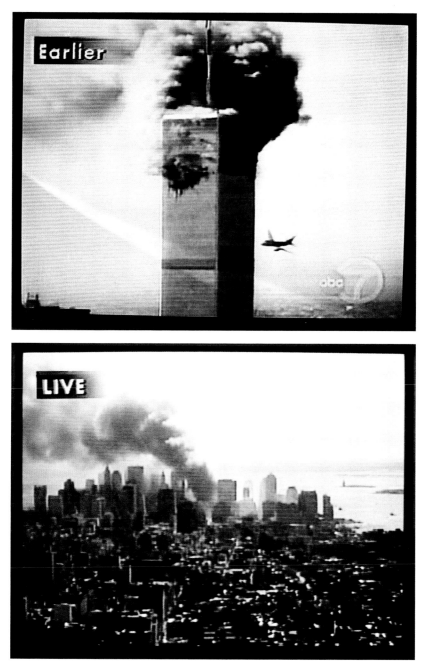

Screenshots from 9/11 taken by the author

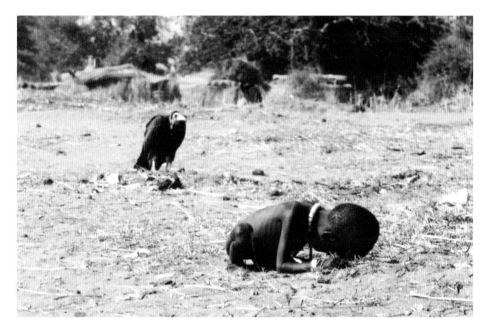

Kevin Carter, *Famine in Sudan*, 1993

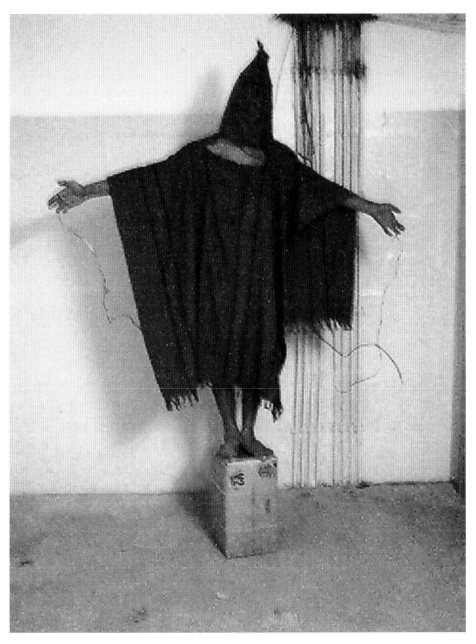

The "Man on the Box" image from Abu Ghraib, November 5, 2003

Hurrying Into the Next Panic?

By Paul Wilmott

THOMAS L. FRIEDMAN

59 Is The New 30

It's not about the ball.

Lament of the Images

By Alfredo Jaar
and David Levi Strauss

Photograph taken at Abu Ghraib prison in mid-December 2003, picturing a small number of individuals using guard dogs to intimidate naked Iraqi detainees.

Autopsy image of an Afghan prisoner who died in U.S. custody, showing rope burns on his neck and a cross cut into his scalp.

Snapshot of an unidentified U.S. soldier crouching down with one thumb raised in victory, grinning and leaning toward a blackened, decaying corpse.

MAUREEN DOWD

Sarah Grabs the Grievance Grab Bag From Hillary

A tale of two women: The cerebral and the visceral.

ONLINE: OPINION TODAY

Alfredo Jaar and David Levi Strauss, *Lament of the Images*, 2009. Mock-up proposal for *New York Times* op-ed page, which was, ultimately, not accepted for publication

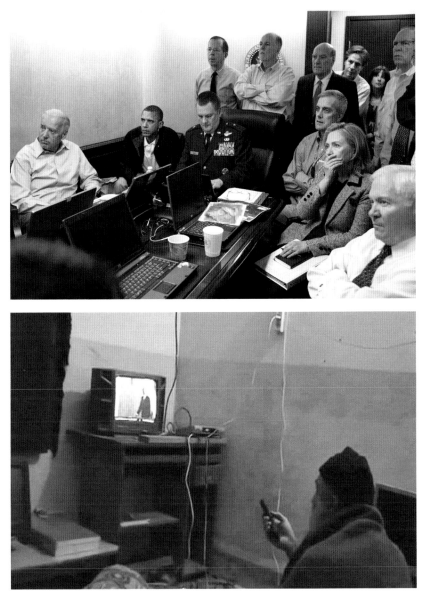

Top: President Barack Obama and Vice President Joe Biden, along with members of the national security team, receive an update on the mission against Osama bin Laden, in the White House Situation Room, Washington, D.C., May 1, 2011. Photograph by official White House photographer Pete Souza. Bottom: Still from a video released by the U.S. Department of Defense, purported to be have been captured in the raid on Osama bin Laden's compound in Abbottabad, Pakistan, showing a man, claimed to be Bin Laden, watching videos of himself on March 7, 2012

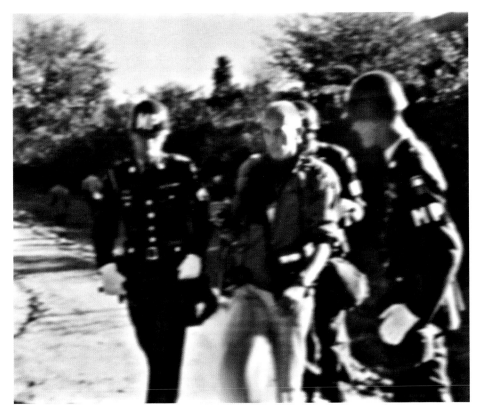

Chris Marker being arrested by military police outside the Pentagon in Arlington, Virginia, 1967.

Stan Brakhage, strip from the 16 mm film *Dog Star Man: Prelude*, 1961–64

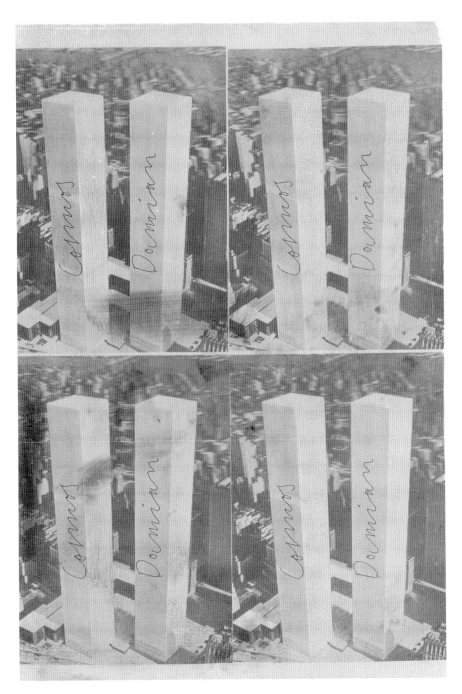

Joseph Beuys, *Cosmos and Damian Polished*, 1975. This Multiple was made by Beuys using a proof sheet of the original 3-D postcard of the Twin Towers from 1974, mounted on gray cardboard, with shoe polish added.

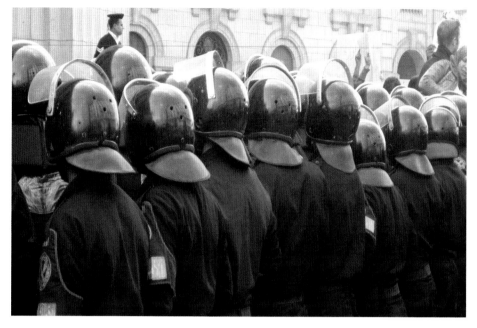

Yasmine El Rashidi, Egyptian riot police outside the main court in downtown Cairo, January 25, 2011

Image tweeted by New York Mayor Michael Bloomberg's office, along with the claim that they had saved the People's Library after the raid on Zuccotti Park, November 15, 2011

IV

Troublesomely Bound Up with Reality

On the Aestheticization-of-Suffering Critique Today

There was a time, at the end of the 1980s, when the critique of documentary photography based on the "aestheticization of suffering" was so influential that it became virtually impossible to defend documentary practice. Any such defense was regarded as at best naïve and at worst ideologically suspect.

Then came 9/11. I have argued elsewhere that the attack on the Twin Towers, the most photographed event in history, effectively reset the clock on documentary images, clearing away years of accumulated censure.[1] The affective unreality of the event cried out for representation, and most people experienced it as an image. Photography's special capacity as a medium of mourning brought us close to it again, and made us realize how much we need public, shared images to make sense of such events. Susan Sontag's book *Regarding the Pain of Others* (2003) was in part a recognition of this epochal shift, and it revised and updated her earlier views of photographic images and their social effects in *On Photography* (1977).[2]

Looking back on it now, those earlier critiques of photographic representation appear dated and overdetermined. Too many of the persistent questions about our complex relation to public images had been answered, as if for good. The trenchant critiques of documentary photography by Martha Rosler, Allan Sekula, Abigail Solomon-Godeau, and others were necessary corrections at the time to a great deal of muddled mystification about the nature of photographic representation, and about the real effects of public images. But over time these critiques became intellectually enshrined as definitive, and later writers and artists began to treat them as unassailable truths rather than as timely interventions. Students made operational assumptions ostensibly based on, but not always supported by, these texts, and the aestheticization-of-suffering critiques, especially, entered a period of academic mannerism.

Beautiful Suffering: Photography and the Traffic in Pain (2007), a companion volume to the exhibition of the same name held at the Williams College Museum of Art in 2006, is edited by Mark Reinhardt, a political scientist, and two art historians, Holly Edwards and Erina Duganne. It includes substantial essays by the three editors, as well as by John Stomberg, deputy director and senior curator at the Williams College museum, and cultural critic and theorist Mieke Bal.[3]

As its title indicates, *Beautiful Suffering* begins with the now-conventional critiques of the aestheticization of suffering in its pursuit of "alternatives to mainstream photojournalistic ways of representing suffering," with the worthy goal of fostering "a more

reflective awareness of how we represent and address the rampant suffering and the corollary spectatorships that characterize our time." "Without scenes of death, destruction, misery, and trauma," the editors write, "the contemporary image environment would be nearly unrecognizable." And they note that since September 11, 2001, "accounts of trauma have become still more crucial to the formation of the social bond and the shaping of national identity."

In his essay, "Picturing Violence: Aesthetics and the Anxiety of Critique," Reinhardt cites the aestheticization-of-suffering critiques of Rosler, Sekula, and Solomon-Godeau as definitive, but registers doubt about the sufficiency of these critiques. He calls aestheticization "an overly blunt tool for getting at what is most troubling about certain photographs of suffering people," and recognizes the anxiety about such images as "an anxiety . . . of the formal choices and rhetorical conventions, and the resulting transformative work, of representation itself."

That, in a nutshell, is what ultimately makes the aestheticization critique insufficient. Yes, there are certain inherent problems with representing the pain of others, but does that mean we should no longer attempt such representations? Reinhardt generously acknowledges my work in *Between the Eyes: Essays on Photography and Politics* (2003) as "a significant resource" for his own thinking, but takes me to task for proceeding "too swiftly" after having "established the futility of seeking to avoid the aesthetic work of transformation." I would argue that the events of the past six years have shown that the world has moved on as well. These images are not going away, and the gap between them and the effective analysis of them is growing. In a footnote, Reinhardt notes that philosopher Susan Buck-Morss pressed him on the real sources of anxiety about images of suffering, asking: "Is there not something in images that resists or eludes every effort to fix meaning through language? Might *that* be the underlying source of anxiety?"

In his "Genealogy of Orthodox Documentary," John Stomberg concludes that "the debates surrounding contemporary photographic representations of human suffering derive, almost unaltered, from . . . polarities invented in 1938" in the debates within the Frankfurt School, and also in the conflict between the documentary approaches of Margaret Bourke-White and Walker Evans. Holly Edwards focuses on the public trajectory and multiple migrations of Steve McCurry's *Afghan Girl* image that first appeared on the cover of *National Geographic* in 1985. In her essay "Photography after the Fact," Erina Duganne addresses the always-contested line between art and documentary by looking at the work of Luc Delahaye, Sally Mann, and Alfredo Jaar, and cites Rosler's brilliant critique of the tradition of "concerned photography" in her 1981 essay "In, around, and afterthoughts (on documentary photography)," in which she accuses concerned photography of embracing "the weakest possible idea of social engagement, namely compassion." This theme is taken up by Mieke Bal in her contribution as "the problem of sentimentality." Bal's "The Pain

of Images" makes the strongest case for the enduring value of the aestheticization critique, but falls back on reductive views of the aesthetic (and of photography), attacking "the indifference of aesthetics," and calling photography "the medium so troublesomely bound up with reality." Referring to James Nachtwey's 1993 image of a starving man in Sudan, she writes: "The photograph is less obviously 'art,' although also well made to an almost troubling degree," concluding that "beauty distracts, and worse, it gives pleasure—a pleasure that is parasitical on the pain of others."

This censure of beauty in the depiction of suffering is never applied to music, and seldom to literature or painting, but often to photography. This censure contends that photographs shouldn't aestheticize their subjects, because this contaminates the real with visual pleasure. It is the performance of this contamination, the making of the image, that "troublesomely" implicates us in its foul mixture, where, as Bal writes, "the questions of empathy, sympathy, or identification—of bottomless but directionless emotion as well as the seemingly opposite question of aesthetics and its required disinterestedness—are bound up with the most obvious problem of what the exhibition's subtitle pointedly calls 'the traffic in pain.'" Why is the emotion elicited by such images "bottomless" or (necessarily) "directionless"? Is there a political efficacy to empathy? To say that compassion is only the first step in responsibility to social justice is one thing; to say that it is destructive to social engagement is quite another. One needs to first feel the pain of others before one can begin to act to alleviate it. And one of the ways humans recognize the pain of others is by seeing it, in images. This emotional attachment to images is unstable and can be manipulated, certainly, but that doesn't mean it should be disproportionately censured. Doing so moves us from the distrust of images to the fear of images, and ultimately to a counterproductive iconoclasm.

The 2007 book *No Caption Needed: Iconic Photographs, Public Culture, and Liberal Democracy* approaches this question of the social effects of public images very differently.[4] The authors, Robert Hariman and John Louis Lucaites, who come from the field of rhetoric (which they call "both a practical art and a theory of public address"), are remarkably free of the basic assumptions of the aestheticization-of-suffering discourse. They announce early on that they "take aesthetics seriously," that they consider photojournalism to be "a patently artistic form of public address," and that "the zenith of photojournalistic achievement is the iconic photograph." Challenging "the presumption that visual media categorically degrade public rationality," they approach photojournalism as "an important technology of liberal-democratic citizenship."

Taking iconic press images seriously aesthetically and politically, they proceed to examine a number of examples, including *Migrant Mother* (1936), by Dorothea Lange; *Explosion of the Hindenburg* (1936), by Sam Shere, with *Explosion of the Challenger* (1968), by NASA; *Raising the Flag on Mount Suribachi* (1945), by Joe Rosenthal, with *Three Fire Fighters Raising the American Flag at Ground Zero* (2001), by Thomas Franklin;

Times Square Kiss (1945), by Alfred Eisenstaedt; *Kent State Massacre* (1970), by John Filo; *Accidental Napalm* (1972), by Nick Ut; and *Tiananmen Square* (1989), by Stuart Franklin. Their close readings of these iconic images employ multiple strategies and tools to investigate how these images create "a public culture that lies somewhere between hegemony and resistance." Avoiding previous approaches that "produce social theory at the expense of what the images are actually doing," they look hard at the images themselves and at the way such images are used, appropriated, parodied, and celebrated.

Hariman and Lucaites recognize that talking appreciatively about icons causes "many in the academic audience to conclude we have a naïve understanding of representation," but they contend it is time for a fresh approach in a new era. "The beginning of the twenty-first century," they write, "has been a renaissance for photojournalism, one driven by events (principally 9/11) and, more significantly, by the addition of digital media." They recognize that "the study of various practices of visual representation is booming," and that this study draws on methods previously underutilized.

Their approach, though grounded in a theory of public address, is primarily practical: "We are dedicated to the critical study of public discourse and public arts on the assumption that they are crucial to the success of democracy." They want to understand "how public address fulfills the interrelated functions of constructing public identity and motivating political behavior."

Could it be that what were necessary and substantive critiques of representation in the past have become, in practical terms, hindrances to actually looking at images? And that this has contributed to an effective political passivity in the face of a rapidly changing communications environment? Hariman and Lucaites rightly point to "the larger problem identified by Peter Sloterdijk . . . that modernity has entered into a terminal phase of 'enlightened self-consciousness' whereby all forms of power have been unmasked *with no change in behavior* [emphasis added]. Irony is too widely dispersed throughout modern consciousness, subjectivity too fragmented, the administration of power too cynical, and critique too disposed to reification for unmasking to be other than a reproduction of the world it would change."

Rather than seeking to unmask "the traffic in pain," Hariman and Lucaites address public life as "a trafficking in attitudes," and they follow literary critic and theorist Kenneth Burke in defining attitudes as *incipient actions*. "Decisive action," they write, "actually is rather rare in stable societies and everyday life, but all of life is in fact defined by one's potential for action." The formation of attitudes through the propagation of words and images is a large part of life in a functioning democracy, and we devalue it at our peril. To Hariman and Lucaites, the stakes in this struggle involve the shift "from democratic to liberal norms of representation," that is, "from democracy and the *public* demands of collectivity to liberalism and the *private* needs of the individual." One of the things iconic public images do is provide a way for us to negotiate collective needs and desires.

The authors' approach is eclectic: "Both traditional conceptions of persuasive appeal and modern methods of ideology critique are needed to explicate the icon, while neither approach alone will capture how collective identity is negotiated aesthetically." In relation to the iconic photograph of the Kent State massacre in 1970, Hariman and Lucaites point to the "general suspicion or suppression of emotional display" in political life in the United States, which is part of a larger derogation of "the role of affect in the public sphere." This derogation perpetuates the shift from democracy to liberalism "by presenting emotions as if they were individual properties," exclusively. Public emotion, they say, operates enthymematically; that is, certain premises are left out, because they are taken up and completed collectively. Hariman and Lucaites go a long way toward explicating a defense of empathy as necessary to collective action. "Citizenship," they say, "is transferable from one body to the other, not by legal entitlement or any contractual relationship, but through acts of empathy, affectional identification, and emotional expression on behalf of the other."

All of which takes time. It requires slowing things down. "'Democracy, consultation, the basis of politics, requires time,'" they write, quoting French cultural theorist Paul Virilio, "while the fundamental dynamic of modern society is the *acceleration* of all modes of exchange." Hariman and Lucaites also point to a related paradox in our current communications environment: "The icon organizes public memory around a very few signal events as the exponential increases in information availability overwhelm individual processing capacity. A few dominant images can reflect either a scarcity of images or the reverse: an overabundance that has to be ignored if one is to function at all."

So, as the number of images and the speed of their transmission increase, fewer and fewer iconic images will become increasingly dominant, while the multitude of images disappears into inaccessible storage (like Bill Gates's Corbis archive secreted away in Iron Mountain). And this could lead to a very big problem: "Should public commemoration become fixated on too few images, memory calcifies around these few events while great swaths of experience are lost. Historians always will have access to other media, but the ordinary citizen living in media space is left with the equivalent of an aboriginal calendar."

And, as William S. Burroughs taught us, the most effective systems of social control in history have been calendrical. Hariman and Lucaites put it this way: "By limiting the record to icons marking major events, and by the formulaic use of the icons over time, tribal memory becomes reduced to oral narratives that increasingly follow the cues on the visual artifact. The same is happening in public memory."

The challenges of public memory and public agency are rapidly increasing as the technologies of communication change at an accelerating rate, and our ability to respond, to keep up, will depend on our willingness to find new ways of analyzing and understanding image flows. The paradox is that some of these ways are ancient, as well as nascent.

NOTES

1. David Levi Strauss, "The Highest Degree of Illusion," in *Between the Eyes: Essays on Photography and Politics* (New York: Aperture, 2003), pp. 182–85.

2. Susan Sontag, *Regarding the Pain of Others* (New York: Farrar, Straus and Giroux, 2003), and *On Photography* (New York: Farrar, Straus and Giroux, 1977).

3. Mark Reinhardt, Holly Edwards, and Erina Duganne, eds., *Beautiful Suffering: Photography and the Traffic in Pain* (Chicago: University of Chicago Press and Williams College Museum of Art, 2007). The citations in the following paragraphs all derive from this volume.

4. Robert Hariman and John Louis Lucaites, *No Caption Needed: Iconic Photographs, Public Culture, and Liberal Democracy* (Chicago and London: University of Chicago Press, 2007). The following citations all derive from this volume.

The Shutters Come Down
On the Death of Kevin Carter

When it comes to political violence, we want witnesses and demand sacrifice, and sometimes the two come together. Every day, professional witnesses get into position to show us what is happening far away and out of sight. We want to see the broken bodies and sorrowful faces of those who do not have our privileges or protections. We want to be connected to these unfortunates through images. Why? Because we feel responsible to them, and we like feeling responsible *for* them. Their suffering gives a context for our comforts, and a distant focus for our empathy.

The rules for this exchange are remarkably inflexible. We want those who take on the work of witnessing to show us things in the right order and in a certain light, within strict rules of propriety. It is permissible to tease the edges of these proprieties—in fact, we reward such flirtations with prizes—but not to be too insistent about it. An excess of truth can be a dangerous thing. Or, as T. S. Eliot had it in a poem about redemption: "human kind cannot bear very much reality."

South African photographer Kevin Carter was a committed witness who became a tragic sacrifice, and a scapegoat for our guilty desire for images of others' suffering.

Kevin Carter was born in 1960, the year Nelson Mandela's African National Congress was banned, and came of age as a professional witness in the years leading up to the new South Africa. When political violence of the most brutal kind erupted in the black townships after the release of Mandela from prison in 1990 (and the lifting of the ban on the ANC), Carter and his photojournalist comrades in what came to be called the "Bang-Bang Club" (Greg Marinovich, João Silva, and Ken Oosterbroek) photographed the daily carnage as the dying apartheid government used sectarian tensions between the ANC and the Zulu-backed Inkatha Freedom Party as cover for political murder and destabilizing mayhem.[1]

These photographers witnessed unspeakable things, day in and day out, during this time. They photographed black South Africans being beaten, tortured, hacked to death, and burned alive in Soweto and Thokoza. The worldwide market for such images was booming, and the members of the Bang-Bang Club became famous. Witnessing these things through the camera lens—being a witness to history—was a rush, but it took a toll. The photographers bonded together, but felt themselves drawing away from the rest of society, and suffering various psychological maladies. Kevin Carter was especially

tortured by what he saw, and by the moral ambiguities of his witness role. In an article on covering conflict, he wrote: "I suffer depression from what I see and experience nightmares. I feel alienated from 'normal' people, including my family. . . . The shutters come down and I recede into a dark place with dark images of blood and death in godforsaken dusty places."[2] One recurrent nightmare had him near death, crucified to a wooden beam, while a television camera with a monstrously large lens zoomed in on his face, closer and closer till he awoke screaming.

Because of their newfound notoriety, the members of the Bang-Bang Club began to garner assignments to cover conflicts and suffering elsewhere. In 1993, Carter went to Sudan, where thousands of people were starving to death while a civil war raged on.

In South Africa, Carter had photographed the perpetrators and victims of violence. There were certainly perpetrators and victims in Sudan, but Carter could not get into position to photograph them. What he did happen to find was another kind of image: an image of a vulture appearing to stalk a starving child. The vulture appeared to be waiting for the child to expire and become carrion, to become food. This is a very different kind of violence than the killings Carter had been photographing in South Africa. This is the inexorable violence of the food chain. The problem with this image was that it was difficult for viewers to find, within the image, someone to blame.

The people who reacted so strongly against this image did so not because they objected to the depiction of natural violence more than that of political violence, but because of its symbolism. Though they struck out at the photographer, accusing him of being no better than a vulture, waiting to make this image while a child died, I believe the real reason for their outrage lies elsewhere. I believe they read this image, unconsciously, as a commentary on their own position in relation to the starving child. They thought that *they* were being called vultures, in their hunger for images like this—carrion-eaters feeding off of the misfortunes of others, as consumers of images of violence and pestilence. And, even further, that perhaps this Sudanese child was dying there in the dirt so that we might consume her *image*.

This was too much reality for some viewers to bear. So they reacted in the normal human way: they blamed someone else. We want witnesses, but we demand sacrifice. Someone had to pay for this impropriety. Kevin Carter paid. He killed himself, at age thirty-three, on July 27, 1994, only two months after Mandela was sworn in as president of the new South Africa that Carter had spent his whole life imagining.

Blaming the photographer who makes these images is like blaming a soldier for what's going on in a war. The photographer and the soldier are our representatives, our surrogates. We put them in position to do our bidding. The troops didn't start the war and they don't decide how it is prosecuted. Photojournalists take the kind of pictures that they know they can sell to the news organizations, who sell them to us. Kevin Carter wouldn't

have gone to Sudan on his own. We put him there. We put him in front of that starving child, and then accused him of *moral detachment* for making the image we wanted him to make. Where is our moral engagement in this? Where is our complicity? And where is our forgiveness?

NOTES

1. Greg Marinovich and João Silva, *The Bang-Bang Club: Snapshots from a Hidden War* (New York: Basic Books, 2000). The book was adapted for a 2010 feature film, *The Bang-Bang Club*, directed by Steven Silver.

2. Ibid., p. 53.

Inconvenient Evidence

On the Images from Abu Ghraib

The photographs from Iraq's Abu Ghraib prison first appeared in public on the television news program 60 Minutes II on April 28, 2004, and then in Seymour Hersh's article in the New Yorker, posted online April 30, and published in the May 10 issue of the magazine. I immediately began to study the images, and gave my first slide lecture on them at the Los Angeles Times Media Center on June 17, 2004. In October of that year, I gave the lecture for the Human Rights Project at Bard College, and in November, as part of a panel discussion with Seymour Hersh and Luc Sante at the Cooper Union in New York. Over the next six years, I gave a version of the following lecture, accompanied by over a hundred images, twenty-five times, around the United States and in Europe. One of the most extreme reactions to the lecture occurred in Santiago, Chile, as part of an event organized by Alfredo Jaar in 2006. Most Chileans had not yet seen the images, and were stunned to see that the United States had, in fact, engaged in torture.

For anyone who is fascinated by images and their social and political effects, these are heady times. From 9/11 on, visual images have had a tremendous influence on public perceptions and have often appeared to be the principal drivers of public opinion. Historians will say that this has been happening for a while, but I would argue that the degree of this effect (in proportion to all other factors) has increased significantly since 9/11, and this makes it more important than ever to try to understand how it works. The only way I've found to do that is to try to slow the machinery down long enough to get a good look at its moving parts.

When I first saw the Abu Ghraib images, I didn't quite know what I was looking at. I didn't recognize them, because I'd never seen anything quite like them. One of the first people I discussed the images with was the painter Leon Golub. I asked him why the "detainees" were hooded. If the aim was humiliation and blackmail—which is what some claimed: that these photographs would be used to convince other prisoners to talk, under threat of receiving the same treatment—it seemed like it would be better to be able to show their faces and identify them. And if they were strictly "trophy" images, for bragging rights back home, then why not show the terrified faces of your victims? Golub explained that these were torture images, and that the techniques pictured—hooding, forced nakedness, sexual humiliation, stress positions, dogs, and so on—were all common torture techniques,

right out of the book. "Walling up" with hoods or blindfolds increases the sense of isolation and defenselessness. Essential to torture is the sense that your interrogators control everything: food, clothing, dignity, light, even life itself. Everything is designed to make it clear that you are at the mercy of those whose job it is not to have any mercy. Hooding victims dehumanizes them, making them anonymous and thinglike. They become *just bodies*. You can do anything you want to them.

One of the things that really drove home what Leon was telling me was a report published in the *New York Times* soon after the Abu Ghraib images first appeared on *60 Minutes II* and in the *New Yorker*. Nina Bernstein's "Once Tortured, Now Tormented by Photos" (*New York Times*, May 15, 2004) reported on the immediate effects of these images on some of the four hundred thousand survivors of torture who have sought asylum in the United States. More than a hundred thousand of them live in the New York area. When they saw the Abu Ghraib images, it was like flipping a switch. It awoke all the old traumas and also ignited a new fear for their own safety in America. These are people who came to the United States for refuge from torture, so to see the American government *engaged* in torture shook them to the core.

None of this was new to Leon Golub. He had been looking at, thinking about, and transforming this kind of material in his paintings for many years. Between 1979 and 1985, Golub depicted the use of torture by repressive Central and South American regimes backed by the U.S. government, and by mercenaries helping them to interrogate subjects. Over the years, Leon assembled an extensive archive of photographic images of interrogations and torture from around the world, to use as sources for his paintings.

Just before the Abu Ghraib images were published, a series of images from Fallujah appeared, showing four "private security contractors" being ambushed, burned, mutilated, and hung from a bridge over the Euphrates as carrion. The images from this gruesome reenactment of Goya's Disasters of War were circulating on the Internet within three hours of the acts, and their appearance the next day on the front pages of many U.S. newspapers and in the lead stories of most television news shows had a chilling effect. They recalled the images from Mogadishu in 1993, of a dead U.S. soldier's body being desecrated, which hastened the U.S. withdrawal from Somalia and prompted Osama bin Laden's reputed assertion that the American public cannot stomach this kind of imagery, making America a "weak horse." Surely the thugs on the streets of Fallujah had this in mind on March 31, 2004. They were enraged, but they were also clearly performing for the cameras, just as Ahmed Chalabi's men had done a year earlier, when they toppled Saddam's statue in Baghdad's Firdos Square and symbolically mutilated it and dragged it through the streets. The media-consciousness of the Fallujah gang was apparent in their faces, and in the pre-printed signs they displayed, reading in Arabic: "Fallujah—the graveyard of Americans."

One of the reasons these ghastly images had such an effect in the United States was that they broke the embargo that the George W. Bush administration, with the cooperation of

the major American news media, were enforcing on images that showed the daily carnage in Iraq, an embargo extending even to images of the coffins of dead U.S. soldiers being returned to their families. No such censorship applied to the major media seen in Iraq, which regularly showed the broken bodies of some of the hundreds of thousands of Iraqi men, women, and children killed in the war. The notion of a "clean" war, a war without carnage, is only saleable to a population that has been kept from seeing images of corpses.

But the effect of the Fallujah images was limited by Americans' ability to distance themselves from them. The *New York Post* ran the image of body parts festooning the bridge under the headline "SAVAGES," and Canada's *Globe and Mail* quoted a U.S. woman as saying: "I'm sorry, but we don't do that here. We don't jump up and down on cars to celebrate the burning of human beings." When I read that, I immediately thought of James Allen's 2000 book *Without Sanctuary: Lynching Photography in America*, examining in nauseating detail the widespread murder of African-Americans in this country not so very long ago, the mutilation of their corpses, and the gleeful celebrations of the perpetrators being photographed beside their handiwork. As the executive editor of the *New York Times* said about the Fallujah images: "The story was in the *desecration* and in the *jubilation*."

Another effect of the Fallujah images was to reveal to the American public the prominence of hired, private military contractors in the Iraqi conflict. The four men killed and mutilated by the mob in Fallujah were all former U.S. military Special Forces personnel-turned-private contractors, working under a Blackwater USA contract with the Pentagon to provide force protection and personal security for the top U.S. administrator in Iraq at the time, Paul Bremer, among others. They were armed with assault rifles and automatic pistols. The Bush administration did not include the deaths of private military contractors in its death toll for the war, and used these contractors to mask the real costs of the occupation.

Less than a month after the Fallujah images appeared, the release of a few amateur digital snapshots taken by reservist soldiers of the 320th Military Police Battalion changed everything in the image wars. These images showed American soldiers "softening up" Iraqi detainees in the Sadean cells of Saddam Hussein's Abu Ghraib prison just outside Baghdad. The first batch, broadcast on CBS-TV's *60 Minutes II* on April 28, 2004, showed a dead, battered body—packed in ice to escape detection—and the naked, hooded bodies of prisoners being tortured by grinning, gesticulating U.S. soldiers. The reality of these images was grasped immediately by all Iraqis under occupation, and then began to break on the American consciousness in successive waves of recognition and revulsion.

Unlike the British, who immediately questioned the veracity of the *Daily Mirror* images of prisoner abuse published a few days after the Abu Ghraib images (which turned out to be a rather clumsy hoax), we believed the Abu Ghraib images without question, because

they only confirmed what we already knew but didn't want to accept: that behind all the pretty talk about wanting freedom for the good people of Iraq lurked naked aggression, deep-seated cultural contempt, and the arrogant smirk of unilateralism; and the realization that we were now mired in a hellish conflict with no end in sight. The looks on the faces of those reservists, and their easy, hamming body postures, were intended to show that they, unlike the Iraqis, were not subject to the depredations of Abu Ghraib; that they were actually not there at all, but back home, mugging for the camera. The anonymous Iraqis (guilty or innocent, it hardly mattered) were demonstrably *there*, and were ridiculous for being there. Stripped and hooded, they'd become impotent and weak. Let's stack them up like cheerleaders. Let's make them jack off in front of American women and make it look like they're giving each other head.

The most striking thing about the images from Abu Ghraib, and what marks them as unmistakably American, is that peculiar mixture of cold-blooded brutality and adolescent frivolity; of hazing or fooling around, and actual deadly torture—reality and fantasy conjoined. So you have the U.S. reservists Charles Graner and Lynndie England, posing and grinning for the camera as if they're frolicking at Disneyland, and in the same picture you have the corpse of a prisoner who's been tortured to death. Most Americans didn't know what they were looking at when they first saw the images, because they'd never seen torture images before, and the incongruity of the actions of the U.S. soldiers was confusing. The soldiers in the pictures wanted to show their friends and family back home that they were not affected by the ghastly acts they performed in Iraq; that they were not *above* these actions, but *below* them, just like their Commander-in-Chief George W. Bush, whose aw-shucks obliviousness to the grave consequences of his policy decisions was oddly reassuring to some Americans. *What we don't know can't hurt us. We're not responsible. They just hate us because we're free. Shit happens. And besides, it's God's will.*

The Fallujah images arose from a public explosion of rage that was performed for and recorded by professional photojournalists, but the amateur images from Abu Ghraib seemed to have erupted from deep within the American public image unconscious. They seem not to have been taken by anyone, and at the same time, by us all. As Susan Sontag's cover of the May 23, 2004, *New York Times Magazine* spelled it out, "The Photographs *Are* Us." And they put a face on the U.S. occupation of Iraq that will never be forgotten.

For an administration that had manipulated and controlled public images so skillfully during the first year of the war—from Saving Private Lynch to the Falling Saddam to the Top Gun speech to Saddam's capture—President Bush's closest advisors were blindsided by the effects of the Abu Ghraib images. Principal Bush political strategist Karl Rove suggested that the consequences of these images were so great that it would take decades for the United States to recover from them. Secretary of Defense Donald Rumsfeld's frustration was palpable as he testified before Congress: "We're functioning with peacetime

constraints, with legal requirements, in a wartime situation in the Information Age, where people are running around with digital cameras and taking these unbelievable photographs and then passing them off, against the law, to the media, to our surprise." That is, we don't have a problem with how we are prosecuting this war, we have a problem with controlling images of the war. Paul Virilio's "Big Optics" (if you can *see* the entire battlefield, you've already won the battle) had gone public, and that created a tremendous problem for the Pentagon. With the ubiquity of small, cheap, digital cameras, this problem is probably now insoluble. What was once a tremendous military advantage has now become a political catastrophe. Conservative commentator David Brooks asked: "How are we going to wage war anymore, with everyone watching?" Could this be the apotheosis of Total Surveillance, the saving grace of the Pandaemonium?

As I said before, the Abu Ghraib images seemed to have welled up from the American public image unconscious. But why did these images have such an immediate and profound effect? Why were they so immediately legible?

Looking at the faces of those U.S. soldiers, I tried to find some comparable images, and the documentarian Eric Gottesman found a collection of images online that is certainly relevant. These images show revelers at "blackface parties" held at fraternity houses in Southern colleges and universities recently. All these images ignited public-relations firestorms only after they were discovered on the Internet. These images come from Auburn University, the University of Virginia, the University of Tennessee, Oklahoma State University, and the University of Mississippi, where an image of a man in blackface and straw hat kneeling on the floor picking cotton while a guard holds a gun to his head came out of the Alpha Tau Omega fraternity, which bills itself as "America's leadership development fraternity." The first fraternity founded after the Civil War, ATO's mission was "to heal the wounds created by the devastating war and help reunite the North and South."

Another direct reference for the Abu Ghraib images is do-it-yourself Internet porn. A very high percentage of all traffic on the Internet is related to pornography. It's the sticky Web of Onan. And when members of Congress went into that dark, sweaty little room to view the whole cache of 1,800 images from Abu Ghraib (most of which *we* haven't yet seen, and probably never will see), they said the torture images were all interspersed with pornographic images of the U.S. soldiers themselves. So this is certainly a big part of what was going on there. Rush Limbaugh called it "standard good old American pornography" (with a little Orientalism thrown in for spice). Just a few good ol' boys and girls behaving badly.

Bush and Rumsfeld refused to call what happened at Abu Ghraib "torture," because torture is what *other* states do, not the United States. If we're doing it, it must not be torture. Just as the tens of thousands of mercenaries who were employed in Iraq must not

have been mercenaries, but "private military contractors," and setting up a satellite government to take the heat off the U.S. occupation was "turning over sovereignty" to Iraqis. After Mogadishu, what we all saw happening in Rwanda in 1994 was not "genocide," because we would have had to *do* something about genocide. This torturing (twisting) of language has become very effective of late, and has mostly managed to deflect language coming through to counter it. Image rhetorics have also been employed with great facility and effectiveness. So why and how did the Abu Ghraib images threaten this hegemony?

Like the earlier images of the Falling Saddam, these images draw on old image rhetorics, striking similar chords. But unlike those planned images, the Abu Ghraib images were *unconsciously* made, and this gave them a special power to operate in the world of phantasms. Again, these images seemed to have welled up out of our own unconscious, showing us what we knew, but didn't know that we knew.

The iconography of the hooded-figure-on-a-box image is especially, rampantly polysemous. It was legible to us because we immediately, unconsciously, recognized its symbolism. The pointed hat or hood carries the sense of derision and ridicule, as in the dunce cap, and also of judgment and punishment—the interrogators of the Spanish Inquisition wore pointed hats, as do Ku Klux Klan knights. The dunce cap was invented (by medieval theologian John Duns Scotus) as a device to aid cogitation, to "focus the mind," and the actions at Abu Ghraib were ostensibly designed to extract intelligence. So both intelligence (or the lack thereof) and the menace of agency are evoked here. The pointed hood or hat is an ancient symbol and shamanic trope eliciting fear and respect that has inspired numerous artists, from Hugo Ball at the Cabaret Voltaire to Alfred Jarry's *Ubu Roi* to Joseph Beuys in his *Coyote* action to Joel-Peter Witkin's early Anonymous Atrocities series.

On another level, to hood or shroud the head is a feminizing or emasculating gesture for Muslim men, and for Americans, the gesture of the hands held out in weakness and supplication in the Abu Ghraib figure echoes an earlier image of the victims of war: Nick Ut's 1972 image of the naked Vietnamese girl fleeing a napalm attack, with arms held out from her body like wings.

The image of the hooded figure on a box quickly became an icon around the world, *the* image of the American occupation of Iraq. There is certainly an element of initiation or hazing here (trying to get the pledges to "break"), but what are these Iraqis being initiated into? Hazing is a devolution of initiation rituals, and both hazing and torture are endemic to illegitimate power. Elaine Scarry, in her 1985 book *The Body in Pain: The Making and Unmaking of the World*, wrote: "In torture, it is in part the obsessive display of agency that permits one person's body to be translated into another person's voice, that allows real human pain to be converted into a regime's fiction of power." Torture occurs when power is uncertain and illegitimate, when a regime is unstable and weak.

Here is one possible narrative for this emblem of the occupation: *The Iraqi people are the exotic, mysterious Other, but also ridiculous figures of fun. We came to liberate them from their primitive state, to modernize and* electrify *them. But they don't understand, so we must keep them in the dark until the process is complete. We've put them up on a pedestal (the same pedestal from which we pulled down Saddam), but this pedestal is made of cardboard, and if they fall off and get modernized (electrified) too soon, they will be killed. They just don't understand. Can't they see that we've occupied them in order to make them free, and that we may have to destroy them in order to save them?*

Top military officials now say that the interrogations at Abu Ghraib yielded almost no new intelligence, that most of the prisoners tortured by the Americans at Abu Ghraib were not linked to the insurgency, and that 70 to 80 percent of the Iraqi detainees at Abu Ghraib were innocents swept up in raids. Techniques and procedures designed for "high-value terrorist targets" (in Afghanistan and Guantánamo) ended up being used on "cabdrivers, brothers-in-law, and people pulled off the streets."

Eleven soldiers were eventually convicted of various charges in relation to what happened at Abu Ghraib, including assault, indecency, dereliction of duty, conspiracy to maltreat detainees, and obstruction of justice. But no senior U.S. military or political leaders were disciplined; indeed, many of those responsible were later promoted.

A New Lament of the Images

On President Obama's Decision Not to Release More Images from Abu Ghraib

This lecture was given at the Creative Time Summit: Revolutions in Public Practice, in the Celeste Bartos Forum of the New York Public Library, on October 24, 2009.

Over the years, the artist Alfredo Jaar has become adept at making the absence of images as palpable and powerful as their presence. In August 1994 he went to Rwanda and returned with thousands of images of the aftermath of the genocide there. Over the following five years, he found many ways of evoking those images without actually showing them. In his project *Real Pictures*, first exhibited in 1995, Jaar buried sixty images from Rwanda in black linen boxes with descriptions of their contents printed in white lettering on their lids like epitaphs.

In 2002, Jaar asked me to collaborate with him on a piece for Documenta II in Kassel, Germany. For that project, *Lament of the Images*, I wrote three texts to take the place of images that, for political reasons, we were not allowed to see.

When President Barack Obama announced on May 13, 2009, that he would move to bar the release of more detainee-abuse images from Iraq and Afghanistan, Jaar asked me to collaborate on a new *Lament of the Images*, to be proposed as an op-ed piece for the *New York Times*. I wrote captions for three missing images, to stand in for the many images the president had decided we should not be allowed to see. The *Times* eventually chose not to publish our piece.

In refusing to release more than two thousand images documenting the abuse and torture of prisoners by U.S. military and intelligence personnel, thereby reversing a previous agreement the government had made with the American Civil Liberties Union to release the images on May 28, 2009, Obama used the same rationale that had been espoused by the George W. Bush administration over the previous five years to ban their release: "The publication of these photos would not add any additional benefit to our understanding of what was carried out in the past by a small number of individuals," Obama told reporters. "In fact, the most direct consequence of releasing them, I believe, would be to further inflame anti-American opinion and to put our troops in greater danger."[1]

The precedents for this argument about disclosure versus danger go back to the Pentagon Papers case of 1971, when the Nixon administration argued that the release of documents

telling the true history of the Vietnam War might increase anti-American feelings globally and somehow further endanger the lives of U.S. military personnel. The Supreme Court decided that risk was outweighed by the fundamental rights of a free people to see and evaluate evidence concerning their government's conduct for themselves. The Pentagon Papers were released, resulting in no increased harm to U.S. soldiers.

The courts in the Iraq and Afghanistan images case had heard the defense of withholding images because of national security before, and had rejected it. Judge Alvin K. Hellerstein of the United States District Court in Manhattan ruled that the public's right to know outweighed such a vague, speculative fear of danger to the U.S. military, and the U.S. Court of Appeals for the Second Circuit upheld that ruling. Amrit Singh, the attorney who argued the case before the Court of Appeals on behalf of the American Civil Liberties Union, which sued for the release of the images under the Freedom of Information Act, told the *New York Times*: "These photographs provide visual proof that prisoner abuse by U.S. personnel was not aberrational but widespread, reaching far beyond the walls of Abu Ghraib."[2]

If the actions depicted in these images were indeed "carried out by a small number of individuals" operating independently, the argument against releasing them would be more convincing. However, the preponderance of the evidence shows that these were not isolated incidents, but in fact the result of policy decisions made far up the chain of command. As Anthony D. Romero, the executive director of the ACLU, told the *New York Times*, decrying Obama's decision to ignore the court's order to release the images: "It is no longer tenable to blame abuse on a few bad apples. These were policies set at the highest level."[3] This means that these things were being done in our names, with our implicit support as participants in a democracy, and we need to know exactly what was done. A functioning democracy cannot afford to close its eyes to what is being done in its name.

We have punished some of the subordinates who carried out these despicable policies, but we now need to hold accountable those who actually formulated them (what has been called in other jurisdictions "The Torture Team": George W. Bush, Dick Cheney, Douglas Feith, Alberto Gonzales, John Yoo, David Addington, and William J. Haynes II). And the only way to do that is to view the evidence, including the images.

In an op-ed piece that the *New York Times* did publish, on May 24, 2009, Philip Gourevitch (author, with filmmaker Errol Morris, of the book *Standard Operating Procedure*, on Abu Ghraib, following the 2008 documentary film of the same name directed by Morris) supported Obama's decision to suppress the images. "Just as it was a public service to release the Abu Ghraib photographs five years ago," Gourevitch wrote, "Mr. Obama is right today to say we don't need any more of them."[4] I think this takes the wrong lesson from the Abu Ghraib images. The torture policies of the Bush administration were already available in text documents when

the first images were published in 2003, but the images brought it home in a way that written accounts cannot. Seeing is believing, and unless people see what's been done in their name, they don't believe it in the same way. Gourevitch also wrote: "Today, with all that we know about the Bush administration's torture policy, the discussion about the release of more photos is a sideshow."[5] At a time when images were increasingly driving public political life, this was an anachronism. The discussion about the release of these images was not a sideshow anymore, and President Obama, who showed in the first six months of his presidency a real understanding of the imperatives of the image, should have recognized this.

I certainly understand President Obama's reluctance to spend precious time and energy bringing people involved in the previous administration to justice, but I believe refusing to release crucial evidence in those cases is misguided. Barack Obama was elected in order to restore the rule of law and bring greater transparency into the process of governing. He, and we, cannot afford to compromise those principles at this point in our history. In any case, history shows us that iconoclasm generally doesn't work. When you try to destroy or censor images, those images *gain* power rather than losing it, and often come back to haunt their suppressors.

NOTES

1. Barack Obama, quoted in Jeff Zeleny and Thom Shanker, "Obama Moves to Bar Release of Detainee Abuse Photos," *New York Times*, May 14, 2009.

2. Amrit Singh, quoted in David Stout, "Pentagon to Release Detainee Photos," *New York Times*, April 25, 2009.

3. Anthony D. Romero, quoted in Zeleny and Shanker, "Obama Moves to Bar Release of Detainee Abuse Photos."

4. Philip Gourevitch, "The Abu Ghraib We Cannot See," *New York Times*, May 24, 2009.

5. Ibid.

Over Bin Laden's Dead Body
On Withholding and Displacing Public Images

When President Barack Obama announced in May 2011 that he would not release images of the dead Osama bin Laden, this decision seemed anomalous. When a "Most Wanted" fugitive at this level of notoriety is captured or killed, it is customary to release photographs of the deceased as evidence, and these images often have tremendous propaganda value. When Saddam Hussein's sons Uday and Qusay were killed in a raid by U.S. soldiers in 2003, photographs of their bloodied corpses were widely disseminated, and when their father was eventually captured, tried, and hanged, graphic images of that also emerged.

But there are risks to such exposures, since these images do not always have the effects their perpetrators wish. When Che Guevara was executed by the Bolivian Army (aided and abetted by the CIA) in 1967, his mutilated corpse was proudly displayed to the world press. But the resulting postmortem photographs had the opposite effect to what was intended, eliciting widespread compassion for the slain revolutionary and revulsion toward his killers.

Osama bin Laden was no Che, but he was an extremely charismatic figure and a master of iconopolitics, who meticulously crafted and controlled his image—an image that will be around for a long time. So the handling of his image in death at the hands of the Americans had to be very carefully considered. The public desire for these photographs was so strong that fake pictures of Bin Laden's bloodied corpse appeared all over the Internet immediately following the announcement of his death.

In the current climate of image saturation, withholding images can have a powerful effect. But it can also unleash powers that may be even more difficult to control. Withheld images make way for specters. The two pictures that were put forth to counter this movement, in a sense to displace the withheld photographs of the dead Bin Laden, did so through a kind of *spectral distancing*.

On May 2, 2011, the White House released an image made by in-House photographer Pete Souza showing President Obama and some of his senior staff watching a live feed of the raid on Bin Laden's compound. Vice President Joe Biden, Secretary of State Hillary Clinton, Secretary of Defense Robert Gates, Chairman of the Joint Chiefs of Staff Mike Mullen, and others sit and stand around a table, transfixed by the images that, we know, are appearing on a screen, just off the lower-left corner of the photograph. The Commander-in-Chief sits

low on the left side of the frame, wearing an unbuttoned shirt and a tuxedo jacket, as if he's just left a party, like James Bond. Obama/Bond is in charge, as we can see from his specular position. He is watching, so he is in command and control. And we are watching him watching, as per our new democratic function. This photograph quickly became the most-viewed image ever on Flickr.

A few days later the government released five videos found in Bin Laden's compound during the raid. All went viral immediately, but the one that had the most effect showed an aged, graying Bin Laden watching images of himself on a small monitor. The most dangerous man in the world sits on the floor, wrapped in a brown blanket and wearing a wool cap, clutching a remote and rocking forward and back as if in an autistic/narcissistic trance.

Both of these images, promulgated in the absence of pictures of the dead Bin Laden, arose from the recognition by U.S. authorities that what was important about Osama bin Laden was not his physical body, but his image. Death images are displaced by spectral images. He is shown in the video fawning over his own image like a washed-up performer—a sad, lonely, self-obsessed figure. Obama is shown watching him die—solemnly and firmly. Osama is subject to the image, while Obama controls the image. The orchestration of the displacement, in iconopolitical terms, was masterful. But it was also the continuation of a much larger effort to obscure the real substance of war—the injury, torture, and death of human bodies—by withholding images of carnage.

I suspect that there may be more revelations to come about what actually happened in that Abbottabad compound, but the current lack of documentary images, and the plethora of fictional ones that arose to replace them—such as the 2012 "docudrama" *Zero Dark Thirty*, "based on first-hand accounts of actual events"—should be a signal that we have not yet seen all there is to see.

Some images can be withheld and controlled and some cannot, as they seem to well up and materialize from out of our collective unconscious. In the current interminable rush of images, certain ones stick with us, because they make our unconscious desires and fears physically visible. We recognize them because we have already seen them in our mind's eye.

v

The Endless Structure of Recollection
On Chris Marker

What is memory but a certain combination of words and images? I remember Aunt Elena at the costume ball, in a feathered headdress and a dress in tiers. I remember the weary eyes of the wandering photographer in Tel Aviv. I remember the launch of the literacy campaign in Havana, the day of independence in Algeria, and a boy and girl, smiling, radiant in a shaft of light, before a phalanx of riot police in Paris in May 1968. I remember a stewardess dancing with her hands in Saigon, a boxer KO'ed in Bangkok, and Gorky's statue under wraps in Novodevichy Cemetery. I remember Checkpoint Charlie. I remember a row of trees saying no. I remember Uncle Anton's abrupt disappearance from the photographs, followed by an image of three severed, mustachioed heads, arranged like a gruesome Mount Rushmore on a low table, and then the plea: "Don't ask me anything more."

> It's banal to say that memory misleads, and more intriguing to see its lies as a form of natural protection that one can govern and shape at will. Sometimes that's called art.

> —from Chris Marker's notes to *Immemory*, 1997[1]

I remember that Christian François Bouche-Villeneuve was born near Paris in 1921, and that in 1962 he made a film consisting entirely of still photographs (with one moving exception). *La Jetée* is a parable about memory, images, and time, that begins: "This is a story of a man, marked by an image from his childhood." But it is really the story of a man who breaks the code governing the bond between images and time, and pays for it with his life.

Thirty-five years and many films and books later, filmmaker, photographer, writer, and traveler Chris Marker, whom Susan Sontag called "one of cinema's all time greats— the most important reflective or non-narrative filmmaker after Dziga Vertov,"[2] made a CD-ROM titled *Immemory*, which he described as "an exploration of the state of memory in our digital era."

Immemory is a collection of images and words drawn from Marker's life, arranged intuitively in order to trigger memories in the reader/viewer. There are seven "zones" in

Marker's *imago mundi*: Memory, Poetry, War, Photography, Cinema, Travel, and Museum. Using a simple navigational system, one follows branches of word and image radiating out from these zones like rhizomes. Sometimes things follow traditional narrative lines and sometimes they don't. Lines surface and dive, become entwined, and end abruptly. Often things relate through rhymes, like Hong Kong and King Kong, or Kafka and Kurosawa, or Proust and Hitchcock, where the former's petite cakes trigger the memory of the character named Madeleine, played by Kim Novak, in *Vertigo*. (Marker: "Coincidences are the pen names of grace for those who wouldn't recognize it otherwise.")

When Marker says: "I claim for the image the humility and powers of a madeleine," he means he intends to unlock the mechanism by which images trigger memories, to get beyond the narcissism of autobiography or memoir. Like Proust, Marker in *Immemory* creates a new literary form, and he does it by modeling his CD-ROM on a five-hundred-year-old technology. The Renaissance art of memory enabled individuals to collect, store, and access vast quantities of information. This pre-cybernetic art relied entirely on the powers of imagination that, it was believed, could be developed in any individual. Over time, this art of memory—a *mnemotechnics* of image placement—joined eros, magic, and alchemy among the principal phantasmic processes of the Renaissance.

The brutal suppression of these arts under the Reformation and Counter-Reformation, and their subsequent materialization, led to the recent development of memory machines (the French call them *ordinateurs*, ordering machines, and we call them *computers*, thinking machines), with parallel advances in seeing machines. Memory has moved away from imagination into mechanical capture, storage, and retrieval. This materialization of mnemotechnics has left the role of the imagination uncertain. At this point, imagination comes into play most strongly in making connections *between* things, especially between words and images.

What we now think of as memory machines should properly be called amnesia machines. The first amnesia machine was writing, and now images have joined in forgetting. Each successive storage medium (for both words and images) is less stable than the one that preceded it, so we are losing our memories at an exponential rate as we move into the future. In the age of Total Information Awareness, wherein we are able to capture and "mine" more and more particles of information, we have become less and less able to digest or act on this information. Total Information Awareness = Zero Agency.

It is very difficult to resist this movement, since it acts on the very tools we would need to combat it. As memory and agency are lost, we acquire the symptoms of amnesia and apathy. Many amnesiacs share the nagging feeling that they have done something terrible, but most of them have not. Many of them turn out to have *contemplated* doing something terrible, and the moral conflict caused them to temporarily lose their memory of themselves. Amnesia, even social amnesia, is a protective mechanism against guilt and fear. What is it that we so desperately need to forget that we acquiesce in this process?

The application of the principles of the Renaissance art of memory (drawn especially from the works of Giordano Bruno, Ramon Llull, and Marsilio Ficino) to hypermedia is long overdue, and Marker did it with characteristic grace and subtlety. He recognized that to engage the memory through skillful placement and combinations of words and images takes time, that the triggers often work only through distraction or reverie, and that "nonlinearity" is too often just a way to avoid transportation.

Marker looked for inspiration especially to the sixteenth-century Neoplatonist Franciscan Filippo Gesualdo, who fashioned an image of memory in terms of its "arborescence" (which Marker said is "pure computerese"), and to the seventeenth-century English polymath Robert Hooke, who constructed the first arithmetical machine:

> I will now construct a mechanical model and a sensible representation of Memory. I will suppose that there is a certain place or point in the Brain of Man where the Soul has its principal seat. As to the precise location of this point, I will say nothing presently and today will postulate only one thing, which is that such a place exists where all the impressions made by the senses are conveyed and lodged for contemplation, and more, that the impressions are but Movements of particles and of Bodies.

> —Robert Hooke, cited in Jacques Roubaud's 1993 *L'Invention du fils de Leoprepes*, quoted by Marker in *Immemory*

As Frances A. Yates wrote in her seminal 1966 book *The Art of Memory*: "The manipulation of images in memory must always to some extent involve the psyche as a whole."[3] There is, of course, a politics of memory, and that is the other arm of Marker's inquiry. In the current rush to forget, what exactly is being erased from history? Under a photograph from Vienna in 1910, Marker writes: "There, as in Russia at the turn of the century, Europe existed, restless and full of memory, as different from what idiotic conquerors attempted in its name as it is from the supermarket they're trying to pass off on us now." Within our current Endarkenment, *Immemory* functions as the opposite of a memorial; rather, it is an *immemorial* to what is being lost.

As the White Queen said to Alice: "It's a poor sort of memory that only works backward."[4] Marker's aim was not just to produce a nostalgia machine. Rather, he intended for his images to move into the future. This is a difficult task, since, as Marker's time-traveler in *La Jetée* observes: "The Future [is] better protected than the Past." But Marker always knew that the cinema can be a form of time travel, and, in *Immemory*, he fashioned another.

NOTES

1. Chris Marker, *Immemory* [1997] (Cambridge, Mass.: Exact Change, 2002). Unless otherwise noted, all of Marker's statements in this essay are taken from his notes to this edition of the CD-ROM.

2. Susan Sontag, blurb for *Immemory*.

3. Frances A. Yates, *The Art of Memory* (Chicago: University of Chicago Press, 1966), p. xi.

4. Lewis Carroll, *Through the Looking-Glass and What Alice Found There* (London: Macmillan, 1872), p. 95.

A Change in the Imaginary
On Images and Magic

This essay was presented as an opening paper for a conference at Princeton University, "Magic and the American Avant-Garde Cinema," March 11, 2006, organized by P. Adams Sitney and sponsored by the program in Visual Arts and the David A. Gardener '69 Magic Project. Other participants in the conference included Robert Kelly, Tom Gunning, Renata Jackson, Rani Singh, William Breeze, and Karen Beckman.

Stan Brakhage, who died in 2003, said this at age twenty-two: "This is to introduce myself. I am young and I believe in magic."[1] This was how he began a combination manifesto and letter of withdrawal from Dartmouth College in March 1955, in order to devote his life to making films. In a later statement/manifesto for a poetry reading at San Francisco State University in 1963, Robert Duncan said: "I have more of being in the magic of the language and in the dreams of poets than I have in my personal existence. . . . The Art, the Way, the threshold, then, is a Theurgy, a Magic."[2]

One of the many things Brakhage and Duncan shared was a propensity for false (and fruitful) etymologies. In a letter to the filmmaker R. Bruce Elder in 1998, toward the end of his life, Brakhage wrote: "The word 'image' has, for me (i.e., this is personal) the immediate connotation of the three wise men—the 'mages' so to speak, plus the intrusion of 'I' (that Greek pillar we each all share so personally)."[3]

Our word *magic* comes from the Old Persian, through the Greeks. The Greeks borrowed the word μᾰγεία to refer to the science and religion of the "Magians"—Zoroastrian "Wise Men" of Persia and Media (later part of Bush/Cheney's "Axis of Evil"), and the Greeks had enormous respect for their special powers, beginning with the interpretation of dreams. These magical practices were distinguished from γοητεία (necromancy) and φαρμᾰκείᾱ (the use of drugs as medicine).

The Indo-European root of the word *magic* means "to be able, to have power"—very basic, it shows up in our *may* and *might*. It is really a verb of fundamental action and agency. Through the Doric Greek, we get to *makhos*, meaning "device," and this becomes our modern *machine* and *mechanism*, like the magic lantern, or the cinematograph.

(Do you know that *cinema* is not in the O.E.D.? Resisting the Gallicism, they insist on the Greek "k" of *kinema*, "a motion," or movement, including a political movement [from

kinein, to move], and the *kinematograph*, writing motion: "A contrivance [invented by Messrs. Lumière of Paris] by which a series of instantaneous photographs taken in rapid succession can be projected on a screen with similar rapidity, so as to give a life-like reproduction of the original moving scene.")

Fundamental to magic is the law of *sympathy*, whereby things act on one another at a distance through invisible links. The manipulation of such linkages is known as *binding*. The magic in Homer's *Odyssey* has mostly to do with bonds and binding, and Giordano Bruno's fundamental text on magic is his 1591 *De vinculis in genere* ("A General Account of Bonding"). "There are three gates through which the hunter of souls ventures to bind: vision, hearing, and mind or imagination. If it happens that someone passes through all three of these gates, he binds most powerfully and ties down most tightly."[4]

In the early twentieth century Henri Hubert and Marcel Mauss advanced the most complete modern sociological theory of magic, and they concluded that, in order to be magical, an act or belief must be common to the whole of a society. Magic is essentially traditional and social—if most people in the society don't believe it, it won't work. "We held," wrote Mauss in his 1902 *Esquisse d'une théorie générale de la magie* (*A General Theory of Magic*), "that sacred things, involved in sacrifice, did not constitute a system of propagated illusions, but were social, consequently real."[5] This lays the groundwork for thinking about the relation of magic to technology and media today.

Our *image* is straight from the Latin *imago*, related through the root to *imitari*, "to imitate," so an image is an imitation, copy, likeness, statue, picture, phantom, conception, thought, idea, similitude, semblance, appearance, shadow. . . . The Greek *eidolon* survives only as a shadow of itself, as "an unsubstantial image, specter, or phantom": H. P. Lovecraft's "putrid, dripping eidolon of unwholesome revelation."[6]

The root is *eidos*, "form or shape," which goes to *eidesis*, "knowledge," and *eidetikos*, "relating to images or knowledge," which survives in the *eidetic image*. This is from art historian Gustav Hartlaub's entry on *magic* in the 1964 *Encyclopedia of World Art*:

> The magician, or magical type of man (*homo magus*), and the visionary or seer (*homo divinans*) are often eidetic types in the sense described by E. R. Jaensch, who has shown that even today, among children and among some artists, evidence of subjective visual images can be found, and that perceptions of things which have happened, or even only been imagined, can be projected as if they were optically visible. The eidetic type has a tendency to visions and hallucinations and takes his dream life for reality, often even a higher reality. This tendency is linked with an inclination toward autosuggestion or mass suggestion and hypnotic phenomena that accompany them.[7]

So we'll imagine this eidetic link between two foundlings, orphans, both Capricorns, one born in 1919 (Duncan) and one in 1933 (Brakhage), who both became "magical types" and visionaries.

I was set off in this inquiry in 1980, by Robert Duncan himself and Diane di Prima, with whom I studied in the short-lived Poetics Program at New College in San Francisco, from 1980 to 1983. Duncan conceived of poetics in its largest (and root) sense, as *the study of how things are made*, so the curriculum included the secret history of creative events. Diane di Prima taught a cycle of courses called "Hidden Religion," where I first read Giordano Bruno and Paracelsus and Marsilio Ficino, at the same time that we were reading (with Duncan) Ferdinand de Saussure, Roman Jakobson, Roland Barthes, Julia Kristeva, and Fredric Jameson.

(I should also mention here that complementing the Poetics Program in those years were Steve Anker's offerings at the San Francisco Cinematheque, where I was introduced to the films of Brakhage, Harry Smith, Kenneth Anger, Maya Deren, Larry Jordan, and many others. Steve participated in the Homer Club and other parts of the Poetics Program, and later married the poet Susan Thackrey, who was an important student in the program and a close friend of Duncan's.)

The book I want to write, *Image & Belief*, is an inquiry into how and why we believe photographic images, technical images, the way we do, and how this credulity allows us to be manipulated by images. Seeing is believing, but something changed with the invention of technical images to make us more subject to this equation. And I believe something changed again with 9/11—the most "imaged" event in history—to solidify and deepen these effects.

When I began to think and write about these things, I realized that to understand our current belief in images, I would have to look into the past, long before the invention of technical images, because it was clear that when technical images were invented, old image-beliefs were transferred onto them, projected onto them. These old image-beliefs came from the time before the era of "art," when images were seen to be not representations, but emanations. This pre-art legacy of the *acheiropoetic* image (the image "not made by hand") was picked up by technical images. Even as they lost their Benjaminian "aura," they gained another, the aura of *belief*. Even though photographs inherited the *acheiropoetic*—and people generally want to think of photographs as being more "real" and more believable than images made by hand (paintings and drawings)—photographs are and always have been more fiction than fact. At their most believable (and most highly manipulated), they project what Robert Duncan called, in another context, "fictive certainties."[8]

Ronald Reagan stumbled onto something when he said: "Facts are stupid things," for facts are, in fact, stunning (from the Latin *stuporatus*) in their priority, whereas fiction (*fictio*, a making, from *fingere*, to touch, form, or model) is generative—of form and content, and of meaning.

I've been looking at the history of Byzantine icons and the iconoclasts, and the Renaissance science of images, especially in the work of Giordano Bruno, who developed a coherent theory of the effects of images on masses of people. This is the world that Renaissance magic foresaw—the world in which we now live.

I want to recall here that P. Adams Sitney, in his 1979 book *Visionary Film*, recounts a "hilariously aggressive lecture" that Harry Smith gave at Yale in 1965, in which Smith spoke of Giordano Bruno as the inventor of cinema.[9] I now think that Harry was about right.

I began this inquiry into images and belief by triangulating three secondary sources: Vilém Flusser's *Towards a Philosophy of Photography* (which appeared in German in 1983), Ioan P. Couliano's *Eros and Magic in the Renaissance* (which appeared in French in 1984), and Hans Belting's *Likeness and Presence: A History of the Image Before the Era of Art* (which appeared in German in 1990).

Flusser's book is a phenomenological approach to technical images—an attempt to understand what these things are and how they operate. He sets out the stakes right away:

> This book is based on the hypothesis that two fundamental turning points can be observed in human culture since its inception. The first, around the middle of the second millennium BC, can be summed up under the heading "the invention of linear writing"; the second, the one we are currently experiencing, could be called "the invention of technical images." . . . This hypothesis contains the suspicion that the structure of culture—and therefore existence itself—is undergoing a fundamental change.[10]

Flusser calls "the space and time peculiar to the image . . . the world of magic," and he sets up an opposition between magic and history: the world of magic is "a world in which everything is repeated and in which everything participates in a significant context," whereas the linear world of history is one in which "nothing is repeated and in which everything has causes and will have consequences." And he says: "The significance of images is magical," and that technical images were invented in the nineteenth century, during a crisis of texts, "in order to make texts comprehensible again, to put them under a magic spell—to overcome the crisis of history."

> Nothing can resist the force of this current of technical images—there is no artistic, scientific, or political activity which is not aimed at it, there is no everyday activity which does not aspire to be photographed, filmed, videotaped. For there is a general desire to be endlessly remembered and endlessly repeatable. All events are nowadays aimed at the television screen, the cinema screen, the photograph, in order to be translated into

a state of things. In this way, however, every action simultaneously loses its historical character and turns into a magic ritual and an endlessly repeatable movement.

Later on, Flusser defines the photograph as "an image created and distributed automatically by programmed apparatuses in the course of a game necessarily based on chance, an image of a magic state of things whose symbols inform its receivers how to act in an improbable fashion."

Ioan Couliano defines magic as "a science of the imaginary":

> At its greatest degree of development, reached in the work of Giordano Bruno, magic is a means of control over the individual and the masses based on deep knowledge of personal and collective erotic impulses. . . . The magician of the Renaissance is both psychoanalyst and prophet as well as the precursor of modern professions such as director of public relations, propagandist, spy, politician, censor, director of mass communication media, and publicity agent.[11]

Couliano believed that the shift from a society dominated by magic to one dominated by science is primarily "a change in the imaginary," and that the European scientific revolution that led to the annihilation of the Renaissance sciences was "caused by *religious* factors which have nothing to do with the sciences themselves." "Because magic relied upon the use of images, and images were repressed and banned in the Reformation and subsequent history, magic was replaced by exact science and modern technology and eventually forgotten."

Hans Belting, in his thoroughly useful history of the image, writes that when old images were destroyed by the iconoclasts in the Reformation, "images of a new kind began to fill the art collections which were just then being formed."[12] Thus began the era of art, which continues to this day. Belting writes a history of the image before the era of art, when sacred icons and other cult images were not thought to be the work of artists, but were believed to be either "of heavenly origin or produced by mechanical impression during the lifetime of the model."[13] It is the latter type of *acheiropoetic* image that I believe is the progenitor of technical images.

Both Flusser and Couliano are writing into what they see as a social crisis, and both raise cries of alarm. Flusser believes that the ultimate effect of "the photographic universe and all apparatus-based universes" is to "robotize the human being and society," and to "act as a magic feedback mechanism," to reprogram people into functionaries. He calls for a criticism of apparatuses "to analyze this restructuring of experience, knowledge,

evaluation, and action into a mosaic of clear and distinct elements in every single cultural phenomenon," in order to "create a space for human intention in a world dominated by apparatuses." Flusser also calls on artists and image makers to "play against the camera," to "place within the image something that is not in its program," and to "address the question of freedom in the context of apparatus in general."

Couliano's book "examines changes at the level of the *imaginary* rather than at the level of scientific *discoveries*," and finds that

> nowadays, if we can boast of having at our disposal scientific knowledge and technology that used to exist only in the phantasies of magicians [including "manipulation through picture and speech" that has "reached an unprecedented level owing to mass communication"], we must allow that, since the Renaissance, our capacity to work directly with our own phantasms, if not with those of others, has diminished. The relationship between the conscious and the unconscious has been deeply altered and *our ability to control our own processes of imagination* reduced to nothing. [Emphasis added.]

To Couliano, the historical record is clear: "The revolution in spirit and customs brought about by the Reformation led to the total destruction of Renaissance ideals. The Renaissance conceived of the natural and social world as a spiritual organism in which perpetual exchanges of phantasmic messages occurred. That was the principle of magic and of Eros, Eros itself being a form of magic." Couliano sees this not as a "mere curiosity of history, but illuminating proof that our civilization continues to die in the trenches dug by the Reformation and by the political events that followed it. The modern West—as Nietzsche foresaw—is assuming the character of a *fatal* result of the Reformation. But is it also the *final* result, its lines of development fixed, once and for all, in the sixteenth and seventeenth centuries?"

On that question Couliano's book closes, as he says, "without daring to express too clearly a hope that may be utopian: that a new Renaissance, a rebirth of the world, may overcome all our neuroses, all conflicts, and all divisions existing between us. For such a Renaissance to appear a new Reformation must arise, effecting once again a profound modification of the human imagination in order to impress on it other paths and other goals."

Ultimately, I'm interested in the ways we respond to and are manipulated by technical images, and I am more and more convinced that the key to this is magical, in Flusser's sense of "a form of existence corresponding to the eternal recurrence of the same," Couliano's sense of magic as "a science of the imaginary," as well as in Bruno's as "a means of control over the individual and the masses based on deep knowledge of personal and collective erotic impulses."

NOTES

1. Stan Brakhage, "Make Place for the Artist," in Robert A. Haller, ed., *Brakhage Scrapbook: Collected Writings, 1964–1980* (New Paltz, N.Y.: Documentext, 1982), p. 1.

2. Robert Duncan, "Concerning the Art: This December 1963," in Christopher Wagstaff, ed., *Robert Duncan: Drawings and Decorated Books* (Berkeley, Calif.: Rose Books, 1992), pp. 6–7.

3. Stan Brakhage, "The Nature of Image," in *Telling Time: Essays of a Visionary Filmmaker* (Kingston, N.Y.: McPherson, 2003), p. 133.

4. Giordano Bruno, *De vinculis in genere* [1591], "A General Account of Bonding," in *Cause, Principle and Unity, and Essays on Magic*, Richard J. Blackwell and Robert de Lucca, eds. and trans. (Cambridge, U.K.: Cambridge University Press, 1998), p. 155.

5. Marcel Mauss, *Esquisse d'une théorie générale de la magie* [1902], *A General Theory of Magic*, trans. by Robert Brain (London and Boston: Routledge & Kegan Paul, 1972), p. 8.

6. H[oward]. P[hillips]. Lovecraft, "The Outsider" [1921], in *The Dunwich Horror and Others* (Sauk City, Wis.: Arkham House, 1963), p. 51.

7. *Encyclopedia of World Art*, vol. 9 (New York: McGraw-Hill, 1964), p. 371.

8. *Fictive Certainties* is the title Duncan gave to his first collection of essays on poetics and mythopoesis, including "The Truth and Life of Myth," "Towards an Open Universe," and "The Self in Postmodern Poetry" (New York: New Directions, 1985).

9. P. Adams Sitney, *Visionary Film: The American Avant-Garde, 1942–1978*, 2nd ed. (New York: Oxford University Press, 1979), p. 235.

10. Vilém Flusser, *Towards a Philosophy of Photography* [1983], trans. by Anthony Mathews (London: Reaktion Books, 2000), p. 7. The following Flusser citations also derive from this volume.

11. Ioan P. Couliano, *Eros & Magic in the Renaissance* [1984], trans. by Margaret Cook (Chicago and London: University of Chicago Press, 1987), p. xviii. The following Couliano citations also derive from this volume.

12. Hans Belting, *Likeness and Presence: A History of the Image Before the Era of Art* [1990], trans. by Edmund Jephcott (Chicago and London: University of Chicago Press, 1994), p. xxi.

13. Ibid., p. 49.

In Case Something Different Happens in the Future

On Joseph Beuys and 9/11

In matters of seeing Joseph Beuys was the great prophet of the second half of our century. . . . Believing that everybody is potentially an artist, he took objects and arranged them in such a way that they beg the spectator to collaborate with them . . . by listening to what their eyes tell them and remembering.

> —John Berger, "Steps Towards a Small Theory of the Visible," 1995[1]

It's a sort of prop for the memory, yes, a sort of prop in case something different happens in the future.

> —Joseph Beuys, in response to a question about his Multiples, 1970[2]

In the year 1974, the United States of America was in crisis. We had lost an ill-conceived and disastrously mismanaged war in Vietnam, and were about to withdraw in defeat. Following the Yom Kippur War, the Arab oil-producing states initiated an embargo on oil shipments to the United States, Western Europe, and Japan, in retaliation for their support of Israel, and this triggered an energy crisis in most of the industrialized world. Economic growth in the United States slowed to near zero.[3] In August of that year, Richard Nixon became the first U.S. president to resign in disgrace, and his successor, Gerald Ford, promptly pardoned Nixon of all crimes committed while in office.

It was at this time that Joseph Beuys chose to make his first visit to the United States. Since 1970, he had been increasingly extending his theories of sculpture into the social realm, calling this new work "Social Sculpture." Rather than mounting a conventional exhibition in the United States, Beuys decided instead to arrange a series of lectures and discussions—in New York, Chicago, and Minneapolis—under the collective title Energy Plan for the Western Man. He arrived in New York from Düsseldorf on January 9, 1974, and from there traveled west. When he flew back into New York from Minneapolis on January 19, he performed a therapeutic operation on a striking new feature of the New York City skyline.

The World Trade Center had been completed only months before Beuys's arrival in New York. It was the world's largest commercial complex, including seven buildings and a shopping concourse, built at a cost of $750 million. Designed by Minoru Yamasaki and Emery Roth and Sons, it was capped off with two 110-story skyscrapers, the Twin Towers, which dwarfed every other building in New York (including the Empire State Building) and rose up out of Lower Manhattan like severed limbs. The towers immediately *stood for* (symbolized) globalized Capital and American dominance in the world market; they were the symbolic pillars of the New World Order.

Beuys was fascinated by the Twin Towers. He must have seen them to great effect when he flew into John F. Kennedy Airport on January 19. In the terms of his theory of sculpture, the Twin Towers were classic crystalline forms: rigid, dry, and cold—like the basalt columns of his later project *7000 Eichen/7000 Oaks*. Beuys immediately did several things in order to warm them up. He chose a 3-D postcard image of the towers that softened their sharp angles and tinted them yellow, making them look like two sticks of butter or fat (a staple Beuys material), a substance that responds to heat very differently than does crystal. The yellow also made the towers appear to be coated in sulphur, which in alchemy is the hot, dry, active seed of metals, the male principle, and was another Beuys staple, often used in his objects and actions. As writer Annie Suquet has put it:

> By drawing or marking a space with fat, Beuys subtracted it from the deadly "appropriating mastery" of the right angle: fat, as unstable matter, can shift from the liquid (warm) to the solid (cold) state and compensates, through its very reversibility, the motionless rigidity of architectures. To prepare the space of action with fat meant warming it up, inscribing it with the possibility of movement—of life.[4]

And then Beuys inscribed on the two towers the names "Cosmos" and "Damian" in blood-red ink. Why?

Choosing the names of these twin Arab saints, martyred by beheading, to adorn the World Trade Center Twin Towers—twenty-seven years before these towers, in collapse, became the symbols of Christian/Muslim strife—was prescient, certainly. At the time, Beuys must also have enjoyed the significance of tagging the Twin Towers, the new image of global Capital, with the names of these two patron saints of physicians. Cosmos (or, more commonly in English, Cosmas)[5] and Damian were known as the *Anargyroi* ("moneyless" or "the unmercenaries") because they refused to accept money in exchange for their services. Was this action by Beuys a goof, a lark? Or was there something more going on? Klaus Staeck, who collaborated with Beuys on this postcard (and some three hundred other postcards, as well as many other Multiples—everyday objects, transformed sculpturally to

add meaning, and produced in quantity to increase distribution of the ideas[6]—from 1968 to Beuys's death in 1986) has written that Beuys "discovered the cosmos in details and was at the same time a master of staging on a large scale. He could devote as much time to the form and contents of a postcard as to the installation of a large environment."[7] So what was Beuys trying to do with the Twin Towers image?

Cosmas and Damian were twin brothers, born in Arabia, and brought up as Christian by their mother. They studied medicine and became great itinerant healers, treating both humans and animals. Since they accepted no payment for their work, the Anargyroi's charity helped to spread the faith. Under the Diocletian persecution, the twins were arrested and tortured, but refused to give up their beliefs. When the authorities tried to burn them at the stake, the flames turned away from Cosmas and Damian and leapt onto their tormentors. When they were stoned, the stones turned back upon the throwers and injured many. When they were crucified and shot with arrows, the same thing happened. They were finally beheaded, probably in 287 C.E., and their remains were buried in the Syrian city of Cyrrhus, where the Emperor Justinian I (who reigned from 527 to 565) restored the city in their honor. In gratitude for their healing of him from a dangerous illness, Justinian rebuilt and decorated their church at Constantinople, and it became a place of pilgrimage. Pope Felix IV (who held the office from 526 to 530) brought their relics to Rome and built a church for them near today's Via dei Fori Imperiali, where magnificent mosaics from the sixth century detailing the lives of the twin saints continue to inspire.

From the fourth century on, the cult of Cosmas and Damian spread widely, to both the East and the West. In the East, they appeared on countless icons, and some of these images themselves had the power to heal. Their skulls traveled from Rome to Bremen in the tenth century, from there to Bamberg, and finally, in 1581, to the Monasterio de las Descalzas Reales (the convent of the St. Clare nuns), in Madrid, where they remain. The cult has been especially resilient and long-lasting in Germany, where Beuys would have known about the saints from childhood.

Since Cosmas and Damian (or Cosimo and Damiano) were also the patron saints of the Medici family (hence all those Cosimos), their images can be found throughout Italian Renaissance art. Statues of the twins, designed by Michelangelo, flank that of the Madonna in the Medici Chapel in Florence, and one of the earliest decorations by Donatello depicts the saints in half relief, set above the doors of Brunelleschi's sacristy in the Basilica of San Lorenzo. Fra Angelico made a series of paintings recording the incidents of the saints' lives for the church and monastery of San Marco in Florence, including the two predella panels now in the Museo di San Marco and seven other panels now in Washington, D.C., Dublin, Munich, and Paris. Cosmas and Damian were often introduced, in various guises (usually dressed in the scarlet and ermine of physicians), into paintings by Fra Filippo Lippi and

Botticelli, and they appear in Rogier van der Weyden's *Medici Madonna* (1460–64), painted in Rome and believed to be the first *sacra conversazione* in the history of Flemish painting. Both Titian and Tintoretto put them in pictures celebrating the recovery of Venice from the great plague of 1512.

A favorite subject for painters was Cosmas and Damian's performance of the first surgical transplant, when they removed the diseased leg of an Italian man afflicted with cancer, and replaced it with the leg of a recently deceased Moor, thus accomplishing, as well, the first interracial and cross-cultural healing, putting a black man's leg onto a white body, a Muslim leg onto a Christian body.

Beuys made another Multiple in 1975, combining a color print depicting Cosmas and Damian transplanting the leg, with a spray of bleeding heart (*Dicentra spectabilis*). This is the Asian species of bleeding heart, often cultivated in gardens in the eastern part of the United States. A similar plant, *Dicentra cucullaria* (called "Dutchman's breeches") is native in the eastern United States, and is known to New Yorkers as the springtime flowers whitening the shady ledges of Central Park. The Iroquois used an ointment made from *Dicentra cucullaria* to make athletes' legs more limber, and a leaf potion made from the plant has long been used in folk medicine for skin ailments, paralysis, and tremors. Beuys might also have been playing on the meaning of the plant's Latin binomial, in relation to Cosmas and Damian: *dicentra*, "two-pronged," plus *spectabilis*, "visible" or "worthy."

Cosmas and Damian are later manifestations of the ancient Indo-European myth of *divine twins*, and especially the tradition of twins as magical healers. There are numerous Vedic hymns extolling their virtues. One relates the story of how the mare Vispata lost a foot in battle, and the Asvins (the name of the divine twins in the collection of Sanskrit hymns known as the Rig Veda) appeared and replaced the stricken limb with an iron foot.[8] The Rig Veda also says that the Asvins possessed two wooden poles that they rubbed together to make fire, and aniconic wooden pillars are among the most common symbols of the Dioscuri—Castor and Pollux—twin gods in Greek mythology.

> Additional evidence of the worship of wooden pillars has been found in Lower Saxony, where archaeologists have found the remains of thatched-roof structures dating from the eighth century A.D. which were so constructed that there were two wooden pillars beneath the gables. The only evident function of these poles is reinforcement of the ridge ends of the roof, and it is generally considered that their primary function was a religious one. When economic factors forced changes in the structure of these houses, these pillars disappeared; however, their religious function survived in items such as horses' heads and swans adorning the gables of

Saxon structures. Since these items are typical Dioscuric symbols, it seems highly probable that the pillars were originally idols honoring the Divine Twins.[9]

The church introduced Cosmas and Damian (and other pairs of saints, including Sebastian and Rochus, Johannes and Philippus, Protasius and Gervasius, and others) into Northern Europe in the hope that they would displace surviving Dioscuric cults, since these saintly twins had already absorbed the Mediterranean divine-twins traditions. But the truth is that powers such as this do not just disappear, but are reabsorbed and continually rejuvenated in different forms, as Beuys well knew.

Show Your Wound, Dicentra Spectabilis

Beuys's aesthetic is embedded in the ideas of alignment, perpetuation, and addition. Rather than advocating invention, he believed it was the artist's task to discover connections and expand upon them.

— Pamela Kort, "Beuys: The Profile of a Successor," 2001[10]

When one speaks about the sociableness of man, one has to know that suffering and showing compassion are the actual prerequisites for becoming a social being.

— Joseph Beuys, 1973[11]

To Beuys, the Twin Towers of the World Trade Center were already a death zone in 1974: rigid, cold, dedicated to the accumulation of money and world domination under Capital.[12] Was his inscription preemptive and tactical, to put the twin healers in place to salve the wounds to come, or apotropaic, as an attempt to ward them off? All of Beuys's work can be seen on one level as therapeutic, an attempt to heal the wounds of the social body—both the external wounds inflicted on others and the internal wounds of complicity and denial. As the patron saints of the Medici, Cosmas and Damian were certainly called upon to cure all manner of spiritual maladies arising from the pursuit and exercise of power. Might they be enlisted again in the New World?

And it is difficult not to view as prophetic the visual cues of Beuys's second trip to the United States later in the same year, for his three-day performance *I Like America and America Likes Me*, in which he lived and communicated with a coyote in a small room separated from the public by bars, in the newly opened René Block Gallery at 409 West

Broadway in New York.[13] We see Beuys on the airplane from Düsseldorf to New York, hooded like the detainees at Abu Ghraib and Guantánamo, on an "extraordinary rendition" flight. Klaus Staeck has reported that "after arriving at the John F. Kennedy airport in New York [Beuys] also had to endure the longest questioning. What was his profession? Sculptor. What kind of sculptor? Social Sculptor. What did that mean? What did he want in the U.S.A.? Give lectures. What kind of lectures? Where? What about? Did he intend to be active in politics? And so on."[14] Beuys was then wrapped up and transported in an emergency vehicle to his meeting with the "despised other," the coyote, behind bars, like another detainee and suspected terrorist.

But in his first visit to the United States, rather than try to blow up the Twin Towers, as Al Qaeda did in 1993, or knock them down, as they did in 2001, Beuys made an attempt to heal the wound these towers stood for through symbolic action—image magic—homeopathically renaming the towers as great healers, famed for their cooperation and cross-cultural surgery. As he had said earlier: "When you cut your finger, bandage the knife."[15]

What if George Bush and Tony Blair (those other twins) had received Beuys's message and taken it to heart, realizing that the Twin Towers were a wound, from the beginning, that needed to be healed, not given "an eye for an eye," and had seen that their loss was an extraordinary opportunity to reach out to the world and bring it together, rather than to use that loss as a pretext for a previously (badly) planned military adventure in Iraq, and the dismantling of sixty years of human rights protections and international law, in the name of an incoherent "War on Terror"?

The writer Michael Brenson, who has called Beuys "the most prophetic voice" in the tradition of healing art,[16] has reminded me of Alberto Giacometti's *The Leg*, from 1958, as a sculpture of relevance to the Twin Towers. This one amputated leg, improbably resolute in its verticality, while remaining as vulnerable as a twig, manages to be (as Jean Genet wrote) "at once anxious, tremulous, and serene."[17] Giacometti saw the mosaics of Saints Cosmas and Damian in the basilica in Rome in 1920, at age nineteen, and they immediately entered the pantheon of works—Tintoretto in Venice, Giotto in Padua, Cimabue in Assisi, an Egyptian portrait bust in Florence—that broke down the barrier between art and life for that young artist. It was shortly after this that Giacometti had his death epiphany, watching Peter van Meurs die, in Madonna di Campiglio, and realizing once and for all how close death is to life. And I think of Giacometti's 1958 leg, now, in relation to what's happened after 9/11—of all the wounded soldiers coming home from Iraq and Afghanistan, and all the severed limbs of innocents, blown up by improvised explosive devices, every day, endlessly. Who will heal these wounds? This endless wound?

The oldest depiction of Cosmas and Damian we have is in a mosaic frieze in the Hagios Georgios, in Thessaloniki, from the beginning of the fifth century. The two saints,

in long white robes, stand in perfect symmetry, facing us, with their arms raised in blessing and supplication. They stand in front of a sumptuous palace, with twin towers rising behind them. The mosaic has been badly damaged, and a jagged wound cuts through the center of the composition, separating the twin saints and obscuring much of the frieze. One inscription is still legible. It reads: "Damian, physician, month of September."

NOTES

1. John Berger, "Steps Towards a Small Theory of the Visible" [1995], in *The Shape of a Pocket* (New York: Pantheon, 2001), pp. 21–22.

2. Joseph Beuys, in Jörg Schellmann and Bernd Klüser, "Questions to Joseph Beuys," part 1, December 1970, in *Joseph Beuys Multiples: Catalogue Raisonné of Multiples and Prints, 1965–1985*, compiled and ed. by Schellmann, trans. by Caroline Tisdall (Munich and New York: Schellmann, 1985), n.p.

3. At the same time, Chase Manhattan Bank reported that the net profits of thirty of the world's largest oil companies increased by an average of 93 percent during the first half of 1974.

4. Annie Suquet, "Archaic Thought and Ritual in the Work of Joseph Beuys," *Res* 28 (Autumn 1995) (Santa Monica, Calif., and Cambridge, Mass.: Getty Center for the History of Art and the Humanities, and Peabody Museum of Archaeology and Ethnology, Harvard University): 151.

5. Beuys's spelling of "Cosmos" on the card is not out of order, since some say the name Cosmas comes from the Greek *cosmos*, in the sense of "order" or "form" (world). Others say the name Kosmas is Aramaic.

6. In his interview with Jörg Schellmann and Bernd Klüser of December 1970, Beuys said of the Multiples: "I'm interested in the distribution of physical vehicles in the form of editions because I'm interested in spreading ideas. The objects are only understandable in relation to my ideas. The work I do politically has a different effect on people because such a product exists than it would have if the means of expression were the written word." See Schellmann and Klüser, "Questions to Joseph Beuys," part 1, in *Joseph Beuys Multiples*, n.p.

7. Klaus Staeck, "Democracy Is Fun," in *In Memoriam Joseph Beuys: Obituaries, Essays, Speeches*, trans. by Timothy Nevill (Bonn: Inter Nationes, 1986), p. 14.

8. See Donald Ward, *The Divine Twins: An Indo-European Myth in Germanic Tradition* (Berkeley and Los Angeles: University of California Press, 1968), p. 18.

9. Ibid., pp. 44–45.

10. Pamela Kort, "Beuys: The Profile of a Successor," in Gene Ray, ed., *Joseph Beuys: Mapping the Legacy* (New York: D.A.P. and John and Mable Ringling Museum of Art, 2001), p. 23.

11. Joseph Beuys, in conversation with Axel Hinrich Murken, March 1, 1973, in Murken, *Joseph Beuys und die Medizen* (Munster, Germany: F. Coppenrath, 1979), p. 149.

12. In the Tarot, the Tower represents man's creations built on the foundations of false science, and it portends conflict, unforeseen catastrophe, and the fall of selfish ambition. P. D. Ouspensky begins his entry on the Tower with these words: "I saw a lofty tower extending from earth to heaven; its golden crowned summit reached beyond the clouds. All round it black night reigned and thunder rumbled. Suddenly the heavens opened, a thunder-clap shook the whole earth, and lightning struck the summit of the tower and felled the golden crown. A tongue of fire shot from heaven and the whole tower became filled with fire and smoke. Then I beheld the builders of the tower fall headlong to the ground." Ouspensky, *The Symbolism of the Tarot* [1913], trans. by A. L. Pogossky (New York: Dover, 1976), p. 48.

13. See "American Beuys," in David Levi Strauss, *Between Dog & Wolf: Essays on Art and Politics* (New York: Autonomedia, 1999), pp. 34–51.

14. Klaus Staeck, *Beuys in America*, ed. and photographed by Staeck and Gerhard Steidl (Heidelberg and Göttingen, Germany: Staeck and Steidl, 1997), p. 7.

15. This was the title (*Wenn Du Dich schneidest, verbinde nicht den Finger, sondern das Messer*, literally "If you cut yourself, do not bandage the finger, but the knife") that Beuys gave to a 1962 sculpture consisting of a seven-inch kitchen knife with a bandage on its blade, now in the collection of Dr. Reiner Speck.

16. Michael Brenson, "Healing in Time," in *Culture in Action* (Seattle: Bay Press, 1995), p. 30.

17. Jean Genet, "The Studio of Alberto Giacometti," in Edmund White, ed., *The Selected Writings of Jean Genet* (Hopewell, N.J.: Ecco, 1993), p. 318.

Enough of Us to Say No
On the Images from Tahrir Square

In March 2011, looking toward the tenth anniversary of 9/11, Melissa Harris of Aperture *magazine asked me to write something for a series titled The Anxiety of Images, dealing with some aspect of how the conflicts of the preceding ten years had been visually articulated. I decided I wanted to write about the images then coming out of Tahrir Square in Cairo. This essay was published (in a different form) as the first in the series, next to a piece by Yasmine El Rashidi, whose reporting from Cairo for the* New York Review of Books, *and reflections in our personal correspondence, had helped to give me a context for the images we were seeing. What has happened in Egypt since this time is a tragedy, and it is clear that Egyptians have a great deal of travail and misery yet to come. But this does not invalidate or erase what happened in Tahrir in 2011.*

As I write this, in April 2011, peaceful protestors in Cairo's Tahrir Square are again being beaten and shot, this time by the Egyptian military. The protesters are calling for the ouster of Field Marshal Mohamed Hussein Tantawi, a former Hosni Mubarak loyalist, as defense minister and titular head of state. The political future of Egypt is very much in doubt, with the Muslim Brotherhood organizing for the upcoming elections, attacks on Copts rising, and calls for stability at any cost increasing. But no matter what happens from this point on, nothing will alter the fact that something extraordinary took place in 2011 in Egypt, and it changed the way the rest of the world sees Egyptians, and more important, the way Egyptians see themselves. It might also have changed the way Americans see themselves.

On Tuesday, January 25, 2011 (National Police Day in Egypt), demonstrators gathered at twenty locations throughout Cairo to call for freedom, justice, and the end of President Mubarak's autocratic thirty-year reign. What started as a few dozen people fanning out across the city in the early afternoon grew to hundreds, then thousands, then tens of thousands, who converged on Tahrir (Liberation) Square. There, they were met by police and state security forces who attacked them with rocks, batons, and water cannons, and thugs working for the regime who attacked them with metal chains and knives. Three protesters were killed and 850 were arrested that night. Police finally broke up the crowds with rubber bullets and tear gas, but the rebellion had just begun. After eighteen days of fighting, with the crowds in Tahrir Square swelling to well over a million, Mubarak finally stepped down, on February 11.

The organizers of the initial demonstrations were mostly public university graduates in their twenties (60 percent of Egypt's eighty million citizens are under the age of twenty-five). Thirty of the organizers had met the week before at the Center for Socialist Studies in Cairo to plan the marches. Inspired by the recent uprisings in Tunisia, they hoped to get tens of thousands of Egyptians out into the streets of Cairo to demand political change. They used Facebook and Twitter to spread the word and to mobilize forces on the ground. As the protests continued, Egyptian intelligence services began to closely monitor Facebook and Twitter accounts, so a twenty-six-page "Manual to the Egyptian Revolution," containing a suggested list of tools, clothes, marching routes, and so on, was distributed using e-mail, home printers, and local photocopiers.

By the time the authorities understood that this uprising was different from all the smaller demonstrations that had been happening in Cairo for years, and moved not only to crush the rebellion, but to control the images of it, the damage had already been done. When those young people came out into the streets on January 25, they were armed not with guns but with *cameras*, and they took thousands of pictures that were immediately uploaded to social media and other sites, and spread around the world. These images showed Egyptians standing up and fighting for their freedom, part of the contagion of hope that was spreading throughout the Middle East.

As we have learned from China and other repressive states, the Internet does have an off-switch. At about 10 p.m. on January 27, Facebook was turned off in Egypt, and Twitter fell silent shortly thereafter. Just after midnight, the Internet was turned off altogether, when the Egyptian government pulled the plug on its four main Internet providers, and the mobile-phone networks came down later that morning. But the images continued to be made, and came flooding back out when services were restored six days later.

The world is watching. What is the world? Watching. To outside observers in the United States and elsewhere, the images from Tahrir Square, whether in print or on screens, were absolutely riveting. People dropped whatever they were doing and watched cable-news coverage of the demonstrations twenty-four hours a day. If these sources flagged, even for a moment, or one's appetite expanded, one went to Al Jazeera English on the Web, to get better coverage and more images. Every day was different. Every day something astonishing happened.

From the beginning, the images coming out of Cairo were different from the images one remembers from other recent popular uprisings and demonstrations. Why?

Technological change is obviously a big factor. The images produced by cell- and smartphones today are of a higher quality than those same images produced a year ago, or even a few months ago. Small, inexpensive cameras now record high-quality video. And the fluidity of propagation of these images has expanded exponentially, via smartphones and social-media sites, especially. As the ability to make and disseminate images publicly has spread, crowd-sourced images look better and are more accessible than ever.

The way these demonstrations formed and proceeded also influenced how the images looked. Things happened quickly, and access, in the beginning, was good. Participants on all sides were surprised by what happened. None of the organizers or demonstrators believed the crowds would grow so large, until they did. There have been demonstrations in Egypt against the policies of the regime for many years, and organizers could always expect a few dozen or perhaps a hundred people to show up. But this time it was different.

Suddenly, everyone was there. And slowly it dawned on the people participating that there were enough of them, this time, to demand change and get it. There were enough of them, this time, to say no. And as soon as they realized this, they were no longer afraid. You can see this happening, this dawning, in the images from Tahrir Square. You can see people looking at their young children wrapped in the Egyptian flag with newfound pride. You can see bloodied young men and boys wearing improvised helmets made of empty water bottles and shields made of can lids, handsome as fearless Quixotes. And you can see women and girls in the images, veiled and unveiled, demonstrating and fighting side by side with the men and boys. "If we can fight and die with you," they eventually said, "we should be able to pray with you"—and that, too, happened.

Everyone was in this together, and you could see in people's eyes, over and over again, that recognition, that they were not alone anymore. It was a beautiful thing to see.

When America's college campuses erupted in antiwar protests in the early 1970s, the governor of California, Ronald Reagan, vowed to put down the uprisings and crush the demonstrators, no matter what it took. "Nothing has ever been solved or changed," he said, "by people demonstrating in the streets." This was said, without irony, in stunning ignorance, by one who would soon become President of the United States, and is currently being repackaged as a great and prescient leader.

As we watched the Egyptians recognize each other in January and February, and risk their lives to come together to demand freedom and justice, we Americans were reminded of where we came from, what we've been, and what we used to stand for, before the "Reagan Revolution" and 9/11, before we fell into fear and bitter division. The Egyptians reminded us who we were.

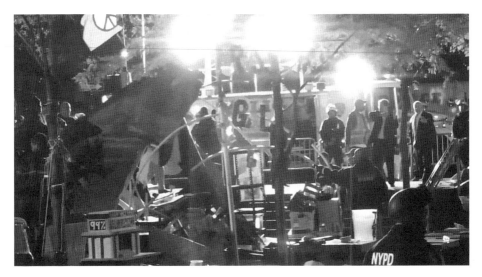

Occupy Wall Street video still showing the destruction of the People's Library, November 15, 2011

Occupied Images

On the Images from Zuccotti Park

Many powerful images emerged from the Occupy Wall Street movement, beginning on September 17, 2011. But when New York's Mayor Michael Bloomberg mounted a military-style raid on the protesters camped out in Zuccotti Park in the middle of the night on November 14–15, the vivid scenes from that action displaced earlier ones to become the iconic images of the Occupation. The mayor tried to control pictures of the assault by blocking access to the news media, but this only ensured that the images made by the Occupiers themselves from inside the park, live-stream videos showing the wanton destruction of the encampment, including the beloved People's Library, become even more powerful. Here is what we saw on the night of the raid:

Dark rows of police officers in full riot gear ring the park, backed up by silver barricades and klieg lights that pierce the night and flare out like menacing suns. The only color is fleeting and bleeding—the clothing, tents, and bedding of the rousted Occupiers, flying through the air or being smashed underfoot. Some of the sleepers awake and tie themselves to the trunks of the honey locust trees with ropes in an effort to ride out the storm. Parents comfort their children and try to gather their belongings together in the dark. As the raid escalates, the level of violence rises. The police begin to push and jab people with their batons, separating them from their belongings. People are screaming and crying. A young black woman stands up on a granite step and speaks through an improvised megaphone, chastising the police for coming into a peaceable encampment in the middle of the night, and entreating them not to harm the sleepers. "Why are you doing this? Do you see what you are doing? Who are you working for? These people are not dangerous; they are peaceful protestors. Shame on you. Shame . . . on you."

The camera then focuses on the scenes of destruction, as orange-jacketed sanitation workers move in and begin throwing everything—tents, pallets, sleeping bags, blankets, clothes, computers, kitchen supplies, food, bicycles, furniture—into a big pile at the southeast corner of the park, under the red girders of Mark di Suvero's welded-steel sculpture *Joie de Vivre*. At that point, it looks like they are building a pyre to burn. Later, garbage trucks appear and everything is loaded into them as their hydraulic jaws crush everything into an undifferentiated mess.

At the northeast corner of the park, policemen tear the cover off the People's Library structure (dubbed "Fort Patti," after its donor, rocker/writer Patti Smith) and rip the tubular structure out of the ground. Then they grab the books from the shelves and out of boxes and throw them into dumpsters and garbage trucks. The destruction goes on interminably, for hours, until nothing is left. Then a new squadron of sanitation workers enters the park with pressure sprayers, as if to wash away the memory of what has happened there.

The raid on Zuccotti Park was a military-style assault—in coordination with counterterrorism agents from the Federal Bureau of Investigation,[1] and an active CIA senior agent, Lawrence Sanchez, working with the New York Police Department's own intelligence division, who "instructed officers in the art of collecting information without attracting attention"[2]—on unarmed, peaceful protestors in the middle of the night. It was intended as a display of force, a spectacle of state power brought to bear against its citizens. Such a display of power is intended as a warning to all other citizens who witness it: Do not stand up. Do not protest or present grievances. Do not organize. And do not gather together in public to show that things can be done differently.

New York's Mayor Michael Bloomberg and Police Commissioner Raymond Kelly attempted to control the images coming out of Zuccotti Park on the night of November 14–15 by refusing to allow the news media into the area. They shut down the subway stations and the Brooklyn Bridge to limit access, and forced photographers to stay a block away from the park. But they failed to fully realize the extent to which the people in the Occupy Wall Street movement had been making, and sending out, their own images, from inside, and that the protestors would continue to make and send them out on the night of the assault. As soon as the raid commenced, at 1 a.m., Occupiers turned on their cameras and began uploading live feeds to the Internet. This is how the world was watching on November 15. By the time the air had cleared of mace and pepper spray, it had also become clear that the mayor and his One-Percent supporters on Wall Street had in fact handed OWS a greater and much more lasting victory, in the battle of images. In trying to suppress images, the authorities had helped to create more powerful and indelible ones.

The images coming out of Occupy Wall Street were important to the overall effort from the beginning, but there was always a contradiction at the heart of the movement, between the values of immediatism and mediation. On one hand, Occupy Wall Street was all about the immediate experience of being in Zuccotti Park: of working, playing, sleeping, making love, and making decisions right there, together. It was about being face to face and shoulder to shoulder. If you weren't there, you weren't doing it. On the other hand, the movement was bigger than the people in the park, and to reach a larger public, it had to rely on images and other forms of mediation. The tension between these two values continued throughout the occupation, and animated the political discussions in and around the park.

These included some of the most trenchant conversations I've ever had about the role of public images in liberation struggles.

The first image of OWS came from the sixty-nine-year-old cofounder and editor of the Vancouver-based magazine *Adbusters*, Kalle Lasn. In early June 2011, he said that "America needs its own Tahrir."[3] Lasn thought of the image of a ballerina balancing on the shoulders of the Wall Street bull and had his designers put it together into a poster calling for the occupation of Wall Street. The text superimposed over the image read: "What is our one demand? #OccupyWallStreet. September 17th. Bring tent."

In a subsequent interview, published in the *New Yorker*, Lasn said that he intended the ballerina-bull image to convey "the juxtaposition of the capitalist dynamism of the bull with the Zen stillness of the ballerina."[4] The background image of police in riot gear advancing with weapons drawn was prescient. But the *Adbusters* "culture jamming" approach of mirroring and turning corporate advertising aesthetics against itself was quickly overwhelmed in Zuccotti Park by a lotek, DIY street aesthetic that led to a tsunami of hand-lettered signs on recycled cardboard. When fifteen thousand protesters took those handmade signs to Times Square, the juxtaposition with the corporate advertising Spectacle was thrilling. This aesthetic was eventually memorialized and extended in the photo-blog *We Are the 99 Percent*, launched as a Tumblr page in late August 2011, that now contains thousands of images of people holding up handwritten signs describing their situation as members of the 99 Percent.[5]

In the days and weeks that followed the initial occupation, mainstream media outlets were slow to recognize the nature and significance of the movement. First they tried to ignore it. Then they vilified it. Then they mocked and dismissed it as retrograde and irrelevant, and fell back on old image tropes and depictions of protesters as "dirty hippies" and inarticulate malcontents. As the movement grew in size and intensity, images of police brutality, especially those involving the use of pepper spray to blind peaceful protesters, began to dominate coverage of the events. These images increased popular support for the protestors, but also drew attention away from the substantive political discussions taking place every day in Zuccotti Park. In the end, the news media recognized OWS as a real grassroots political movement, and some of them even celebrated it.

Like the other parts of Occupy Wall Street that worked the best, the People's Library started from a simple idea, in response to an immediate need. We're all here, in the park, with time on our hands, so why don't we use this time to educate ourselves? Half of us are buried in student-loan debt, so let's build a free lending library: all donations accepted, check out whatever book you want to read, on the honor system, and if you want to keep it, de-accession it right there on the spot and it's yours. As one Occupier said: "The kitchen area feeds our bodies; the library feeds our minds and imaginations." It started slowly, but

then took off, growing in leaps and bounds. People from all over the city brought books to donate, and librarians appeared to help organize them. The first book cataloged in the People's Library was my friend Hakim Bey's *T.A.Z.: The Temporary Autonomous Zone, Ontological Anarchy, Poetic Terrorism* (1985), because it was considered a kind of handbook for the Zuccotti Park Occupation by many of the protesters. By the time Bloomberg trashed the library, it had grown to more than 5,500 volumes, all carefully cataloged. After the raid, the mayor's office tweeted an image of books neatly piled on a folding table, indicating that the library had been saved. But when the librarians went to the New York Department of Sanitation garage on West 57th Street to recover it, they found only a few of the books had been salvaged. Most had been destroyed. The image released by the mayor's office was a ruse.

The battle of images was a big part of what Occupy Wall Street was ultimately about. Contrary to conventional wisdom in the press, Occupy Wall Street did not fail. It did exactly what it set out to do; that is, to provide a tangible demonstration of direct democracy in action: "This is what democracy looks like." That it managed to do this in the spectral shadow of the Twin Towers and among the surviving towers of Wall Street, in the face of a repressive mayoral regime with a police force newly militarized after 9/11, which that regime had been itching to unleash, is astonishing. Today, Zuccotti Park is back to its bland, barren self, but the images of Occupy Wall Street will endure.

It must also be said that the "We Are the 99 Percent" message about the ravages of wealth and income inequality in America did have a demonstrable effect on the mainstream political discourse in this country. Would Bill de Blasio have been elected mayor of New York City in a landslide victory in November 2013—on a platform that insisted on addressing inequality in the city and repudiated everything the Bloomberg mayoralty stood for—if Occupy Wall Street hadn't happened? Would President Obama have called income inequality "the defining challenge of our time" in a December 6, 2011, speech (and again on December 4, 2013)? Or, for that matter, would Pope Francis have said in his Apostolic Exhortation of December 2013 that "inequality eventually engenders a violence which recourse to arms cannot and will never be able to resolve," without OWS?

What matters most about OWS is what happened in real time, from September 17 to November 15, 2011, to actual bodies in a particular place, Zuccotti Park in New York City, and all the real occupations it generated and inspired around the world: real bodies in real space, speaking up.

But the millions of images that were made during that time—by professional journalists, amateurs and tourists, and the OWS legions themselves—matter, too. In our time, you cannot have an effective demonstration if no one is watching. The next revolution will not only be televised; it will be instantly disseminated far and wide on stationary and mobile devices, in images made smaller by ubiquity and unspent words. One of the central

questions in the future of iconopolitics is: Will we be able to respond to this constant flow of images with action and decision, or will we be lulled into inaction and indecision, as passive consumers? The exciting thing about Occupy Wall Street was that such big questions were being asked again: Do we still have something to do *together*? And if so, how? These are the kinds of questions that put us at a beginning, or, rather, before the beginning.

NOTES

1. See Michael S. Schmidt and Colin Moynihan, "F.B.I. Counterterrorism Agents Monitored Occupy Movement, Records Show," *New York Times*, December 24, 2012.

2. Michael Greenberg, "New York: The Police and the Protesters," *New York Review of Books* (October 11, 2012); and "The Problem of the New York Police," ibid. (October 25, 2012).

3. Kalle Lasn, quoted in Mattathias Schwartz, "Pre-Occupied: The Origins and Future of Occupy Wall Street," *New Yorker* (November 28, 2011): 29.

4. Ibid., p. 30.

5. See http://wearethe99percent.tumblr.com. (Last accessed December 1, 2013.)

REPRODUCTION CREDITS

Essays

Many of the essays in this volume first appeared in relation to exhibitions, in catalogs and books published by museums and galleries; others were first published in periodicals. All previously published essays have been edited and updated for this book, and some of the titles have been changed.

Part I: A previous version of "An Amplitude That Information Lacks" was published in *Susan Meiselas: In History*, edited by Kristen Lubben (New York and Göttingen, Germany: International Center of Photography and Steidl, 2008). "Eros, Psyche, and the Mendacity of Photography" was published in *Sally Mann: The Flesh and The Spirit*, edited by John B. Ravenal (Richmond, Va., and New York: Virginia Museum of Fine Arts and Aperture, 2010). "Revolt, She Said" was published in *Carolee Schneemann* (Cambridge, Mass.: Pierre Menard Gallery, 2007). "Written in the Blood of Women" was published in *Witness to Her Art: Art and Writings by Adrian Piper, Mona Hatoum, Cady Noland, Jenny Holzer, Kara Walker, Daniela Rossell, and Eau de Cologne*, edited by Rhea Anastas and Michael Brenson (Annandale-on-Hudson, N.Y.: Center for Curatorial Studies, Bard College, 2006). "Fictrix Jane" was published in *Jane Hammond: Recent Photographs* (Hanover, N.H.: Dartmouth College, 2006).

Part II: "Words Not Spent Today Buy Smaller Images Tomorrow" was published in *Aperture* 184, Fall 2006. "On the Edge of Clear Meaning" was published in *On the Edge of Clear Meaning* (Göttingen, Germany: Steidl, 2008); a shorter version of the essay appeared in *Aperture* 191, Winter 2008. "The Democracy of Universal Vulnerability" was published in *Robert Bergman: Selected Portraits*, edited by Phong Bui (New York: PS1 Contemporary Art Center, 2009). "La Mirada, and the Evidence of Things Not Seen" was published in *La Mirada—Looking at Photography in Latin America Today*, edited by Hans-Michael Herzog (Zurich: Daros Latin America and Edition Oehrli, 2002). "Out on Hypoluxo Road" was published in *Lots* (Paris: Coromandel, 2002).

Part III: "On Susan Sontag" was published in the *Brooklyn Rail*, February 2005. "On Larry Clark" was published in *Photograph*, March/April 2004. "On Daido Moriyama" was published in *Artforum*, March 2000. "On Helen Levitt" was published in *Artforum*, October 1997. "On James Nachtwey and 9/11" appeared on the *Time* magazine website *LightBox*, September 7, 2011, edited by Kira Pollack and Paul Moakley.

Part IV: "Troublesomely Bound Up with Reality" was published in *Bookforum*, June/July/August 2007. "The Shutters Come Down" was published in *Fotofest 2006: Artists Responding to Violence* (Houston: Fotofest, 2006). "Inconvenient Evidence" was published first in the *Brooklyn Rail*, December 2004–January 2005, and then in *Abu Ghraib: The Politics of Torture* (Berkeley, Calif.: North Atlantic Books, 2004). "A New Lament of the Images" was published in *Aperture* 197, Winter 2009. "Over Bin Laden's Dead Body" was published in *Image Counter Image* (Cologne: Walter König, 2012), in German and English, to accompany an exhibition at the Haus der Kunst, Munich, June 10–September 16, 2012.

Part V: "The Endless Structure of Recollection" was published in the *New York Foundation of the Arts Quarterly*, April 2003, edited by Alan Gilbert. "A Change in the Imaginary" was published in *Link: A Critical Journal on the Arts*, no. 11, Fall 2006, edited by Mark Alice Durant. "In Case Something Different Happens in the Future" was published as a booklet in the 100 Notes—100 Thoughts series from Documenta 13, in German and English, edited by Bettina Funcke (Kassel, Germany: Documenta 13/Hatje Cantz, 2012). "Enough of Us to Say No" was published in *Aperture* 204, Fall 2011, edited by Melissa Harris. "Occupied Images" appears for the first time in this volume.

Photographs

All reproduction material is copyright and courtesy the artist, unless otherwise noted.

INDEX

Page references in *italics* refer to illustrations.

O